THE CREATIVE UNDERCLASS

Youth, Race, and the Gentrifying City

THE CREATIVE UNDERCLASS

TYLER DENMEAD

Duke University Press
Durham and London
2019

© 2019 Duke University Press
All rights reserved
Printed and bound by CPI Group (UK) Ltd, Croydon, CR0 4YY
Designed by Drew Sisk
Typeset in Minion Pro, Antique Olive, and ITC Century by
Copperline Books

Cataloguing-in-Publication Data is available at the Library of Congress
ISBN 9781478007319 (ebook)
ISBN 9781478005933 (hardcover)
ISBN 9781478006596 (paperback)

Cover art: Sylvie Larmena.

To Katherine, Virginia, and Elliott
And in memory of Nancy Abelmann

Contents

Acknowledgments

I wrote myself into a new position through this book, and I am so thankful for the support of many throughout this process of transformation. Support for this book was provided by New Urban Arts through the Ford Foundation's support of the Artography program, the Center for Public Humanities at Brown University, the Office of the Vice Chancellor for Research at the University of Illinois at Urbana-Champaign, and the Illinois Program for Research in the Humanities (IPRH), also at the University of Illinois. Several colleagues and friends at Brown University were crucial to the development of this project, including Susan Smulyan, Annie Valk, Steven Lubar, and Jenna Legault. While at Brown for a postdoctoral fellowship during the 2012–13 academic year, Lauran Abman provided helpful research assistance. Thank you to Melanie Bradshaw, Darlene Zouras, and Martha Makowski, who served as research assistants while I was at the University of Illinois. At Illinois, I was surrounded by generous and thoughtful colleagues who were key in my development as a scholar. Thank you to Craig Koslofsky, Kevin Hamilton, Joseph Squier, Soo Ah Kwon, Raha Benham, Efadul Huq, Paul Duncum, Jennifer O'Connor, Allison Rowe, and Barlow Levold, who provided feedback on earlier drafts of this book. There were some individuals who read earlier drafts of this book and offered their feedback before declining to be included any further in this project. Without naming them, I am thankful for their critical suggestions.

I am indebted to Ruth Nicole Brown for always encouraging me and challenging my thinking. I was amazed by the generos-

ity of Maria Gillombardo, who would sit with me for hours and talk through different ideas for this book. She provided comment after comment on early drafts that were crucial to bringing the arc of this book into formation. Nancy Abelmann envisioned me writing this book before I did. If it were not for her, I would not have written it. She will never see this book published. Her spirit of generosity lives on with so many scholars around the world, including me, who were touched by her intellectual force and her grace.

My participation in the IPRH Faculty and Graduate Student Fellowship Program during the 2016–17 academic year was crucial to the development of this book. Antoinette Burton's intellectual stewardship of that fellowship was remarkable. I cherished the critical feedback and endless encouragement of the IPRH fellows. I would also like to thank Jillian Hernandez, Ashon Crawley, Ruth Nicole Brown, and Lisa Yun Lee for their participation in the 2017 symposium "Public Spaces: The Art and Sound of Displacement," which was sponsored by IPRH. Their contributions to that symposium forced me to think through the social, cultural, and political significance of joy and pleasure, love and laughter, which helped me in revision. I am also grateful for the opportunity to have participated in several reading groups, which helped me wrestle with the interdisciplinary nature of this project, including Youth in the Creative City and the Cities, Communities, and Social Justice reading groups at the University of Illinois, as well as the Race, Empire, and Education Collective at the Faculty of Education, University of Cambridge. Thank you to its participants.

I am also thankful for feedback on early drafts of chapters by Bremen Donovan, Peter Hocking, and Rebekah Modrak. Amelia Kraehe and Tyson Lewis pushed my thinking through their editing of a special issue on creative cities and education. I would like to thank Elizabeth Moje and her colleagues at the University of Michigan for inviting me to present on this book. I would also like to extend my thanks to Karen Hutzel at the Ohio State University for doing the same. The feedback that I received after these two talks was generative for me. Thank you. Thank you to Dan McGowan of WPRI-TV who helped me fact-check Providence property development policy and practice.

Christine Bryant Cohen provided invaluable editorial support as I developed this book. She always made the next iteration of drafts possible. She pushed me forward, and this book would not be in the world without her. I am deeply grateful for the editorial support of Duke University Press, and in particular Courtney Berger, for always pushing me to keep youth at the center of this multilayered analysis. The two peer reviewers pushed this book in such positive directions. It is so much better for it.

My deepest appreciation goes to the youth participants, artist-mentors, and staff at New Urban Arts. Thank you for letting me back into the studio five years after I stepped down as director. Thank you for sharing your lives and your magic, for participating in interview after interview, and for allowing me to make some art alongside you. I have always considered you to be partners in life, and I hope this book reads foremost as a testament to your humanity. Please know that this analysis was never intended to be critical of individual people or programs. Instead, this book is a critique of the social conditions and ideas that were swirling about in one particular creative city, which recruited me and others to perform particular kinds of subjectivities that have been entangled in the reproduction of racial and economic inequality. Your ideas and your practices have been central to that criticism and offer so many contributions to youth activism. Daniel Schleifer, the executive director of New Urban Arts, spent so much time reading and commenting on early drafts, and his analysis contributed greater complexity and more nuance to this book. New Urban Arts is in great hands.

Finally, I would like to thank my wife, Katherine, and our two children, Virginia and Elliott. In the final month of this project, after four years of collecting and analyzing data, and writing and revising draft after draft, they each took turns surprising me by leaving notes and chocolates at my various workspaces. My seven-year-old son, for example, wrote, "You can do it. You just have to do it!" He included a drawing of me flexing my bicep. And my twelve-year-old daughter wrote, "Today, I want you to edit, then edit some more, then edit again, then edit some more, then edit again, then edit another thing, then edit a bit more, then edit, then edit again, then edit one last time. Then STOP! No actually, STOP. Take a break." What writerly wisdom! Katherine Denmead started this journey with me by pushing me to volunteer in the Providence Public Schools when I was a sophomore at Brown University in 1995. Throughout the repeated challenges of founding and leading New Urban Arts, as well as while I worked on this project, she provided endless love and support, particularly when I struggled most. I am so thankful to have the three of you in my life, together.

xi

Introduction

In this book, I reckon with my tenure as a nonprofit leader in the youth arts and humanities field in Providence, Rhode Island (USA). This period of my life began in 1997 when I founded New Urban Arts, a free storefront arts and humanities studio primarily for young people of color from working-class and low-income backgrounds (see figures I.1, I.2). My leadership in Providence was a contradiction. On the one hand, I helped create the pedagogic conditions for young people to develop and to theorize creative cultural practices that have troubled their subjectification as culturally deprived members of an underclass. On the other hand, I was a "gentrifying force," as one former youth participant put it, who helped reconfigure Providence at the expense of these youth participants. This irreconcilable record unfolded as the city transformed itself, through the discourses of youth and creativity, from a depressed postindustrial city into a young and hip, affluent and white lifestyle destination.

My educational leadership was a contradiction because this conjuncture in Providence, branded the "Creative Capital," presented claims and intentions that were never compatible. Chief among them was that programs such as New Urban Arts could and should transform its "troubled youth," as Providence's cultural plan put it, into "creative youth."[1] That is to say, the state was invested in a new kind of citizen-subject, what I am calling a "creative underclass." The "creative underclass" is my term for minoritized and marginalized young people who have grown up in cities before they were branded creative but are summoned to en-

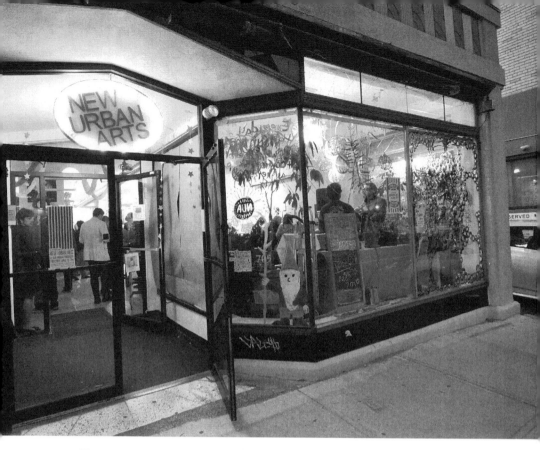

Figure I.1 Storefront of New Urban Arts, 2017. Permission New Urban Arts.

act cultural performances that become legible within the context of creative-led urban renewal as creative. These performances become enmeshed in the reproduction of their subordinate class futures and the reconfiguration of urban space for the economic and cultural benefit of whiteness. The discursive formation of a creative underclass is an intention at odds with creative-led urban renewal. This new urban discourse professes social inclusion and economic mobility for young people ("troubled youth"), while at the same time remaining invested in the cultural and economic dominance of young, educationally credentialed, politically liberal, relatively affluent, and often white people ("creative youth"). This contradiction was easy for me to ignore because I profited from this new urban vision as one of the good white creatives who transformed "troubled youth," enabling their cultural labor to become stitched to this new subjectivity, the creative underclass.

In the first half of this book, I focus on the more positive yet still complex and contradictory aspects of my educational leadership. I describe and

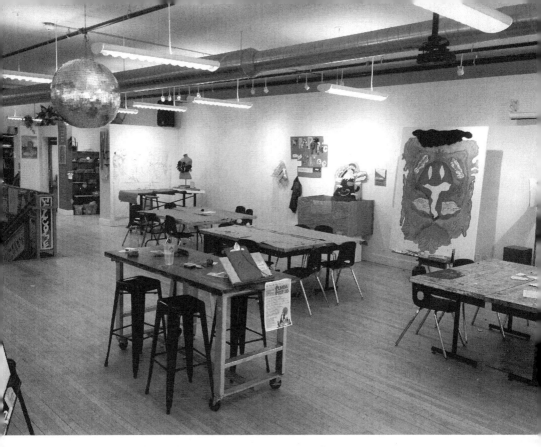

Figure I.2 Interior of New Urban Arts, 2017. Permission New Urban Arts.

interpret three symbolic cultural practices created and interpreted by youth participants in and through New Urban Arts. This thick descriptive account is based on ethnographic fieldwork that I conducted in the studio during the 2012–13 academic year. The first practice, *troublemaking*, is one in which young people *undermine* degrading and dehumanizing representations of their social identities, particularly in relation to race and class. The second practice, *the hot mess*, is one in which young people *conform to and exceed* these racist and classist representations for the sake of their pleasure and possibility, and indeed, their survival. The third practice, *chillaxing,* is one in which young people *refuse* treatments designed to cure them of their supposed cultural deprivation, including strategies designed to "transform" them into creative youth. Through this ethnographic account, I argue that spaces for such practices need to be supported so that young people can continue to find mutual respect and refuge through their creative innovations, which are rational responses to the indignities and injustices they face. These practices provide

them basic dignity, strengthen social bonds, and improve their chances of living. In the conclusion of this book, I illustrate how these symbolic cultural practices can complement youth activism in opposition to gentrification in the name of creativity.[2]

In the second half of the book, I critique the contradictory ways in which I became "entangled" in reconfiguring the city at the expense of these youth participants and for the benefit of white and economically privileged creatives such as myself.[3] This analysis is driven by the perspectives of some young people who participated in New Urban Arts and critiqued the Creative Capital, my leadership, and the sociopolitical position I represent and embody. I show how the promise of creativity as a means to upward mobility is a false one because the model of production in the creative industries reproduces social inequalities rather than redresses them. Moreover, I show how the pedagogic conditions that I helped to establish played a key role in transforming some "troubled youth" so that they could participate in the city's high-status cultural underground scene as creatives. But this performative transformation also entailed "choosing" to reject the possibility of getting a "real job" (even though that choice was never really alive for them in the first place). This insight shows that a creative underclass—that is, "troubled youth" transformed into "creative youth"—is a political subjectivity that the Creative Capital cannot refuse. A creative underclass does not demand economic mobility *and* at the same time contributes to the street-level cultural scene that is so key to the city's new gentrifying-enabling brand, the Creative Capital.

This creative underclass is valuable to the Creative Capital because it signifies that this new urban vision is inclusive when it is not. The dominant, white, and affluent-centered commitments of the Creative Capital are at odds with the futures of this creative underclass. The Creative Capital is invested in the cultural and economic interests of young graduates who remain in the city after graduation from its elite colleges (I am but one of many examples) while also driving real estate speculation and encouraging new consumer patterns that privilege whiteness and the property rights of white people. These commitments produce "collateral," as one youth participant put it, for low-income and working-class communities, and communities of color, including displacement and cultural hegemony. Through an autoethnographic portrait of my white educational leadership at New Urban Arts, I show how I facilitated young people's cultural production in ways that produced these negative effects, thus supporting young people's claims that I was indeed a "gentrifying force" in the Creative Capital.

These contradictions mean, at a minimum, that supporting young people and their creative cultural practices must be intertwined with dismantling notions of urban renewal that are foremost invested in white profitability. Some of this work must be cultural, including challenging the commonsense connections among whiteness, creativity, and urban progress. This fight for creative youth justice must also be economic. The new creative economy in Providence has reasserted the advantage of those who are already in an economic position to launch freelance careers as creatives, while rendering invisible the intense and growing competition for low-wage jobs in the service industries, as well as the need for affordable housing among young people who are attempting to live in the city as it becomes more upmarket and expensive. This unequal opportunity has only been exacerbated by the state, which has eroded welfare support and suppressed the minimum wage in startling ways since I founded New Urban Arts in 1997. Moreover, I show how the state redistributed economic opportunities upward toward landowners and property developers through tax breaks and the marketing muscle needed to support their speculative real estate investments. Thus, economic policies are needed to redress these past injustices while also ensuring that young creatives who participate in places such as New Urban Arts have access to their fair share of creative jobs and educational places, as well as secure housing and a living wage that is necessary for them to both work in the service industries and be creatives. In the conclusion, I propose political strategies complemented by the creative cultural practices of youth at New Urban Arts to fight for creative youth justice in the Creative Capital.

MY POSITIONALITY AND THE CIRCULARITY OF WHITE REFLEXIVITY

I wrote this book in the critical ethnographic and autoethnographic tradition. I presumed that ethnographic representation always hinges upon the position and power of the ethnographer.[4] To shed light on the contradictions facing me and those involved in New Urban Arts in the Creative Capital, I have moved back and forth between biography and ethnography, from the personal and the political to the historical, cultural, and economic. These representational moves not only illuminate the creative cultural practices of young people at New Urban Arts and their relationship to the cultural political economy of Providence but also my own complex and contradictory role in shaping them and being shaped by them.

This methodological approach was not my plan. I began this research project in 2012 through a postdoctoral fellowship at the Center for Public Hu-

manities at Brown University, five years after I stepped down as New Urban Arts' director in 2007. At first, I intended to use a participatory approach in which young people from New Urban Arts were coresearchers with me, and together, we would study the "magic" of New Urban Arts, as several youth participants put it. During the academic year of 2012–13, I spent at least two afternoons a week in the storefront studio, participating alongside young people in the program and interviewing current participants and alumni. But the nonlinear and nonhierarchical nature of New Urban Arts, as well as my one-year timeline for the bulk of the fieldwork, made a participatory approach to research difficult to execute. So I turned to more traditional forms of participant observation and interviews while also reflecting back on my own experiences as the director of New Urban Arts from 1997 to 2007.

At first, I was skeptical that I could access or fairly represent thick data from young people about their participation in the studio (and beyond) due to my position within the organization, and more broadly, within society. Most young people in the studio during the 2012–13 academic year knew me only as the "founder" of New Urban Arts. Frequently, young people approached me to thank me for establishing an organization that, in their words, had changed their lives, kept them off the streets, and helped them transition out of the juvenile justice system. One mother approached me to thank me because she believed that her son would have committed suicide without New Urban Arts. I never doubted the sincerity of these young people and their parents. But I also wondered whether they were sharing insights with me based only on what they thought that I wanted to hear about New Urban Arts. Moreover, if I simply put forward these perspectives in this book, then I risked putting forward a representation that valorized my role and repathologized youth as "troubled," rather than troubling the unequal and unjust material and symbolic conditions in Providence that have produced the trouble that they have experienced. I feared representing myself as a white savior attempting to resolve my complex emotional experiences as a white and economically privileged person who has struggled with my own "investments" in the dynamic social relations that shore up the power and profitability of white-identified people (i.e., whiteness).[5]

Some young people suggested that I could not represent—or should not even attempt to represent—the cultural viewpoints of young people in the studio due to my position as a straight and cis-gendered white man. This possibility became apparent during a conversation with one gender nonconforming young person of color. This conversation took place on my first day back in the studio while I was attempting to help this student, Lunisol,[6] write her artist statement for an upcoming exhibition at New Urban Arts:

6

Lunisol: Why did you come back to the studio?

Tyler: This place fascinates me. I'm still trying to understand it.

Lunisol: I don't like adults who try to understand this place. I am here. I understand it because I experience it.

Tyler: I think people want to understand those experiences. Aren't they worth sharing?

Lunisol: Who do you mean by "people"?

Tyler: Good question. I don't know. Let's get back to your artist statement.

Lunisol: Don't tell me what we are going to talk about next. Young people run this place.

Tyler: This is a tough conversation. Why is this so hard?

Lunisol: I'm just trying to understand why people adore you.

Tyler: Yeah . . . I'm trying to understand that too.

Lunisol: "You're the founder. . . . Oooh . . ." (mockingly)

Tyler: Yeah man. I agree.

Lunisol: Why did you say, "Yeah man"? That hurts me.

Tyler: I'm sorry. I didn't mean to hurt you.

Lunisol: I'm not a man.

Tyler: Right. I'm sorry. I'll try not to do that again. But yeah, I get it. I've had a lot of people come up and thank me. It's weird.

Lunisol: You're right. That is weird.

Tyler: I have been afraid to write this story, you know. . . . I don't want to glamorize myself, that young people need to thank me, worship me. . . . I'm not interested in that.

Lunisol: I don't like white men who try to help people of color. People of color should help themselves.

Tyler: I think there are good reasons to not trust white men who do this kind of work. I have a hard time trusting myself.

Lunisol: I agree. I don't like white men. Straight white men particularly suck. Do you know why I hate straight white men?

Tyler: Because we've got it easy and we don't know how easy we've got it?

7

Lunisol: Yup.

Tyler: Are we going to get past this?

Lunisol: Past what?

Tyler: This. Why are we doing this?

Lunisol: I don't know. I don't understand why everyone here likes you. I want to understand.

As I reflected on this difficult conversation on my first day back in the studio as the "founder," as a straight, cis-gendered white man who did "suck" by exacting symbolic violence on a young person in the studio, I became wary of my capacity to represent these young people in ways that were not exploitative and that honored their interests and experiences. I turned to countless readers, including young people who participated in this research, to help me see my blind spots, while never assuming that my hard work and my deep concern could compensate for the blindness inherent in my privileged positions (or my deeply entrenched investments in that blindness).

Through seeking feedback from youth participants in particular, I started to fear positioning youth and other stakeholders of New Urban Arts as cogs in the Creative Capital machine who needed my enlightened criticism for their liberation. These young people from New Urban Arts did not need me to educate them on the obvious, on what they already knew—that their city has exploited their cultural labor while privileging the cultural labor and economic interests of young white creatives such as myself. They already knew what public intellectuals of color have been saying for decades about urban renewal projects. In the 1990s, for example, bell hooks described urban renewal projects as "state-orchestrated, racialized class warfare (which) is taking place all around the United States."[7] And James Baldwin described urban renewal in 1960s San Francisco as another name for "negro removal."[8] I was arriving late at this understanding of urban renewal as a racist and classist project. Of course, that willful ignorance is one racist way in which white and economically privileged people attempt to protect their own interests.

Despite my obvious limitations, I also came to appreciate through this process of reflection, and with the help of others, how my position is useful analytically because I have been interpellated as a member of the privileged creative class who did precisely what the Creative Capital wanted me to do—move into a low-income and working-class neighborhood of color and attempt to kick-start that neighborhood through my creative and cultural innovations. This performative tale of white creativity needs to be dissected and

deconstructed, disseminated and debated, if progress is to be made with respect to justice for creative young people who lived in cities before their cities were branded creative.

So, in this book, I have tried to shed light on how the logic of creative urban renewal has possessed productive power in my professional life as a source of white profitability, for better and for worse. In adopting this reflexive approach, I still recognize the circular trap that faces white people who commit to racial and economic justice after an awakening of sorts. I am at risk of representing myself in the form of a self-pardon, acknowledging the pain that I have caused, while seeking forgiveness. And yet, in so doing, I reassert my supremacy through a veneer of race and class consciousness, performing what is now construed as the correct brand of white liberal politics. This identity performance has been referred to dismissively as "performative wokeness" and "virtue signalling."[9] These terms point to the circularity of contemporary white antiracism, which has a productive purchase on how white liberals in dominant social positions act and manage impressions. This iteration of contemporary whiteness is entirely aware of its totalizing effects, and yet, this awareness has become key to buttressing the power of whiteness through representational investments in its own benevolence and capacity for self-reflection.

In this vein, I could be positioning myself as a reformed white and male liberal in this societal moment of white patriarchal regret, spurred by the #MeToo movement and Black Lives Matter.[10] The centering of my regret would simply fit into the pattern of white men keeping intact the social order that benefits them by showing that they are enlightened enough to be aware of their privilege and their sins (and believing that such awareness is antiracist or antipatriarchal enough). This performative wokeness can be as troubling, if not more troubling, than the in-your-face, unapologetic brand of white supremacy that "recruited" me during my adolescence and informed my actions as a student in an elite, and largely white, prep school in Columbus, Ohio, and later, at an Ivy League institution.[11] While unforgivable and pathetic, that brand of classist racism is not self-deceiving.

So I recognize that the circularity of white reflexivity is highly problematic in this contemporary moment. To deal with this problem, I have attempted to engage in a "double-lensed act" of looking at myself look at myself,[12] trying to pay attention to the ways in which I have represented myself in ways that shore up whiteness. I have held on to the idea that there is analytic potential in that process with specific reference to disinvesting whiteness of its power and profitability in relation to state-orchestrated, creative-led urban

9

renewal. My hope is that the "people" who read this book—students, creative practitioners, urban and youth policymakers, nonprofit leaders, and scholars of youth arts and humanities programs and the cultural political economy of cities—find this analysis useful in advancing that project.

THE PERFORMATIVITY OF YOUTH IN CREATIVE CITY POLITICS

In this book, I am less interested in creativity as a skill or practice that can be taught and learned by young people in an educational setting—a pedagogic perspective that interested me most when I started New Urban Arts and led it during its first decade. In this book, I am invested theoretically in the performativity of creativity and its relationship to youth, race, and class. This perspective does not presume that young people have an authentic self or voice that is waiting to be empowered or expressed through developing a creative practice, a viewpoint that shaped how I understood New Urban Arts when I started it in 1997. This viewpoint is common in what is now called the field of creative youth development.[13]

Instead, I am approaching youth and creativity as discourses, as systems of meaning, that recruit young people to perform particular kinds of subjectivities. These repeated and embodied lifestyle choices are always already entangled in the reproduction of social inequality.[14] This poststructural orientation is key to deconstructing how and why it has become common sense for a city such as Providence to invest in transforming "troubled youth" into "creative youth." This system of meaning racializes "troubled youth" as deviant threats to urban progress while propping up "creatives" as the most desirable kind of urban youth. This embodied expression of creativity tends to be associated with lifestyle choices made by young white people from more economically privileged backgrounds.

This performative subjectivity is signified by various lifestyle choices, including dress, speech patterns, and residential choices, as well as unauthorized local knowledge about what distinguishes a local creative scene. One does not have to identify as white to perform this kind of creative citizen-subject. But the cultural markers of creativity in Providence and other cities in 2012—tattoos, black skinny jeans, piercings, fixed-gear bicycles, flat-brimmed hats, dyed hair, living in undeveloped loft spaces in low-income neighborhoods, knowing where the cool creative sites are, and so on—has been constructed as the property of white people. Indeed, Arlene Dávila has argued that urban progress is now associated with the presence of "the highly educated, white, liberal, Brooklynite independent writer."[15] I am but one example of a young person of my generation who has been recruited to live my life in that image.

Moreover, minoritized youth who perform these new cultural norms of creativity are constructed as "transformed" from "troubled youth" into "creative youth." For them, "choosing" to live in an undeveloped industrial loft space, embarking on a career marked by precarious or low-wage employment, becomes curiously coded as a bohemian middle-class and white choice within this particular script for urban renewal. The urban discourse of creativity thus transforms class refusal associated with middle-class bohemianism into a complex and potentially desirable option for minoritized youth. This finding contradicts the commonsense belief that creativity is a twenty-first century skill that "troubled youth" must develop to experience upward mobility in the knowledge economy. The prized creative skill that I encountered in my research was the performative ease needed to navigate and transform the city's high-status creative underground scene. While this "choice" is certainly not economically determined, it is a facile socio-economic solution for a city that has failed to provide decent paying creative jobs that would guarantee economic security for many, some, or even only a few members of the creative underclass.

Simultaneously, creative-led urban renewal is invested in the idea of white creativity as a profitable resource for the city. Its image and identity, its look and feel, its very presence generates buzz that is so useful to disinvested cities as they seek to transform themselves into consumer lifestyle destinations. In so doing, this discourse provides a return on investment for white people who are legible as creative, as well as those who engage in real estate speculation or consumer patterns based on this image of white creativity.

Creativity is useful to this state-orchestrated, racialized class warfare precisely because it is a positive and ambiguous rhetorical concept. Our emotional attachments to creativity shape our understanding, making it hard to argue against a city becoming more creative. Who would argue against creativity, against more creative citizens, against a more creative city? It is easier to argue against racist classism, is it not? Moreover, creativity appears color-blind because people now tend to think that anyone can be creative. By that logic, every person should have equal chance to succeed in the creative city. But this color blindness of creativity camouflages the ways in which the creative city reproduces racial and class inequality.

It is important to recognize however that creativity is not color-blind when it comes to urban planning. No city government in the United States, as far as I am aware, has launched a state-sanctioned project to market itself, for example, based on cultural innovations mostly associated with communities of color. Such innovations, often in music, have been a key feature of urban

life for decades, long before Richard Florida discovered that cities became creative when racially and class privileged youth such as me decide to live and work in them. But the creativity of people of color has never been constructed as a valuable catalyst in relation to urban redevelopment. As a result, creative communities of color have never had the chance to profit from state efforts to rebrand cities in their image. So the creative city discourse presumes that the desirable form of urban creativity is primarily located in and on the bodies of young white people. It makes it seem natural or truthful that these people are creative urban redeemers and that young people of color are displaceable barriers to urban progress. And yet, the whiteness of creativity is so often left unsaid to obscure the racial and class antagonism of creative city politics.

From this critical race perspective, the discourse of creativity thus protects and expands white property rights and profitability.[16] Young white people, through their phenotypes and their politics of style, are rewarded. We are lifted by symbolic groundwork that enhances our status as creatives. We are presumed to possess the right kind of skills and dispositions that are necessary to compete in a symbolic economy that prizes creative thought and self-expression over mindless manual labor. I now know that I never would have received support to start a youth arts and humanities organization as a senior in college with little arts or education background without this presumption of white and male creativity. As we will see, the discourse of creativity has tended to promote the viewpoint that it is acceptable, if not desirable, for young white creatives such as me to move into lower-income nonwhite neighborhoods because profits from real estate speculation will be enhanced as these creatives move in. Moreover, the cultural consumer landscape of the creative city is one that celebrates white people moving in and through the city with little surveillance and relative impunity from the state. This right to enjoyment in urban space, and indeed, the right to life, has never been afforded to its residents of color.

Youth is also useful in relation to the discourse of creativity because it is an ambiguous and elastic category, one that can engender both anxiety and hope for the future. That is to say, I am not approaching youth as a biological life stage between, say, the ages of fifteen and twenty-four. Instead, I am approaching youth as a social construct and as an image, one that is always implicated in plans for the organization of social life. For example, youthful cities can be seen as both terrifying and backward or hip and modern. To do this semantic lifting for urban space, youth must be linked in a signifying chain to race and class, among other social categories. To put it bluntly, youthful white cities are seen as good and modern, and young black cities are seen as bad and

12

backward. Crucially, the differences in those two imagined cities can be explained with the social categories of race and class even if those categories are unspoken.

I began to turn to this critical and poststructural theoretical orientation after conducting initial fieldwork for this project in 2012. During that fieldwork, I constructed a timeline that implicated my educational leadership in the displacement of a youth participant and her family from their home (chapter 5). This discovery shook me. After reflecting on this chronology and its implications, I returned to Providence in 2015 for one summer to do additional interviews with ten young people who participated in the previous phase of research. I sampled these ten young people, including Lunisol, based on my hunch that they would provide illuminating and varying perspectives on the city and their formation as creatives. These participants had graduated from high school before this second phase of research, and most of them were in college or taking a break from college while they tried to sort out their finances. Of these ten youth, six graduated from a selective admissions college preparatory public high school in Providence, two graduated from a charter high school, one graduated from a traditional comprehensive public high school, and one graduated from an alternative GED program. Most of these participants mentioned the financial challenges of their upbringings, and nine of the ten students identified as young people of color. Seven of them traced their common cultural heritage, or ethnicity, to countries in Central America, South America, and the Caribbean. Two identified as African American and one identified as white. Several of them self-affirmed as lesbian, bisexual, gay, transgender, and/or queer.

The demographic profile of these select participants featured more prominently in this book is representative of young people who tended to participate in New Urban Arts in 2012. However, the aspirations of these sampled participants were not. Many of these select participants intended to go to art school after high school. That aspiration was uncommon among the New Urban Arts' youth population when I conducted most of my fieldwork, and it remains the case as I finish this book several years later. But I sampled these youth participants precisely because I thought that their experiences and perspectives were symbolically and materially significant within the particular context of this discourse of creative-led urban renewal. As young people of color from low-income and working-class backgrounds who saw arts and creativity playing a key role in their lives during and after high school, they fit this representation of "troubled youth" becoming "creative youth." Moreover, they tended to be aware of the problematic nature of this representation, with

great insights into creative cultural strategies that they used through New Urban Arts to trouble their subjectification as "troubled youth." My interest then was working with critical and poststructural theoretical perspectives as I interpreted their insights toward the development of political strategies to fight for creative youth justice in the gentrifying city.

PROVIDENCE, THE CREATIVE CAPITAL

When I arrived in Providence in 1994, I entered into discursive and material conditions that were not of my choosing, circumstances that made the subjectivity of the "creative" possible for me. Tracing Providence's history is useful in understanding how this subjectivity emerged as a desirable form of human life in Providence at that time, and why it is necessary to consider how the "creative" is inflected with social dimensions such as race, class, and gender.

Located in the northeastern United States between Boston and New York City, Providence is the capital city of Rhode Island, the smallest state in the United States. Roger Williams established Providence in 1636 as a "lively experiment" committed to religious freedom after he was excommunicated from the Massachusetts Bay Colony. The Narragansett Indians were one of the prominent tribes in the area at that time.[17] The settler colonialists who followed Williams dispossessed the Narragansetts of their land through violence, debt, slavery, land grabs, and state denial of tribal authority.[18] Slavery of Africans arrived in Rhode Island as early as 1652. Newport and Bristol, which are located to the south of Providence, were the major slave markets in New England. By the mid-eighteenth century, the ratio of black slaves to free white people in Rhode Island was the highest of any colony in the North.[19] Rhode Island merchants controlled between 60 and 90 percent of the American trade in African slaves after the American Revolution.[20] With this control of the slave trade, Providence began to amass families with fortunes. My alma mater in Providence, Brown University, is named after one such family, which ran one of the largest slave-trading businesses in the United States.[21]

In the nineteenth century, the descendants of colonial settlers in Providence, known colloquially as the "Yankees," needed to innovate, as profiteering from the slave trade was no longer legal in Rhode Island.[22] Their land provided a competitive advantage. Several rivers converge in Providence and open into the Narragansett Bay and then the Atlantic Ocean. These fast-moving rivers descend quickly from higher ground inland so that they neither freeze nor go dry. These topographical features supported the young nation's first mills powered by water.[23] The Yankees had capital to invest in these mills because they had amassed fortunes through the triangular trade

14

of slaves, sugar, rum, and cotton. They also had access to knowledge about industrial innovations in Europe through those trading relationships. Providence thus grew rapidly in population and became one of the leading manufacturing cities in the nineteenth century. The city was home to the country's largest textile manufacturer, Fruit of the Loom, and the largest silverware factory, Gorham. The city also led the industrializing country in the production of precision tools, steam engines, screws, and files.

With this growth, the Yankees saw themselves as racially superior for their inventiveness, work ethic, self-sufficiency, and technical skill.[24] They believed that they were naturally predisposed for the complexities of advancing science, business, and entrepreneurship. With God on their side, they continued to construct and reconstruct racial hierarchies through this self-ascribed superiority, which in turn legitimized the exploitation of successive waves of desperate and disenfranchised labor immigrating to Providence.[25] These immigrants included Irish, French Canadians, and Italians for the most part, but also included Russians (mostly Jews), Scandinavians, Portuguese, Germans, Polish, and Armenians.[26] The Yankees who controlled the means of production relied upon these waves of immigrants, as well as women and children, to populate a cheap and exploitable labor force in the mills.[27]

15

To protect their economic interests, Yankees controlled the political machinery in Rhode Island as the immigrant population swelled and the Yankees became outnumbered. The fact that naturalized citizens did not gain full political equality in Rhode Island until 1928 is a historical product of the Yankees' multicentury project to protect their political and economic power.[28] At different moments in Rhode Island's history, its people have been denied the right to vote based on age, skin color, gender, place of origin, property ownership, or the ability to pay a voter registration fee. Until 1935, Rhode Island had a disproportioned state senate, which gave small Yankee Republican dominated towns with 475 people the same political representation as the city of Providence with 275,000 people.[29] This political disenfranchisement prevented popular majorities, always composed of recent immigrants, from threatening the Yankees' economic interests. In addition, the state of Rhode Island stopped recognizing Narragansett Indians as a tribe in the 1880s based on the premise that this racial group had been eliminated through intermixing, disappearance, and death. The tribe did not regain state recognition until 1983.

Following the Second World War, Providence endured decades of industrial disinvestment. Capital moved factories south and then offshore in search of cheaper labor. The city was vulnerable to offshoring because its

manufacturing industries were relatively low-skilled. People of color migrated to the city and were segregated within it through racist real estate practices such as redlining. And white people isolated themselves in particular Providence neighborhoods and fled to the surrounding suburbs. In 1950, the city was more than 95 percent white. Today, Latinx communities comprise more than 40 percent of the overall population (180,000 in the 2010 census), as well as a majority of the public school population. These residents are often first and second-generation immigrants from the Dominican Republic, Puerto Rico, Bolivia, and Columbia. In the 2010 census, these ethnic communities were more concentrated in the West End and Elmwood neighborhoods, as well as Upper and Lower South Providence. The African American population, which comprised 16 percent of the city's population in the 2010 census, has tended to concentrate in the Mount Hope and South Providence neighborhoods. Much of my analysis will focus on young people who live in these neighborhoods, as well as the downtown core and the West End neighborhood near where New Urban Arts is based.

At the turn of the twenty-first century, the city was suffering from difficult economic conditions that perhaps affected vulnerable children and young people the most. The city held the unenviable position of having the third-highest rate of childhood poverty in American cities with more than 100,000 people.[30] The city was also being held back by decades of political corruption. The city's longest-serving mayor, Vincent "Buddy" Cianci (1975–84, 1991–2002), resigned from his office *twice* as a result of felony charges. One of these charges was for an altercation with the alleged lover of his estranged wife, and the other for a racketeering conspiracy.

Despite his shortcomings, Cianci is often celebrated as an early adopter of using arts and public infrastructure projects as a means to attract inward capital investment to the city's economically struggling downtown core. In the mid-1990s, he spearheaded a major public works project that established a riverside park in the downtown area—a park with panoramic views of the city's skyline. With this park, the skyline steadily became reshaped by surrounding development, including a new shopping mall, hotels, and corporate headquarters.[31] Cianci also established a downtown district that provided tax subsidies for the production and sales of art.[32] With these changes, Cianci branded Providence the "Renaissance City," thus becoming one of the first mayors in the country to use arts and culture to attempt to alter the image of his poor, racially segregated, disinvested, and politically corrupt city.[33]

After growing up in Columbus, Ohio, I arrived in Providence in 1994 as a freshman at Brown University, an elite private Ivy League institution. I

16

came to the city as a student just as Waterplace Park was being completed and Cianci was launching the downtown arts and entertainment district. As an eighteen-year-old undergraduate, I started to volunteer in the city's public schools as a mentor, and I began to ponder Cianci's vision for the city. I began to imagine what it would be like for me to contribute to this project of urban renewal as an educator. Then, four years later, I led a few peers from Brown University and the Rhode Island School of Design (RISD) to start New Urban Arts in the loft of a church located in Cianci's arts and entertainment district through the support of Brown University's public service center, and, later, a fellowship in social entrepreneurship awarded by the Echoing Green Foundation.

Today, New Urban Arts is a tuition-free storefront studio located near the West End. In 1998, I moved the studio to this new location in Providence so that the studio was more accessible to students at four nearby high schools. Youth participants are typically between the ages of fourteen and eighteen, and hundreds of young people now choose to participate in New Urban Arts after school and during the summer each academic year. Youth participants at New Urban Arts also interview and select a corps of fifteen to twenty-five artist-mentors who work in the studio two days per week. These artist-mentors collaborate with young people as they work on their arts and humanities projects. Artist-mentors also offer friendship and support.

The application process for becoming an artist-mentor is competitive. In 2015, New Urban Arts received forty-nine applications for thirteen open positions, while welcoming back seven artist-mentors who returned from the previous year. Throughout New Urban Arts' history, artist-mentors have tended to be between the ages of eighteen and thirty-five. The majority of artist-mentors in the organization's first two decades have been students, graduates, or employees of Brown University and RISD—a model that I established in 1997. Historically, the majority of these artist-mentors have also been white. It is important to note that some artist-mentors are former youth participants. In 2015, seven of the twenty artist-mentors were youth alumni. As we will see, this arts mentoring model established a meeting point in the city that traverses the cultural divide between young creatives from Brown and RISD and those from the local public schools, making it an interesting case to study given the swirling discourses of youth and creativity.

In 2002, five years after I launched New Urban Arts, Buddy Cianci went to jail and the city was desperate for a more redeeming image.[34] The next elected mayor of Providence, David Cicilline, continued Cianci's vision for using arts and culture as a means to drive urban redevelopment. Creativ-

ity became the keyword. Richard Florida, the urban theorist who coined the term "creative class," visited the city in 2003 and celebrated the city's future as a creative hub.[35] In 2009, Cicilline unveiled his creative city plan titled *Creative Providence*.[36] With this new plan, Cicilline rebranded Providence from the "Renaissance City" to the "Creative Capital." Given that two Providence mayors have tried to revitalize the city through arts, culture, and creativity since the 1990s, the material and symbolic effects of these state-sanctioned efforts are now observable.

Providence is also useful as a case study because other cities throughout the world have adopted this same approach to urban renewal during the past two decades.[37] This approach has been referred to as "the conventional creative city script."[38] This phrase points to a paradox: cities become "conventional" when they brand themselves "creative."[39] This script for urban renewal is associated with Florida, who now recognizes that this script has only exacerbated urban inequalities.[40] This script in Providence and elsewhere includes

· a marketing and public relations campaign to rebrand the city's image;

· supporting and promoting existing cultural assets including arts organizations, festivals, and events;

· investing in public infrastructure such as bike paths and riverfront parks; and

· providing tax incentives to redevelop property that is deemed to have historical, aesthetic, geographic, and economic value.[41]

These strategies are designed to attract young creatives who will then spur the city's cultural and economic development.[42]

There was a clear rationale for adopting this script in Providence. The city already attracts young people to the city who fit the image of these young creatives. These creatives come to Providence each year in droves to attend Brown and RISD. Both of these elite schools are located on College Hill, a neighborhood that overlooks downtown Providence. These schools are known for attracting and cultivating youth who fit the mold of Richard Florida's creative class—the highly educated, white, liberal, Brooklynite independent writer comes to mind. There are also bohemian creatives from these two institutions in Providence who participate in the city's underground punk scene and volunteer at places such as New Urban Arts.

During the past two decades, many of these college students, like me, chose to remain in Providence after graduating from these schools, as the creative city script asked us to do. *Creative Providence* celebrated us for "[driv-

ing] redevelopment in neighborhoods and city streets . . . [breathing] life into our aging industrial infrastructure and [for being] the catalysts for civic engagement."[43] Like me, many artist-mentors at New Urban Arts fit this creative profile. They have kick-started their own design firms, lived in collectives with other artists, run underground galleries, invested their time and energy in launching their own community-based initiatives, and volunteered and worked at New Urban Arts alongside high school students.

To Cicilline's credit, however, young people from Brown University and RISD were not the only youth who figured prominently in his plan for *Creative Providence*. One of the plan's goals was to "educate and inspire the next generation of creative thinkers."[44] This "next generation" referred to young people growing up in the city, most of them low-income and working-class youth of color. In particular, *Creative Providence* envisioned arts education as a mechanism to ensure that these young people could have the chance to participate in the city's creative economy. *Creative Providence* stated that one of its aims was to develop a creative industry workforce by not only investing in Providence's existing creative workers, and recruiting new creative workers, but also preparing this next generation of creative thinkers.[45]

So New Urban Arts is a compelling site to study in this history of the creative city precisely because two of its key citizen-subjects collide there: youth who are expected to transform the city, and youth who are expected to be transformed. That said, New Urban Arts has never stated its mission in terms of creative workforce development. The mission of New Urban Arts, which I wrote in 2003, is "to empower young people to develop creative practices that they can sustain throughout their lives." Nonetheless, posing creativity as a strategy for workforce development has been a theory that leaders of youth arts and humanities programs in Providence have had to negotiate as they have pressed for public support. It is difficult to imagine these programs thriving in Providence without this rationale, and this rationale inevitably shapes public understanding of the value of these programs. When Cianci coined the term "Renaissance City" and I started New Urban Arts, the storefront studio became entangled in the formation of different kinds of youth as creative citizen-subjects.

New Urban Arts is not alone here. The city is home to several programs that have earned national and international recognition for innovative work in arts and creativity. For example, Sebastian Ruth won a MacArthur Genius Award for establishing Community MusicWorks, a classical music program for youth, that is located just up the street from New Urban Arts.[46] Like me and others, Ruth attended Brown in the 1990s, participated in the Swearer

Center, and remained in Providence after graduating. As of 2018, five youth arts and humanities programs in Providence were recognized by the White House for their important work, including New Urban Arts.[47] That accomplishment is unprecedented for a city as small as Providence, and, I believe, reflects the ways in which young, white, and male elites from Brown and RISD have been identified and valorized as the right kind of creative.

Lynne McCormack, the former director of the Department of Art, Culture and Tourism, played a key role in shepherding the *Creative Providence* planning process in ways that focused on youth in the creative city. She is trained as an artist and as an art educator, and she had a long history of supporting young people, arts education, and social equality in Providence. The emphasis on education in *Creative Providence* reflects her recognition that the city's turn to creativity could be leveraged to support arts education inside and outside schools. There were several ways that *Creative Providence* benefited New Urban Arts under McCormack's leadership. For example, Providence's Department of Art, Culture and Tourism, the municipal agency responsible for designing and implementing *Creative Providence*, received a $300,000 grant from the 2009 American Reinvestment and Recovery Act.[48] This grant supported three hundred youth summer jobs in arts, culture, and environmental organizations, including at New Urban Arts. In 2014, Rhode Island voters approved a "Creative and Cultural Economy Bond," which established a $6.9 million fund for competitive matching grants from the state of Rhode Island for capital improvement projects undertaken by arts organizations who owned or controlled their spaces.[49] McCormack and *Creative Providence* contributed to this outcome by raising the profile of arts and humanities organizations in the public sphere. In 2014, New Urban Arts added nearly four thousand square feet of program space through taxpayer approval of this bond and its own fundraising efforts. Since I left New Urban Arts in 2007, annual participation has doubled to over four hundred new registrants each year. This publicly supported studio expansion supported that program growth.

However, public support leveraged through *Creative Providence* was not evenly distributed among arts and humanities organizations in the city. Support for youth arts and humanities programs was minute in comparison to those arts organizations with a more obvious connection to white audiences and the economic development of the downtown core. For example, according to the 2014 annual newsletter of the Trinity Repertory Company, the city of Providence supported this downtown theater company with a donation between $15,000 and $25,000.[50] New Urban Arts received a $1,000 unre-

20

stricted social service grant from the city that year. This data point is consistent with historically sustained inequalities in cultural funding that privilege elite art institutions and tourism magnets in cities.[51] These organizations are privileged in part based on a white Eurocentric framework, which assumes that these elite arts organizations produce artistic value that is superior precisely because their artistic content has tended to be devoid of nonwhite associations.[52]

In another example, according to the "2013 Annual Report" of the Providence Downtown Improvement District Commission, the quasi-public Providence Redevelopment Agency commissioned a downtown arts organization, AS220, to create a "colorful storefront-level mural" in a "derelict" downtown building as a means of "highlighting attractions within the downtown district."[53] At the time, the Providence Redevelopment Agency was preparing to sell the building to a private developer. This example shows how the cultural labor of this arts organization was valued because this project might support a real estate transaction. It is important to note that AS220 also provides crucial arts education programs to youth transitioning out of the juvenile justice system. Yet, arts and humanities programs whose sole mission is to serve young people of color, such as New Urban Arts, are not as well poised to compete for such commissions because they are more likely to be positioned as social service ventures, not arts-based ones.[54] So support from the city to "transform" troubled youth through programs such as New Urban Arts has been rhetorical more than material, and yet, as we will see, this rhetoric has had material effects.

Arts education inside Providence's public schools has also suffered even as the city turned to creativity. When I returned to Providence in 2012 to begin this research project, I worked closely with Lynne McCormack, the director of the Department of Art, Culture and Tourism, to host a public symposium to call attention to this fact. In this symposium, "Now's the Time," we shared our disturbing finding that the number of art and music teachers in the Providence public schools had decreased by eighty-three positions, or by 54 percent, between 2002 and 2012.[55] This decline of art and music education in the Providence public schools reflects a national pattern in the United States that has disproportionately affected public schools with higher proportions of students of color and schools with high-poverty rates.[56]

The elimination of arts, music, sciences, and other subjects in US public schools has been a rational but troubling response, as David Berliner put it, to the ever-increasing influence of high-stakes testing that measures school efficacy through students' test performance on reading, writing, and arithme-

21

tic.[57] Indeed, Rhode Island was one of the winners of the US Department of Education's Race to the Top competition in 2010.[58] This competition awarded funding based on Rhode Island's commitment to enact reforms that emphasize standardized curricula, teaching to high-stakes tests, low-risk and depoliticized teaching, and the use of corporate management strategies, including auditing, as a means of regulating performance.[59]

In other words, as the city government in Providence was touting creative learning in its plan for urban renewal in 2009, state government in Rhode Island was working with municipal school districts, including the Providence public schools, to adopt educational practices pushed by national policy that were inconsistent with developing young people's creative practices. At the precise moment that local urban policy expected primarily young people of color to develop their creative practices through exposure to arts education (assuming that arts education does indeed promote creativity), state and national educational policy dictated to the city that these same young people become increasingly subjected to practices in school that value convergence of thought and conformity. This same paradox has been noted in other contexts, including in the United Kingdom and Australia.[60] What is specific to the American example is that this pattern fits a long and troubled history of gross educational disparities along racial and economic lines. One could argue that the rise of programs such as New Urban Arts has enabled this shift in the Providence public schools because the city preserves the appearance of a well-rounded education for all of its children and youth, when, in fact, that is simply no longer the case. I have regularly heard this important criticism of programs such as New Urban Arts from art and music teachers over the years. Successive waves of leaders at New Urban Arts have tried to address this real problem by forming more strategic and mutually beneficial partnerships with the local public schools.

Despite this decline of arts education inside schools, publicly touting creative learning outside of the public schools was tethered to the city's plans for urban renewal. The city of Providence used creative learning as a key component in its messaging strategy to build support for its urban vision based on real estate speculation. But the city government never committed any substantial resources to that education project. Moreover, due to the nature of municipal revenue in the United States, which is dependent upon local property taxes, consecutive mayors attempted to drive real estate speculation to expand the property tax base to fund local public schools. This development strategy is incompatible with creating neighborhoods and schools for communities of color that lived in the city prior to its new urban brand. These

are the contradictory conditions for youth with respect to arts, creativity, and education in the gentrifying city.

Despite these contradictions, numerous people from the arts education communities participated in the *Creative Providence* planning process to advocate for better outcomes for youth.[61] These people came together to discuss the role of the arts, humanities, and education in the future of the city precisely because they saw *Creative Providence* as a moment to leverage support for their interests and the interests of young people. I had stepped down as the director of New Urban Arts, and moved away from Providence for the first time, when this planning process was under way in 2008. However, if I had been working in Providence at that time as the director of New Urban Arts, I would have participated in this planning process because I would have thought that it would be beneficial for New Urban Arts and for me if I did so. In his book *The Creative Capital of Cities* (2011), Stefan Krätke explained why the artistic community has participated in creative city planning initiatives: "The potential for positive identification is further extended to include artists, a group whose role in social and economic development has been neglected for a long time. With reference to the creative class concept, the artistic community can improve its public legitimacy and attain a better bargaining position in the struggle for public support."[62] Obviously, artists have tended to think that they would benefit from this new vision for creative cities. The same logic extends to those invested in arts and humanities education. Once social entrepreneurs and educators in the arts and humanities are recognized as a force in supporting the creative development of youth, then they logically expect a better bargaining position in their struggle for public support. Given diminished public support for arts and humanities education in Providence, educators in the creative sector were pleased to be valued for once in city planning efforts.

As much as their participation yielded some positive outcomes for arts and humanities education in Providence, positioning education programs as a mechanism to develop the next generation of creatives in Providence has posed several risks to this community and to its youth constituents. One risk was that the participation of the arts education community in this planning process appeared to signal their consent for this new vision in the city, a vision that produced "collateral" that included gentrifying the city at the expense of the young people that these programs serve. Indeed, when I was leader of New Urban Arts from 1997 to 2007, I remember employing the language and the logic of this creativity city discourse without critiquing its damaging side effects. In meetings with philanthropists and policymakers, I co-opted the lan-

23

guage of creative urban renewal as I emphasized the fact that New Urban Arts was a positive force in rejuvenating the West End neighborhood.

At the time, I did not entertain the negative potential consequences for youth participants. I failed to see how this script for urban renewal expanded their opportunities for creative learning at the same that that it might displace them from their neighborhoods. I failed to see how this script for urban renewal reproduced the same brand of "racial capitalism," as Cedric Robinson coined it,[63] that has been endemic to Providence since its founding. In retrospect, I can now see that my own ignorance toward this negative aspect of the Creative Capital was willful—an epistemology of white ignorance, as Charles Mills might put it[64]—because, as one of the good white creatives from Brown University, I stood to profit personally from this script if it worked. And now, as an academic in the arts and education at an elite institution, I clearly have. As a result, my capacity to critique this vision for the city, to see its contradictions and my own complicity, was compromised. Writing this book has been an attempt to reclaim this critical capacity and reeducate myself, assuming that that project is neither never too late nor complete. Hopefully, this reflection has some bearing on how and why members of the arts and education communities participate in urban planning processes in the future.

The second and related risk concerns the subtle ways in which creative arts programs become entangled in the exercise of state power in cultivating particular forms of human life—in this case, the creative kind. I cannot imagine having started New Urban Arts in 1997 if it were not for Buddy Cianci's proclamation that Providence was a "Renaissance City." I cannot imagine starting New Urban Arts if it were not for the newfound appreciation for social entrepreneurs from elite colleges and universities. From the moment I founded it, New Urban Arts was entangled performatively in this vision for the city that viewed arts and culture as a means to drive upmarket property development, a vision that valorized the role of young white and male youth in urban life. As such, I was performing a role that was already anticipated for me. From the Renaissance City to the Creative Capital, I became what the performative discourse of creativity had already named.[65] I was the young male white wunderkind rejuvenating the postindustrial city through his commitments to creativity and the common good.

Press coverage of my role at New Urban Arts and in Providence illuminates the productive power of white creativity in my early professional life. In the August 2003 issue of *Rhode Island Monthly*, the editors named me Rhode Island's "Best Role Model" because, they wrote, "Tyler Denmead is still in his

24

twenties and has already found his passion."[66] After a summer culinary apprenticeship in France following my sophomore year in college, the magazine noted that I had reconsidered my future in medicine "for more creative ventures."[67] In the November 2004 issue of the *Providence Monthly,* I was named one of the city's "10 People You Don't Know about but Soon Will" because I discovered my "more intuitive calling" to "empower" youth in "finding their creative voice."[68] And when I stepped down as director of New Urban Arts in 2007, the editorial board of the local newspaper, the *Providence Journal-Bulletin,* wrote that I was an "unlikely" kind of urban hero, one who had "uplifted" the city. The editors suggested that I return to the city after graduate school to run for mayor.[69] This press coverage points to the ways in which this new cultural political economy in Providence prized racially and class privileged creatives such as myself who sacrificed traditional career pathways set out for them (e.g., becoming a doctor). These representations of me were at work, producing my own identity in ways that expanded public support for New Urban Arts while also calling others to dedicate themselves to renew the city through their cultural innovations.

In other words, this new urban discourse of creativity established an epistemic horizon for how I understood the symbolic and political potential of my life. In being summoned to live my life as a creative, I established a youth arts and humanities program designed to cultivate the creative practices of youth. In so doing, I mobilized a discourse in which all young people in the city had to measure the value of their own lives in relation to an expression of life prized most by the state and by capital, that is young creatives from Brown and RISD, including myself, who were creating street-level culture that could be capitalized. This expression of life was and remains articulated to a signifying chain of educational privilege, affluence, maleness, countercultural style, whiteness, unthreatening liberal politics, and so forth. That investment, and therefore my life, is already at odds with serving the young people from New Urban Arts despite my best intentions.

Creative Providence did contain some ominous language that signals the biopolitical aspects of creative-led urban renewal for young people of color who participated in local youth arts and humanities programs. As I have stated, the plan wrote that "the local creative sector also nurtures society's young leaders [and] *transforms* some of our most *troubled youth.*"[70] This passage is saturated with the racist and classist ideology of the conventional creative city script. Youth of color growing up in the city are read as troubled, in need of life transformation, in need of being fixed and cured. By contrast, the

25

local creative sector, often composed of white imports from elsewhere, are to be read as redeemers, as white saviors, who can lift up troubled youth through exposing them to their creative ways.

In some ways, I performed this logic through the vocabulary that I established for New Urban Arts (or that was established through me). One example is arts mentoring. "Arts mentoring" refers to the relationship in the studio between students and artists. (I am using the term "artists" loosely to refer to visual artists, poets, fashion designers, textile artists, musicians, and so forth who participate in New Urban Arts as artist-mentors.) Arts mentoring suggests a dyadic partnership between an artist-mentor and a high school student. Through mentoring, the former is a knowledgeable other in Vygotskian terms who scaffolds the development of her youth apprentice.[71] In the past, the knowledgeable other has historically been young people associated with Brown or RISD even as the composition of artist-mentors has changed over the years to include more former youth participants.

To some extent, the vocabulary of arts mentoring has never really been an accurate reflection of what actually happens in the studio of New Urban Arts. For the most part, high school students and artist-mentors engage collectively in their creative practices in the studio. Some high school students participate in New Urban Arts without much interaction with artist-mentors at all. Most artist-mentors interact with multiple youth, sometimes the same ones. Nonetheless, the vocabulary of arts mentoring does fit comfortably within the logic of "good creatives" transforming "troubled youth." As such, arts mentoring possesses its own productive power, providing the terms through which people both within and beyond New Urban Arts can make sense of what happens and how they should act, or not, in the storefront studio.

Curiously, Providence never had to commit significant financial resources to realign arts and humanities programs in the city toward this biopolitical aim of transforming "troubled" youth. As I have pointed out, public financial commitments to youth programs were thin. Instead, the city upheld race- and class-privileged creativity as a desirable expression of human life. As a result, New Urban Arts and other youth arts and humanities programs have had to negotiate their role in transforming "troubled youth" into "creative youth" precisely because these programs are desperate for funding and their students cannot pay tuition. Thus, these programs are forced to sacrifice some autonomy from the state and must reckon with its discursive power. This power shapes the priorities of private philanthropy, which then expects programs such as New Urban Arts to produce the creatives that capital and

26

the city desire. As a result, programs such as New Urban Arts are forced to govern themselves to conform to this logic so that they are in a better bargaining position to support their youth participants, even if tangible public support from the city never materializes in any substantive way.

To describe this complex biopolitical dynamic, Soo Ah Kwon introduced the term "affirmative governmentality" as she analyzed the social distribution of power through youth civic education and political activism.[72] Kwon theorized this biopolitical mode of governance in which youth programs and their leaders become entangled in state efforts to cultivate particular subjectivities among youth that serve dominant social and economic interests.[73] Kwon was principally concerned with political organizing programs for youth, but her poststructural critique is relevant to youth arts and humanities programs in cities motivated by creativity as a means of urban renewal. Kwon wrote,

> My phrasing of affirmative governmentality articulates the explicit set of rhetorics and practices aimed at affirming youth of color—not only as actors in their own lives, but also as community leaders—in their quest to become better democratic subjects. Specifically, I am concerned with youth organizing as a technology of affirmative governmentality exercised on youth of color at the site of nonprofit organizations. When youth organizing came into vogue among a select group of private foundations in the 1990s, it was posed as an ingenious strategy in providing potentially "at-risk" youth of color with community involvement opportunities that would lead not only to self-esteem and empowerment, but also to community responsibility. . . . "Empowerment" operates here as a strategy of self-governance to make the powerless and politically apathetic act on their own behalf, but not necessarily to oppose the relations of power that made them powerless.[74]

27

Kwon argued that the political opposition of one youth program in Oakland was supported by the state and private foundations so long as this work was redirected away from confronting structures of power that produce youth injustice, such as racism. Through subtle strategies of self-management, program leaders are steered toward the cultivation of youth who see themselves as ultimately responsible for their own futures and for their own neighborhoods. This subtle shift foists a particular subjectivity on youth, one that embraces market-oriented values of self-responsibility and self-blame, not collective-oriented strategies of structural critique and transformation.

Mayssoun Sukarieh and Stuart Tannock have made a similar critique

in their observation of the rise of youth development programs in the 1990s.[75] They argued that the popularity of youth development programs such as New Urban Arts among funders since the 1990s stems precisely from the fact that these programs were, and continue to be, saturated in market-oriented vocabularies, which affect how people think about and enact these programs. Private foundations and donors have supported youth development projects precisely because these programs are expected to depoliticize youth work, infusing the education of young people with rhetoric and practices that appeal to those who want to "shift attention away from structural inequalities and injustices to center attention on the responsibilities of individuals, families, and local communities for enabling children and youth to get ahead on an individual basis."[76] In the field of youth development, youth, for example, are represented as if they possessed "assets" such as resiliency that require "investment" so that young people will transition successfully into adulthood.[77]

This market-oriented vocabulary and practice has been a strong feature of successful youth development programs in the arts and humanities. For example, one organization, Artists for Humanity in Boston, has been celebrated for its entrepreneurial model in which young people sell artwork that both supports their organizations and provides them with stipends. Staff at New Urban Arts have told me that there has been some pushback in the youth arts and humanities field in recent years against this entrepreneurial model precisely because young people's cultural labor is paying the salaries of the predominantly white administrators who lead these organizations. Nonetheless, New Urban Arts came into being in the 1990s only because private philanthropy and the state recognized that youth programs were a site where they could exercise some control over the expressions of human life being "developed" there. The philanthropic focus has always been on transforming "troubled youth," not the uneven and unjust distribution of power and resources based on social categories that include race, gender, and class. As a result, New Urban Arts has never operated outside this logic of cultivating self-responsible and creative youth.

But my ethnographic research did not find alumni from New Urban Arts who internalized self-blame and shifted their attention away from structural inequalities and injustices. Indeed, the structural criticisms of Providence presented in this book are theirs. Moreover, all of the young people who participated in this research reported to me that they cherished New Urban Arts because it takes a *collective* approach to cultivating their creative practices, not an individualized one. Yet I show how the studio at New Urban Arts can *still* operate as a site where some "troubled youth" become trans-

figured into creative sources of speculative profitability for the city in ways that unevenly reward whiteness and reproduce class injustices. New Urban Arts can operate as an affirmative site where some young people learn creative lifestyles, becoming recognizable as legitimate members of Providence's high-status creative underground scene through adopting signifying markers that have already been ascribed to white creativity. The Creative Capital needs only a few young people from New Urban Arts and other programs to be "transformed" in this way for the city to market its status as both inclusive and trendy, even if the evidence suggests that youth do not experience much socioeconomic mobility, if any, by choosing creativity.

At the same time, New Urban Arts remains a powerful place where young people are developing cultural practices that can inspire and complement social justice movements that hold racial capitalism accountable, rendering the need for its replacement while inspiring people to behave more ethically toward one another. In the first half of this book I describe and interpret the cultural political strategies developed by young people at New Urban Arts. This ethnographic account, I hope, will come in handy as we work toward an effective political response to the ways in which creativity reproduces social inequality through gentrifying cities.

29

1

TROUBLEMAKING

Troublemaking is a privilege. I learned this theory from Gabriela, a young woman I first met as a high school freshman when she joined New Urban Arts in 2004.[1] When I returned to the studio as a researcher in 2012, I met Gabriela for a second time after she had transitioned from a youth participant to an artist-mentor. That year, Gabriela participated in a few interviews with me and others to describe and theorize the creative practices of young people in the studio. Her keyword in these interviews was "troublemaking." In a reflective interview with a staff member, Gabriela chose Dennis the Menace as a figure to illustrate how she learned through New Urban Arts that troublemaking is a privilege. She stated, "Without New Urban Arts, I don't think I would have ever learned to question privilege. When I think about troublemaking and privilege, I think of Dennis the Menace."[2]

Gabriela's theorization of troublemaking as a privilege is nuanced with many layers. And troublemaking, I believe, is key to understanding the cultural and political significance of New Urban Arts in the lives of young people at this particular historical moment. Moreover, through troublemaking, Gabriela offers insights into the cultural politics of young people at New Urban Arts that can complement youth activism in gentrifying cities.

Dennis the Menace is an iconic character in a syndicated newspaper comic strip. Unlike the British version, the American

Dennis the Menace is a lovable but mischievous five-and-a-half-year-old white boy with a blond cowlick. Dressed in overalls, he wreaks playful havoc in his suburban neighborhood in Wichita, Kansas. He resorts to pranks and practical jokes, as well as insults and annoyances levied against his parents and other adults. For all intents and purposes, Dennis is one kind of troublemaker—the misbehaving, antisocial type. Indeed, Gabriela referenced the activities that are associated with Dennis's mischief: arguing with adults, writing on walls, being loud, and, more generally, roaming the neighborhood without much adult supervision.

Gabriela compared Dennis's opportunity to be mischievous with her experiences growing up as a child and adolescent in Providence. She reported that her parents kept her close to home because of their fear for her safety in their neighborhood. She noted that her family lived in small, rented apartments. It was not until her participation in New Urban Arts as a teenager that Gabriela realized that she had neither the permission nor the possibility to make art in these rented apartments because her parents wanted to keep these borrowed spaces tidy and intact. She said that her parents were always preventing her from making a lot of noise because she might wake up other families who lived nearby—perhaps in one of the apartments above or below in the triple-decker homes typically found in the working poor neighborhoods of Providence. Her parents were also concerned that noise would draw the unnecessary scrutiny of the police.

In thinking about Dennis's privilege, she also reflected on her public schooling, which she said tended to approach her as a "poor kid who always needed to be on task, following directions." Her perspective is consistent with the research of scholars such as Jean Anyon who argue that the "hidden curriculum" of schools—the unwritten knowledge and practices taught in schools—reproduces social stratification through preparing students for their respective class positions.[3] Learning to stay on mundane tasks, for example, prepares poor children for working-class jobs in which compliance is prized while performing alienated labor. Gabriela argued that the children and young people whom Dennis the Menace represents—suburban, middle-class, male, and white—instead grow up with the opportunity to, as Gabriela put it, "explore and to have freedom and space." She noted that she did not grow up with this special advantage, which prepares young people with a sense of entitlement, an acquired right to explore space.

Gabriela explained this privilege in relation to discursive differences between her and Dennis the Menace as much as material ones, such as her rented apartments. Competing ways of ascribing meaning to her and to those

represented by Dennis the Menace imply differences in how power is expected to organize and to regulate different young people's lives. For example, when Gabriela commented on the tendency of her schools to position her as a "poor kid who always needed to be on task, following directions," she pointed to the presumption that she and her peers were already legible as troublemakers, or at risk of becoming troublemakers. She and her peers were pegged as "troubled youth." This presumption, Gabriela argued, was stitched to her social class, to her poverty. The attitude was that she, as a poor kid, needed to be kept in line through a strict disciplinary regime and rote instruction because she was, or was "at-risk" of becoming, a troublemaker.

Through contrasting the lovable mischief of a young white boy in the suburbs and the threatening troublemaking of poor young people of color living in the city, Gabriela illustrated her belief that this perception and treatment is also tied to other social categories, including, for example, her race and geographic location. In fact, through her theory of troublemaking, Gabriela, who identifies as Afro-Latinx, engaged critically with the racist and classist representation of youth who participate in New Urban Arts as members of the *underclass*. The use of the term "underclass" has often been used to insist that the style, comportment, and values of poor people, including, for example, poor people of color living in cities, explains their poverty. What defines the underclass, as Robin D. G. Kelley has argued from critical race and cultural studies perspectives, is not the type of labor performed by the poor, or their minimum wages or their lack of wealth, but rather their culture, which is deemed by whiteness to be deprived, deficient, and often racially determined.[4] When Creative Providence refers to youth in the city as "troubled," it is recirculating this racist and classist system of meaning even if that was never the intention.

This cultural deprivation theory of poverty intersects with race to put forward the claim that those who are affluent, and those who profit from associations with whiteness, are deserving of such power, resources, and opportunities. Unlike the underclass, this logic of supremacy maintains that white people have learned respectable ethics, aesthetics, and behaviors that are needed to be successful—so they are deserving of the power, resources, and opportunities that they acquire. This discourse of social class and race mobilizes support, particularly among affluent and white people, for policies and practices that benefit them based on the presumption of their moral superiority, if not racial supremacy.[5]

Gabriela provided an important example that illustrates how poor young people of color become implicated in this representation of the underclass—

32

that is, as troublemakers. In one interview, Gabriela referenced an education reform proposed by Newt Gingrich during his candidacy for the Republican presidential nomination in 2012. During the campaign, Gingrich gave a speech in which he proposed that poor kids should be paid to do janitorial work at their schools. He asked, "What if they [poor kids] became assistant janitors and their job was to mop the floor and clean the bathroom?"[6] Gabriela stated that she had a "real problem" with this argument. She expressed her consternation with his attitude that she should have to spend time cleaning bathrooms at school while affluent white kids were provided with the privilege to play. For this very reason, she prized the relatively unstructured nature of New Urban Arts, which, she said, provided her with autonomy as an artist and as a thinker.

Indeed, these doubts about providing poor youth of color flexibility and independence in their education, and Gingrich's proposed education reform involving poor kids cleaning their school bathrooms, hinge upon a representation of Gabriela and her peers as members of the underclass, as troublemakers, who are a threat to their own future, a threat to the future of society, and a threat to the production of capital to be accumulated primarily by white people. His suggested policy insists that the reason poor people are poor, and that poor people of color are poor in particular, is that they have failed to learn respectable styles, values, and behaviors through their schools, their families, their neighborhoods, and so on. I am assuming that Gingrich has the tendency to see people of color only as poor. From this racist and classist position, the children of the underclass are born into troubled ways of life and therefore are likely to become troublemakers.

The problem with this theory of the underclass and childhood development is that it is nonsense. The theory of cultural deprivation would suggest that youth of color and/or poor youth could be cured of their ascribed moral inferiority by going to elite schools, and once there, immersing themselves in affluent white culture, where there is alcohol abuse, humiliating hazing rituals, sexual assault, racial hostility, loudness, and so on. The idea is absurd. But I was rarely asked by society to consider the cultural deprivation of my elite white culture. As one of the affluent white kids who grew up with a sense of an already guaranteed future, I learned through my upbringing that I was racially and culturally superior. As an undergraduate at an elite private prep school and Brown University, I had the privilege to roam my cloistered campuses making noise and havoc with impunity. I never thought about any infringements on my enjoyment because I assumed my enjoyment in public space was a natural right for me, something that I deserved and had earned.

The underclass assumption may be nonsense, but it has had violent and uneven effects. For example, when white people and/or affluent people engage in behavior that is troubling to society, their actions and their consequences are never used to make any essentialized claims about the nature of being affluent and/or white. White people's race is never put on trial through the evaluation of their behavior, even when they are poor. That is the privilege of Dennis the Menace and the middle-class white children whom he represents. His mischief is never used to explain what it means to be a young boy, middle-class, suburban, and/or white. Dennis the Menace can be lovable to his readers precisely because his actions are considered inconsequential in relation to his race, class, gender, neighborhood, and so on. As a middle-class white boy living in the suburbs, the threat of Dennis's mischievous troublemaking is *never* conflated with his threat to society or to his future. His promising future seems to be already guaranteed no matter his behavior or his aesthetics, which is probably true. The children and young people whom Dennis represents get to be troublemakers, and yet at the same time remain normal and untroubling. Their troublemaking remains in the realm of the playful. That is privilege indeed.

And yet, white people are constantly policing people of color based on the presumption that their behavior is troubling, at least to white people. Gabriela pointed out to me, for example, a white woman who called the police on an eight-year-old black girl who was selling water on the sidewalk without a permit. This woman, Gabriela said, owned a cannabis oil company, which she could do without being criminalized as a drug dealer. Gabriela also pointed out how she now lives on the edge of a gentrifying neighborhood in Providence where white people are constantly berating black people for loud music, riding mopeds, and so on. She described these cultural practices as central to her community's vitality. Indeed, processes of gentrification seeks to displace these shared ways of life based on the presumption that these practices are "troubled," that these ways of life need displacing, that these places are placeless, or without ways of life that matter, because of this ascribed cultural deprivation.

This construction of cultural hierarchies and the policing of cultural difference has its epistemological and ethical roots in America's long and violent racist history. For example, in 1851, Samuel Cartwright, a physician, proposed that fugitive slaves suffered from a mental illness, which he called "drapetomania."[7] According to Cartwright, this illness—that is, the desire of slaves to escape chattel slavery—was caused by their masters, who were too lenient with them and treated them as equals. This soft treatment, Cartwright argued, gave them a taste of freedom, or what Gabriela might call

"space." From this convoluted and self-serving perspective, this taste of free-dom caused slaves to want to escape. Cartwright's proposed preventative cure for drapetomonia was harsher, more violent treatment of slaves by masters. But presuming that the desire to escape chattel slavery is a mental illness is to deny the humanity of slaves, because being human comes with the inherent desire to resist being owned by other humans. The notion that young people of color today deserve harsher and more authoritarian regimes in their up-bringings (because freedom is dangerous for them) finds its discursive roots in a violent, racist, and profitable system that hinged upon treating slaves as unhuman.

This racist logic in slavery reverberated in conversations about progres-sive education at the turn of the twentieth century. Charles Eliot, a former president of Harvard University, argued in 1909 that "savage or semi-civilized children," as he put it, needed more authoritarian regimes in their education in comparison to their civilized peers.[8] Eliot subscribed to the theory of reca-pitulation, which proposed that human development mirrors civilization. Ac-cording to this theory, the "savage" child grows up into a "civilized" adult in ways that recapitulate the Eurocentric telling of history, that is, the progres-sion of the human species from barbarianism to civilization.[9] Again, from this convoluted and self-serving perspective, history has demonstrated that only the children of civilized adults, or those from white and Western Euro-pean origins, naturally progress from the barbaric state of childhood to the civilized state of adulthood. Alternatively, "savage and semi-civilized chil-dren," according to this theory, grow up and remain uncivilized. They do not recapitulate history. These "savage" adults remain fixed in the past, as uncivi-lized as children, even as they grow up.

The educational historian Thomas Fallace has shown that this theory of recapitulation was influential among nineteenth-century American progres-sive educators such as Eliot.[10] For Eliot, the pedagogic implication was that children from civilized parents should be provided with the opportunity to explore the world as if they were uncivilized "savages," or to have "space," as Gabriela might put it. Under these conditions, due to some innate and supe-rior characteristic, these children would naturally grow up into modern and civilized adults.[11] By contrast, as Eliot put it, "for the savage or semi-civilized man, and for some children who pass through barbaric stages of develop-ment, authority is needed to restrain them from injuring themselves."[12] In other words, Eliot argued that these "savage" children, say African American and Native American children, could not be provided with opportunities for unsupervised spontaneous play because they were incapable of doing so with-

out harming themselves.[13] For Eliot and other subscribers of recapitulation theory, stern chiding of "savage" children was the fix.[14]

The echoes of recapitulation resound today in the notion that young people of color from low-income communities deserve harsher treatment in schools because they were born into troubling cultures that produce trouble-makers. Insert here Gingrich's absurd and pathetic proposal that poor young people of color should clean their school bathrooms.[15]

Of course, Gingrich's proposal has thankfully not taken hold in public schools. However, beginning in the 1990s, public schools across the United States did start to adopt like-minded practices and policies, which are now known as "zero tolerance."[16] Under this policy, students in schools, dispro-portionately students of color, began to be punished harshly no matter how minor the offense. Bans on particular forms of clothing, including hats; im-mediate suspension for school disruption; and heightened use of law enforce-ment in schools increasingly became the norm, despite the fact that inci-dents of school violence, for example, were decreasing prior to its widespread adoption.[17] Federal policy expanded the number of "school resource officers," or sworn law enforcement, in United States schools from 9,446 in 1997 to an all-time high of 14,337 in 2003.[18] This authoritarianism, and the seeping of the justice system and its tactics into schools, is now often referred to as the "school-to-prison pipeline."[19] This term is used to critique policies and practices designed to ensnare youth of color, particularly African American youth, into the criminal justice system at a young age, thus producing a series of outcomes such as school expulsion and a criminal record that increase the likelihood of their imprisonment later in life.

Behavioral management strategies rooted in policing have also tended to feature in charter school designs as charter schools have played a more prominent role in US public education in the early twenty-first century. Joan Goodman, for example, noted how the charter schools that she observed fo-cused on creating a highly rule-ordered and regulated environment with "a blanketing emphasis on obedience that can create conditions for accepting instruction."[20] This environment, Goodman argued, might be good for rote instruction, but it also leads children to relinquish their sense of agency and the capacity to form their own moral compass.[21] Gabriela noted this same phenomenon in her high school, where she believed that she was being trans-formed into a "receptacle" for instruction.

The notion that young people of color must be forced to comply, must be dealt with harshly and violently because they are less than human, or be-cause they are already a threat to society, also resounds in their interactions

with the police, particularly for African American youth. To illustrate, consider what would happen to Dennis the Menace if his phenotype was black or brown. Juxtapose the loveable and livable, albeit fictional, life of Dennis the Menace with the very nonfictional deaths of black teenagers and children killed by the police. How long would a black Dennis the Menace live as he played with water pistols and slingshots in the park? How long would a black Dennis the Menace live as he started playful fights with other boys his age in his front yard? How long would a black Dennis the Menace live after he leaned out of the backseat window of the family car to tell off a police officer who pulled his parents over? Indeed, that is exactly what the fictional white Dennis the Menace did and said in his first appearance in American newspapers in the 1950s.[22] "You didn't catch us!" Dennis screamed at a white cop as he approached the family car, holding his motorcycle gloves, not his gun. "We ran outa gas!" The implausibility of this example for a black Dennis the Menace illustrates the stakes of troublemaking for young people of color and the privilege afforded to the children and young people Dennis the Menace represents. The stakes are survival. The stakes are life.

With these stakes in mind, Gabriela reframed troublemaking as a means of political opposition against the harsh, humiliating, and sometimes deadly logic of the underclass. Gabriela co-opted the discourse of troublemaking, which is used as an indication of her deprivation and her unhumanness, and then reversed its meaning into a good thing, a strategy for her and her peers to use against the organization of social power that has uneven material effects, including the opportunity for urban young people of color to not be displaced, to experience life pleasurably, to live. For example, when Gabriela was a youth participant at New Urban Arts, prior to becoming an artist-mentor, she screen-printed T-shirts for her peers that read, "Be the trouble you want to see in the world." With a turn of phrase, Gabriela refracted Mahatma Gandhi's mantra "Be the change you want to see in the world" through the prism of troublemaking.[23] With these T-shirts, Gabriela argued that doing the work of social justice, the work of Gandhi and others, does not just involve *being change* but also involves being trouble or becoming troublesome to supremacy. She called on her peers to play with their subjectification as troublemakers, to become threats to the way things are—and rightfully so.

In an interview, I asked Gabriela how and why young people might go about being these kinds of troublemakers, not the mischievous sort represented by Dennis the Menace. Gabriela began by discussing her hair, and, as she put it, its "unprofessionalism":

Tyler: So, I remember when that Gandhi quote became a mantra in the studio. But then you mixed it up with "Be the trouble you want to see in the world." What was that about?

Gabriela: Well, in in order to make change, you have to be a trouble-maker, right? It's this whole idea of existing, of being seen, of being seen as a person of color. Take my hair. I want to talk about my hair.

Tyler: Yeah, let's talk about your hair.

Gabriela: It's huge. It's a huge, fucking Afro. How inappropriate is it for me to have an Afro? It's unprofessional. It's out there. It's like, "Why don't you do something with it?" I should braid it and make it straight, right?

Tyler: Yeah.

Gabriela: So, there's troublemaking that comes with a huge fucking Afro. Angela Davis had an Afro. She was a troublemaker. She was a Black Panther. In order to exist in this world, in order for people of color to exist in this world, and to not conform to this idea of whiteness, that is what it means to be a trou-blemaker. Take this whole idea that things can be inherently white. For example, consider how nerd culture is assumed to be inherently white. Look around New Urban Arts. We have a bunch of black and brown nerds in here!

Tyler: What does that mean?

Gabriela: They are troublemaking. They are fucking up your ideas about what it means to be a black or brown child.

Tyler: Right . . .

Gabriela: They should be playing basketball, right?

Tyler: Or dancing to rap music or something . . .

Gabriela: Right, but they are not. They are being nerds. And that's great. It's actually really great.

In this passage, Gabriela describes how conscious and embodied cultural per-formances become a strategy to trouble racist discourses that are used against her and other youth at New Urban Arts.[24] Gabriela, for example, pointed to her Afro, which breaches norms of what she calls "professionalism" but might also be read as "respectability."[25] Her Afro, in other words, does not conform

38

to aesthetics that whiteness has deemed respectable for black and brown life. Instead, to Gabriela, her Afro signifies the antiracist, anticapitalist, and anti-patriarchal politics of the troublemaker, Angela Davis. Through her "huge, fucking Afro," Gabriela claims that the Afro is not a surface-oriented fashion statement but a visible and embodied politics of cultural resistance.

Robin D. G. Kelley has traced the cultural political significance of the Afro, noting its roots in the style choices of black women in the 1950s and 1960s who embraced a natural hairstyle over chemical hair straightening.[26] Nine Simone, for example, wore an Afro at the time. This black cosmopolitan and bohemian style evolved to signify black power and pan-Africanism, with, for example, the Black Panthers adopting this hairstyle in the 1960s. Angela Davis feared in the 1990s that young people opted for Afros based on nostalgic desire, a sign for her of social and political atrophy, not activism.[27] In the current Trumpian era of unbridled white supremacy, it should perhaps come as no surprise that young people of color such as Gabriela are reinterpreting the Afro as a cultural expression of black power and possibility.

This example illustrates how Gabriela's troublemaking is expressed in language, carved out through style, and rooted in black cultural and embodied politics. Her personal experience, her body, becomes a legitimate site to understand and contest, or trouble, the way in which society is structured in and through social dominance in relation to race, class, and gender. Through engaging with the notion that her body and her personal experiences are always already politicized, she seeks opportunities to trouble the logics of whiteness and patriarchy through her body. With her troubling Afro, Gabriela is refusing the notion that if and when young people of color, particularly African American and Latinx youth, shed the signifying practices and styles associated with the underclass, and adopt an aesthetic deemed professional and respectable, then they will be treated as human, with a right to profitability and with a right to life. For Gabriela, troubling supremacy therefore means performing an image and identity that destabilizes the ways in which whiteness constructs expressions of racial identity that it deems acceptable.[28]

Gabriela also pointed to young people in the studio at New Urban Arts who are "being nerds" as a form of troublemaking. Here, she referred to several pastimes in the studio at New Urban Arts, including young people playing Dungeons and Dragons fantasy games, reading and making comics, or designing cosplay costumes. For young people of color to engage in these practices, these "nerds" are claiming cultural practices that are deemed to be in the possession of whiteness due to the fact that these practices signify in-

telligence, which is presumed to be a natural characteristic of white people and lacking in young people of color. So Gabriela sees young people at New Urban Arts reasserting their humanity through playing games in the studio that trouble the image and identity that whiteness demands of young people of color, that it demands of the underclass.

Through referencing both the troubling Afro of Angela Davis and the fissure of black and brown nerds, Gabriela drew upon examples from her own life and the life of the studio in which young people of color violated the white-constituted norms for what is deemed both respectable and possible for them. Their antinormative and antirespectable performances of identity and style reject the notion that there is a proper or singular, natural or essential way of being black or brown, and certainly not one that conforms to stereotypes of an underclass, which presumes an innate, socially learned, or culturally acquired lack of intelligence. For Gabriela, fucking up how I have been constructed, as a white person, to think about how young people of color should behave or stylize themselves is her politics of troublemaking. Her troublemaking is hypervisible, staring me in the face and troubling my gaze, a white way of seeing that is always being refracted through the logic of my culturally acquired sense of what is normal, what is supreme, what is guaranteed, what is profitable, what should live.

It is crucial to point out, then, that through her theory of troublemaking Gabriela did not conflate the antisocial behavior of Dennis the Menace with her oppositional politics. This point is crucial because there has been a tendency in youth scholarship, written in the Marxist tradition, to conflate the mischief of young people with their activism. More precisely, the overreaching assumption is that mischief is good training for becoming a socialist revolutionary. In their analysis of youth activism, the education scholars Pedro Noguera and Chiara Cannella challenged this assumption by arguing that cutting class, challenging adult authority, and committing acts of violence against other youth should not be read as political opposition or activist training.[29] Doing so only valorizes troublemaking that does not contribute to social justice and may well be counterproductive. To avoid conflating young people's antisocial behavior with activism, they point instead to education scholar Henry Giroux, who argued that young people's activism must be "rooted in a deliberate critique of one's circumstances."[30] Giroux's theorization of youth's political activism as deliberative and self-aware is rooted in the thought of the highly influential educational philosopher Paulo Freire and his notion of critical consciousness.[31] Freire argued that the reproduction of oppression stems in part from the failure of the oppressed to see their

circumstances of oppression clearly.[32] The key to their emancipation then is the development of a critical consciousness, which, Freire argued, emerges through an iterative cycle of action and reflection oriented toward social justice.[33] Without such deliberate critique, Noguera and Cannella warn, youth defiance simply devolves into deviance.[34]

Gabriela's theory of troublemaking is clearly rooted in a deliberate critique of her circumstances and the circumstances of her peers in the studio. Yet troublemaking as a means of cultural opposition to whiteness and patriarchy is concerned with the visible and the symbolic, the lived and the felt, as much as it is concerned with abstract notions of consciousness. Her embodied cultural politics of troublemaking is not concerned with standing outside the structures of dominance to try to understand those structures more clearly, less falsely. Rather, she is concerned with standing within them, using her body and symbolic practices such as style to trouble the threat of racist, classist, and sexist discourses that are felt and lived, that are inescapable and entrenched.

The arts and humanities are key to this form of embodied politics because it is through these modes of inquiry that young people can give shape and form, light and color, texture and breath, rhythm and language—in short, an aesthetic—to these ideas and feelings of opposition. Places such as New Urban Arts may not be seen as outwardly political given that they are not explicitly training young people to become political activists or community organizers. But New Urban Arts has become a place where some young people develop cultural political strategies because it provides young people scope to reckon with the discursive and material realities of their lives, including their subjectification as members of an underclass.

To understand New Urban Arts and its significance, then, it is important to broaden the analytical focus beyond what counts as the arts and humanities in a traditional sense, as well as abstract commitments to critical consciousness as the correct basis for youth activism. The focus must also include how young people shape their shared ways of life and, relatedly, their bodies, to communicate ideas and feelings that are critical of the circumstances they have inherited.[35]

"Take my hair," Gabriela said. "I want to talk about my hair."

Fashioning her hair is how Gabriela formulates a cultural politics of style, a politics of being seen in ways that fuck up my ideas about what it means to be a respectable black or brown young woman. Her proposed politics of troublemaking for youth of color in the studio is a means for them to recenter themselves symbolically in the world, a means of shaping what their

41

bodies mean and why, a means of resisting the closure of what their cultural performances might say about their social identities.

This interpretation of troublemaking resonates with other critical ethnographic scholarship on why young people participate in programs "beyond the borders of schooling."[36] Michelle Fine, Lois Weis, Craig Centrie, and Rosemarie Roberts, for example, have argued that young people are constantly confronted with harsh and humiliating representations of their identities, and they therefore turn to spaces such as New Urban Arts "to re-educate" themselves.[37] In these spaces, they trouble the discursive representation of their identities and invent new ones through symbolic creativity.

At the same time, there has been considerable debate for decades about the efficacy of young people's cultural politics. In 1992, five years before I started New Urban Arts, David Bailey and Stuart Hall, for example, reflected on the contradictions of identity work and style as political resistance: "It is perfectly possible that what [identity] is politically progressive and opens up new discursive opportunities in the 1970s and 1980s can become a form of closure—and have a repressive value—by the time it is installed as the dominant genre. . . . It will run out of steam; it will become a style; people will use it not because it opens up anything but because they are being spoken by it, and at that point, you need another shift."[38]

This perspective points to the paradox of Gabriela's troublemaking. As young people such as Gabriela "open up" discursive possibilities for themselves through troublemaking, such as the black and brown nerd, or the next iteration of Angela Davis, troublemaking in turn produces styles with their own productive power and with their own power of closure. In other words, new styles, such as the brown or black nerd, which might have once been transgressive, become installed as the dominant genre. In that event, some young people of color who attend New Urban Arts might feel summoned to live their lives as black or brown nerds or as a simulacrum of Angela Davis. Performing these identities thus becomes a strategy of fitting in among their peers and conforming to the demands of the marketplace, not a strategy of troubling, for example, whiteness and patriarchy.

This paradox is important to consider within the logic of consumer capitalism, which is always at work transforming cultural transgressions into commodified styles. In 2018, for example, Sesali Bowen wrote an opinion piece in the *New York Times* titled "The New Black Hotties," which commented on the emergence of "Black nerds, Black queers, and Black weirdos" as a style that has become installed in dominant popular culture.[39] Bowen pointed to actors and actresses in Hollywood films, as well as popular musicians, including

Donald Glover, Issa Rae, and Janelle Monáe. For Bowen, the visibility of these celebrities affirms black eccentrics in everyday life. When people who transgress dominant cultural norms through their identity can recognize their identity in popular culture, they become affirmed as political subjects that are human, that deserve life.

This example is relevant to New Urban Arts because young people of color in the studio have tended to identify as nerds, queers, and weirdos who do not fit in elsewhere, and those identities are produced in part through the troublemaking that Gabriela has theorized. Through troublemaking, their innovations in identity, once signs of the outcast, once strategies for troubling violent norms, then become incorporated into the dominant culture. Given the history of racial capitalism in the United States, when a style becomes installed in dominant culture, it means that that style has necessarily become unthreatening to the possessive interests of whiteness.

Simultaneously, through this incorporation of the "New Black Hotties" into dominant popular culture, those young people *who are not legible* as black or brown nerds, as black eccentrics, are at risk of being positioned by dominant popular culture as those who are unfashionable, perhaps even stuck in the culturally inferior location of the underclass. That is to say, I am worried about the implications of this black eccentricity for those young people of color who do not perform this style, and therefore are reinscribed as members of an underclass because they have failed to "keep up" with the cultural innovations of their peers. Troublemaking is therefore at risk of producing styles that become incorporated into consumer capitalism, which, in turn, reproduces the same symbolic violence—this time against people of color who do not fit this style of the new black hottie—that troublemaking was seeking to counter in the first place.[40]

This point is important to consider within the cultural politics of the creative city, where bohemianism is often stitched semiotically to whiteness, even if there is no natural basis for this link. That is to say, young people of color who become legible to whiteness as creative—because they adopt hairstyles that whiteness can read as bohemian or play games that whiteness associates with its own intelligence—lose their political force within the establishing dominant white narrative for this new urban life. This depoliticization hinges upon the problematic assumption that white creatives' dispositions can and should be acquired by other social groups if they want to gain status and be rewarded in the creative city.[41] Young white people are presumed to naturally possess the creative skills and dispositions that are necessary to compete in a symbolic urban economy that prizes creative thought and self-expression.

This white creativity is signified by their bohemian stylistic choices, whether piercings and tattoos or fixed-gear bicycles and flat-brimmed baseball caps.

Those young people of color who engage in troublemaking are always at risk of making stylistic choices that then become incorporated safely into the cultural style of the creative city, which, in turn, privileges the profitability of young white people who are already deemed to be creative, who are deemed to have a possession—creativity—that other social groups want. The meaning of the huge fucking Afro can thus easily slip from Gabriela's radical intentions— she associated the Afro with black power—into a safe style of cosmopolitan creative eccentricity. Those young people of color who do not learn to perform these bohemian styles become repositioned as culturally deprived members of an underclass, as those who lack creativity. As a result, like any cultural political strategy in the age of consumer capitalism, Gabriela's radical intentions for troublemaking are always at risk of becoming depoliticized, even counterproductive, in a city where young people's style choices are key to manufacturing a new urban image based on the privileging of white creativity. Of course, such an outcome would not be the Gabriela's fault or the fault of any other cultural innovator of color. The blame lies in processes of racial capitalism that are always at work attempting to extract and undercompensate their cultural wealth.

Nonetheless, Gabriela's creative practice of troublemaking, which she has theorized as a racial privilege, remains an important intervention for young people at the precise moment they are figuring out how to survive and thrive amid the constant barrage of racist representations of them as "troubled youth." Her troublemaking illustrates how New Urban Arts has served as an important place for Gabriela to develop an oppositional strategy that is rooted in both critical consciousness and embodied self-fashioning. And I do believe that I played an important role in establishing the pedagogic conditions in the storefront studio of New Urban Arts, where young people such as Gabriela can experiment with and test their ideas, ideas that fuck up white notions of what it means to be black or brown. The next two creative practices that I will present, the hot mess and chillaxing, perform similarly as embodied and lived symbolic cultural practices that will come in handy in opposing the cultural logic of the gentrifying city.

44

2

THE HOT MESS

In 2011, two artist-mentors and a high school student made a zine together to reflect on their experiences at the storefront studio of New Urban Arts.[1] In this self-published pamphlet, the makers of the zine described New Urban Arts as a place where young people come together "to make a lot, make together, and celebrate what they make until what they make ends up on the floor." For the makers of this zine, New Urban Arts is a place where young people make a lot of art and have fun celebrating it in a messy environment with remnants of their art projects strewn across the studio. This zine provided me with a field guide for my ethnographic research in 2012. As I participated alongside high school students and artist-mentors throughout the academic year, their zine pointed me toward what to observe if I wanted to understand what young people did in the studio and why it mattered to them. Like troublemaking, it is useful to investigate how and why young people have developed this cultural practice in the studio and consider what its implications might be for complementing youth activism in the gentrifying city.

During my year in the studio as a researcher, over one hundred youth participants regularly came to the studio and created a convivial and messy, unpredictable and fun environment during the afternoons and early evenings. The term most frequently used by young people to describe this environment was "chaos."

Others called it "magic." One young person affectionately referred to the studio as a "hot mess." "Hot mess" is a popular slang term that refers to something or someone that is in obvious disarray but remains enchanting and attractive in spite of it, or perhaps because of it. I watched young people create and enjoy this hot mess in the studio every time I went. For example, they stopped screen-printing their posters, writing their poems, developing their photographs, and making new fashion designs to erupt in spontaneous song and dance. Throughout the year, they performed popular songs from different genres and eras during these studio sing-alongs, including Biz Markie's "You Say He's Just a Friend" (1989), Cindi Lauper's "True Colors" (1986), and Boris Pickett's "The Monster Mash" (1962). I watched them navigate the actual mess of the studio—the piles of magazines and fabric on the worktables, the glitter on the floor, and a colored paper chain hanging from the walls and ceiling. I laughed when I heard yet another young person ask a peer if she knew where the lost and found box was. The irony of a missing lost and found box was too rich.

I observed young people play games and perform parodies too. They played "Ninja Slap," a game that involves players tagging one another like, well, ninjas. They played "Bootlegged Dungeons and Dragons," their own version of D&D complete with an originally drawn game board, characters, and house rules (which were always being renegotiated). They reminisced about "Nerd Week," a weeklong celebration held the previous year of all things nerd. The itinerary for Nerd Week showed that one day they ate "Pi Pie," and on another day, they explored a science fair experiment, "Coke + Mentos = Boom." I also observed young people participate in frequent dance ciphers to parody old and new moves: Gangnam style, the lawn sprinkler, and the memorable partnered dance from Kid 'n Play's *House Party* to name a few.

I joined young people as they made art while sitting together around tables, holding clever and funny discussions of popular culture with their peers and their artist-mentors. One of my personal favorites was their discussion of plot amendments to *Teenage Mutant Ninja Turtles*, a Marvel comic series in which four turtles battle villains from their home in the sewers of New York City. How would the story go, they asked, if the Turtles were, like them, always hungry and broke? In their rendition, *Teenage Mutant Ninja Dirtbags*, the turtles would get jobs as pizza deliverers but they would eat the pizzas before delivering them. "Shellshocked!!!" one Ninja Dirtbag shouted, sitting in the sewer holding his belly after eating yet another customer's pizza. In another funny riff on popular culture, I watched as one young person turned away from his art making to point at spilled Coca-Cola on the floor and told

anyone listening that someone needed to "clean up the diabetes." And finally, at the end-of-the-year celebration, appropriately named "The Art Party," I joined young people in hitting a studio-made "unicorn poop" piñata. Unicorns, after all, have experienced a resurgence online in recent years, and as I learned from young people and artist-mentors at New Urban Arts, unicorns are so magical that their poop is rainbow colored.

I asked Gabriela, the young person who theorized troublemaking, whether she had ever used this vocabulary of "hot mess" or "chaos" to describe New Urban Arts. She said that she did describe New Urban Arts as a hot mess when she was a high school student. But after high school, when she became the studio manager with responsibilities that included tracking student attendance, ordering supplies, and preparing exhibitions, Gabriela realized that the studio is well planned out by staff and artist-mentors. There is a structure, she said, but it is a structure that is unfamiliar to young people who join the program. In one interview, Gabriela said,

> So, the chaos is a lie. Young people use that word because it makes them comfortable. They say, "It's chaos." What that means is that they can do whatever they want in the studio, which, for the most part, is true. I mean, don't hit each other, please. And that is respected for the most part . . . but that is because there is only a certain type of student that tends to stay around. But there is structure here. It's simply not the kind of structure that they are used to. They associate structure with school, which they don't like. So, New Urban Arts becomes "chaos." It becomes their way of describing how the studio is nonhierarchical.

In this chapter, I explore how and why the young people who do tend to stick around at New Urban Arts take advantage of this unfamiliar, nonhierarchically structured environment to produce a "hot mess," an atmosphere of learning that appears to be in obvious disarray but remains enchanting to them in spite of it, or perhaps because of it. A key assumption driving this chapter is that teenagers who "mess around" and delight in their mess do so for rational reasons that matter to them, and ethnographic research should suspend evaluative judgment, to the extent that is possible, and tend to those reasons on their terms. Suspending that judgment is particularly important for me, as Gabriela might point out, given the fact that the race of young people of color is always on trial. The hot mess could easily be weaponized to ascribe cultural deprivation to youth participants at New Urban Arts.

To illuminate the power of this "hot mess" for them, I present a typology of youth participants that was created by one youth leader in the studio

named Cassandra.[2] Each of these four peer groups has a particular role to play in producing and profiting from the hot mess. When I returned to the studio in 2012, Cassandra had participated in New Urban Arts for four years. So, she was well enculturated into the studio's daily life. Cassandra also led the Student Team Advisory Board, which is a youth leadership group in the studio that advises staff on programming, designs and leads their own programming, participates in adult hiring, and so forth. During one interview, Cassandra named and described these four types of students:

· Plebeians,

· Loudest Human Beings to Ever Exist,

· Wits, and

· Silent ~~Van Goghs~~.

Cassandra also interpreted their relative hierarchy. The Plebeians were a low-status group, and the other three types were high-status.

Other young people did not use these terms. But I did ask other youth participants and alumni whether these terms were useful to their understanding of New Urban Arts. Most of these young people seemed startled by the accuracy of Cassandra's analysis, and I incorporated their amendments to her framework. Through this typology, I show how the hot mess of New Urban Arts is a paradoxical way for young people to conform to and to exceed representations of "troubled youth" as culturally deprived members of an underclass. My capacity to interpret the cultural political potential of excessiveness has been greatly informed by the work of the gender, race, and youth studies scholar Jillian Hernandez.[3] Later in the book, I will show how the pleasure and possibility of this excessiveness is useful in challenging white investments in creative-led urban renewal.

PLEBEIANS

The first group in Cassandra's typology is the Plebeians. Cassandra described the Plebeians as "the friends of friends" of current youth participants of New Urban Arts. For the most part, Cassandra was referring to new participants of New Urban Arts. These young people come to the studio of their own accord, probably after learning about the studio via word of mouth from other teenagers. Plebeians come "into the studio very hesitantly," Cassandra said. They "travel in packs" and "are still discovering their type as artists and/or their general personalities." For these reasons, Cassandra plays on the term "plebes" to categorize them. Plebes are new cadets in military academies.

They stand without power on the lowest rung of the ladder and are only identifiable as a pack, not as unique individuals.

Several young people at New Urban Arts described their experiences of joining the program, which resonate with Cassandra's category. Some mentioned to me during interviews how they came to the studio for the first time to sign up but then refused to enter the studio alone because the place seemed so strange to them. Two participants told me that they used pseudonyms when they filled out their registration forms on the first day. They wanted to keep their participation secret until they decided whether to commit because they thought the place was so weird. Of course, this hesitancy is to be expected from newcomers to any community. New places and new people present an unfamiliar experience, one that causes social anxiety. At the same time, so many young people told me that they were scared of New Urban Arts because they did not identify as artists or poets when they first arrived in the studio. They came to New Urban Arts only because their peers suggested that they should. They reported being intimidated by the artwork hanging on the walls when they walked into the studio for the first time. One student told me that the first thing that she noticed on her first day was a black bra with crystals pinned to the wall with a thumbtack. A sign tacked to the bra read, "Work in progress."

"The studio was so weird," she said, smiling and laughing. "I wanted to leave."

So many of the young people I interviewed also told me that, as Cassandra put it, they had not yet "discovered their type" before New Urban Arts. When I asked one alumnae of the program, Alondra, whether the plebeian description was accurate, she reflected on her first day at New Urban Arts. She arrived in the studio, she said, as a devout member of her Pentecostal church. She had never cut her hair, and she wore long skirts only as a symbol of her devotion to her church community and to God. She was quiet and timid, she said. She was a rule follower at school who never caused any disruptions. She told me that her first impression was that New Urban Arts was a place "where all the loners go to entertain each other with their loneliness." For her, it was a place for "weirdos," and she did not see herself in that light. But she decided to try New Urban Arts anyway, and, as we will find out later, she did indeed discover a different type.

As the term "plebeian" suggests, several young people described themselves as sheepish rule followers when they first joined New Urban Arts. In fact, several young people told me during interviews how much they struggled with the autonomy provided to them in the nonhierarchical studio, in

the hot mess. Some alumni of New Urban Arts told me that it took them weeks, months, and even years to trust that they could go to the studio's open supply closets and take materials to use on their own terms and for their own purposes. New youth attendees approached me regularly when I conducted fieldwork for this project and asked me for permission to use supplies. This happened despite the fact that youth participants were told during orientation and reminded regularly by staff members and artist-mentors that they did not need to ask adults for permission to use supplies.

Gabriela told me that she also struggled when she first came to New Urban Arts as a high school student with the fact that the answer to any yes-or-no question in the studio was already "yes." Rather than accepting this fact as a newcomer, Gabriela said that she sought permission from staff members before starting new art projects. She described learning that staff members would tell her "no" only under the "most ridiculous circumstances." When I asked for an example of such circumstances, Gabriela laughed and said that the staff in the studio would probably tell her "no" if she asked them to purchase six Roombas—the automatic, self-navigating vacuum cleaners—because she wanted to build a robot. According to Gabriela, a robot made from six Roombas was the threshold between the possible and the impossible for young people at New Urban Arts. This student evaluation of New Urban Arts made me proud, because I believe a creative education almost always requires saying yes to new lines of intellectual travel, assuming a moral pulse is being taken repeatedly along the way.

It is not a surprise that Gabriela observed how the answer to most "yes-or-no" questions in the studio was already yes. Staff at New Urban Arts invest time and energy in hiring and training adults to create this climate of possibility. Daniel Schleiffer, the director of New Urban Arts, told me that program staff try to hire adults as artist-mentors who have trust, patience, and care for young people. The right adults are chosen for the job because young people are engaged directly in the hiring process. Then, he said, program staff "spend a lot of time and energy structuring the presence and experiences of grown-ups [in the studio] so that young people can have the most flexible experience possible." These efforts include maintaining a low student-to-adult ratio—10:1 would be the highest—so that adults, both part-time artist-mentors and full-time program staff can interact meaningfully with youth participants even if some students choose to interact rarely with any adults. The studio also provides adult training that foregrounds the importance of young people's independence in the studio, as well as the work of building relationships with them. Again and again, staff and artist-mentors stressed during conversations

with me the importance of this relational work in the studio in addition to teaching artistic skills and critical thinking. Adults tended to participate in open-ended dialogue and collaborative hands-on projects with student participants and artist-mentors as youth navigated the hot mess of New Urban Arts.

Young people in the studio often used their artwork to call out what they saw as the cause of this compliant disposition, this plebieanism. The cause, according to them, was often their schooling. For her senior exhibition, for example, Gabriela made an installation in the storefront of New Urban Arts, facing her public high school. This installation featured a life-sized figure made of plaster, sitting at an old wooden school desk. As figure 2.1 shows, the figure had no head and was surrounded by three walls that she had wallpapered with Scantron answer sheets, the bubble sheets that are used for multiple choice tests and can be scored by machine. In her artist statement, Gabriela argued that high school first turned her into a student number and a test score. She said that school had "remodeled her from a human being into a receptacle for lectures and test scores." She argued that learning should result from "curiosity, not obligation." She observed that her affluent and (often) white peers who attended more resourced schools were given opportunities for autonomy and experimentation, while she was constantly subjected to the attitude that young people of color from low-income communities should always be working, always on task, always following directions, and, as she illustrates here, always doing menial and reductive intellectual tasks such as filling out multiple-choice tests.[4]

Other youth participants noted both subtle and not-so-subtle discipline regimes in high school. One young person, for example, described how she and her peers were positioned in school as thieves based on their race and class. Whatever limited materials they had in school would always be kept under lock and key. She claimed that this positioning in school was the culprit for the plebeian behavior at New Urban Arts. At school, they were positioned as members of the underclass, as people who failed to respect authority and the property of others. Young people of color had learned in school, and in society at large, that they were perceived as threats to social institutions. From this perspective, taking materials from the supply closets at New Urban Arts without asking entailed the risk of racial and class injury—the risk of being accused by people in authority, by those who may be white or may be shoring up whiteness, that they are thieves. As a result, by not taking supplies without asking at New Urban Arts, plebeians could be attempting to avoid yet another traumatic racialized encounter. So, as much as compliance, plebeianism could be seen as an act of self-preservation.

51

Figure 2.1 Installation by Gabriela, 2010. Permission New Urban Arts.

I also interviewed alumni of New Urban Arts who attributed this plebe-
ianism to being, as one put it, "whitewashed" in school. In other words, they
were subjected to a curriculum that taught them a white Eurocentric view of
history, echoing William Pinar's argument that curriculum is a racial text be-
cause curriculum constructs and reconstructs knowledge about race.[5] School
curricula tends to obscure structural racism and classism, smooth out differ-
ences among different ethnic groups, and gloss over the imperialist tenden-
cies of the United States at home and in countries where some young people
from New Urban Arts were born.

In one interview, Thomas, who immigrated with their parents from South
America—note gender-neutral pronoun—wrote a poem, "Native Tongue,"
while participating in New Urban Arts to call out this whitewashing. The
poem describes how their public schooling cut out their "native tongue" by
marking it as inferior and illegitimate in white America. I present this poem
in full to show another aspect of plebeianism at New Urban Arts, which is
most relevant for first-generation immigrants who are not white and whose
native tongue is not English.

She uncovers my naked frame on a metal slab

Runs a latex finger along my lips

Splits them apart and grips my treason tongue

Unholy hands hold me open, invade my buckled cavity

Broken *boca esa boca rota*

He cuts out the troubled tongue

Stitches stability into me.

I wriggle the orifice in my mouth

Uncle Sam is an impeccable surgeon

Says "this change is perfect, this change is permanent, a civilized
 operation."

We flew here from Venezuela

I just came for Disney World

Didn't know my mom planned on staying indefinitely

She saw free speech, protection from the seventh most violent city in
 the world

But these rights aren't free to foreign bodies

Instead we got lessoned on the proper existence

Harsh stares reminded us of our difference, our traveler tongue

Gringos thought we were either deaf or dumb,

Yelled at so we'd get it.

Their disdain pierced the language barrier

Not White therefore inferior

So Mom handed me to Uncle Sam for the fixing

The only remedy for my menacing mouth

I practiced the master sounds to belong

To become natural, naturalized

For a while the new tongue helped others understand

I could be a loyal American

Patriotic articulation

Saying the words I was fed, they were finally listening

But sometimes I felt like my jaw was missing something

Like something was buried beneath its hinges, a guttural sound

A scalpeled rhetoric

An old tongue resurfacing, rising from the dead

53

Ancient and distant like the land it abandoned, speaking out of turn

The ghost tongue haunts my conquered mouth

It stirs the Venezuelan blood in me

La sangre, the slaves and Spaniards

Wars raged across a saliva sea

Claro que si coursing between my gums

En sabor rico connects me to the histories of twenty countries

People who carry their indigenous roots

Chanting their ancestors' names

Singing with *bocas rotas, bocas* broken by empire

Sounds beautiful

Their language beautiful

Our loss is beautiful, beauty is a mutant tongue struggling to speak

It is survival when a piece of us is forced to die

Smiling with a mouth that isn't ours

For centuries conquistadors ransacked villages,

Enslaved natives to rename our lives

To infiltrate our minds

Uncle Sam's vigilantes corner us in classrooms and work zones

Correct us whenever we open our mouths

They search and destroy, oppress and avoid the other

Language is a murderous tool

Selectively it scours the earth to search

Ensure he's doing you a favor

Beauty is a naked body uncovered on a metal slab

It is a sterilized mouth that screams through Uncle Sam's incisions

Language is all I have to tell this story

So when I speak I resurrect this bloody history

The homes left behind, the rotting flesh come back to life

And though this will never be enough to describe the loss

The sounds that will never be mine

I refuse to be silent, to be slaughtered, and quiet

So I will take this troubled tongue

This menacing, mutant mouth

All it destroys and recovers and speaks beauty.

In this poem, Thomas uses the image of Uncle Sam as an imperialist surgeon, using schools to extract the treasonous tongue from a young person whose family is escaping a region with a troubled political and economic history with the United States. The specter of their lost tongue, their ghost tongue, haunts them as they come to New Urban Arts, as they negotiate how to speak and how to write when their lost tongue was cut out for being treasonous, when their transplanted tongue, a whitewashed tongue, a sterilized tongue, cannot speak of the histories of slavery and of imperialist conquest. Thomas's poem shows that characterizing plebeians as shy and introverted may not be entirely accurate. Another way of interpreting plebeians is that they, metaphorically speaking, have had their tongues cut out so that they cannot speak for themselves. They are refused the opportunity to speak about how they are subjectified in society as treasonous and foreign, as inferior and incorrect, in need of being civilized, of being made proper.

This interpretation resonates with work that has examined how and why poor young people of color struggle with their experiences of learning in urban public high schools. Michelle Fine, in her 1991 book *Framing Dropouts: Notes on the Politics of an Urban Public High School,* speaks of the ways in which urban public schooling is designed for the most part to "silence" youth of color living in cities.[6] Engaging intellectually in the personal complexities of their lives, and the ways in which such complexities reveal the ways society is structured in and through dominance, is not accepted. Through such "silencing," "low income schools officially contain rather than explore social and economic contradiction, condone rather than critique prevailing social and economic inequalities, and usher children and adolescents into ideologies and ways of interpreting social evidence that legitimate rather than challenge conditions of inequality."[7]

Thomas's perspective suggests that not much has changed for them since Fine wrote this book in the early 1990s. To succeed in schools where intellectual engagement with lived experiences of injustice is invalid, where dealing with social and economic complexity and contradiction is often not permitted, then Thomas must in, effect, silence themselves. They must become a plebeian without a native tongue in order to try to succeed in school.

But, as Michelle Fine notes, this act of self-silencing comes with an intense psychological cost, a cost that is expressed in and through Thomas's poem, as well as Gabriela's headless sculpture. These artistic examples illustrate that New Urban Arts is a place where some young people can trouble this silencing and wrestle with these psychological costs in their search for

55

healing and for ways forward. With the strong support of their artist-mentors and their peers, plebeians can make art and write poetry to destroy and to recover, to speak beauty, to negotiate and to overcome their subjectification as those in need of a civilizing operation on a metal slab. New Urban Arts therefore serves as a site where some plebeians can, as Michelle Fine and her peers argued, "re-educate" themselves and "break down public representations for scrutiny and invent new ones."[8] That aim is precisely the rationale that Gabriela put forward in her theory of troublemaking.

It is critical to point out here that young people who participate in New Urban Arts attend a variety of public schools in Providence, and, of course, not all public schools are the same. In 2012, a majority of young people who participated in New Urban Arts attended a selective admissions college preparatory high school for students from across the city. That is to say, a majority of youth participants in New Urban Arts during the academic year of 2012–13 were young people of color that tended to be from low-income and working-class backgrounds who were on an academic track that put them on the pathway to a four-year college. In this school, these young people came into contact with a higher percentage of relatively affluent and white young people than in their more segregated neighborhood elementary and middle schools. As a result, it is safe to assume that these young people were developing an increased awareness of their location in racial and class hierarchies in high school at the same time that they were participating in New Urban Arts after school. There are numerous examples in this book, "Native Tongue" being one of them, that illuminate the psychological toll of this newfound awareness.

There is a strong theoretical basis for this toll that young people bring with them from this school into the studio. Our understanding of ourselves as racial and classed individuals emerges through our relationships with others. As Julie Bettie argued in her book on the racial, class, and gender performances of youth, *Women without Class,* young people's awareness of these differences and their hierarchies is dependent upon the "class and race geography of the environments in which one lives and moves."[9] So young people's accounts of whitewashed curricula, of being silenced, of being positioned as thieves, are testimonials of the racial and class injuries that they have experienced in the specific context of this college preparatory school. They were suffering from their newfound awareness that they were being treated differently in school based on their social position as "troubled youth" at the precise moment that they had a secondary school experience that was, in theory, preparing them to be upwardly mobile. They then brought those injuries with

them as they entered into the studio with caution and trepidation, with self-preserving compliance and sheepishness.

As they entered the studio for the first time, these quiet and hesitant, sheepish and silenced plebeians did have low status at New Urban Arts. Yet it is also important to recognize that Cassandra used the term as one of endearment, not derogation. Cassandra knew well that their time as compliant rule followers, as young people who conformed to the respectable aesthetics and behaviors demanded of them to earn their humanity, would be short-lived precisely because of the hot mess of New Urban Arts. Cassandra called one type of student most responsible for this hot mess the "Loudest Human Beings to Ever Exist."

LOUDEST HUMAN BEINGS TO EVER EXIST

The Loudests, according to Cassandra, were not just audibly loud in the studio. Their "presence was loud." She said that the Loudests were the "catalysts for every unauthorized, unexpected, chaotic, and unscripted event" in the studio. In other words, they were the catalysts for this sense of chaos in the studio, from the sing-alongs to the dance ciphers. When I shared Cassandra's analysis of the Loudests with Thomas, the author of "Native Tongue," a few years after they graduated from high school, Thomas looked back upon their time at New Urban Arts and said that the storefront studio benefited from a few Loudests, but not too many. Of course, what is interesting about the Loudests is that they conform to a representation that is used to cast them as culturally deprived, as inferior, as members of the underclass whose social station is caused by their lack of respectable style and comportment. And yet, they are performing the stereotype of being loud *excessively*, to the point of becoming the Loudest Human Beings to *Ever Exist*.

Newcomers to New Urban Arts meet the Loudests on their first day in the studio. High school students learn about New Urban Arts through word of mouth and then come to the studio after school to sign up. The studio hosts orientations for these newcomers at the beginning of the school year and after the winter holiday break. I participated in one of these orientations in fall 2012. Two of the Loudests, as identified by Cassandra, led tours of the studio for these newcomers, signaling to them that the Loudests are leaders with high status in the studio. I tagged along on one of these tours as one of the Loudests, Lewis, led his group of ten students around different areas of the minimally partitioned studio, including its darkroom, library, screen-printing studio, office area, and general purpose room.

During the tour, Lewis became a mash-up of different characters, in-

cluding an emcee, a carnival barker, and a cowboy. Here is how Lewis started his tour in "The Big Room":

> So!!! Welcome to New Urban Arts! If you haven't already gotten a proper welcome. . . . Welcome from me . . . per . . . son . . . al . . . lee. This is awesome sauce. We're going to have a great time together! So, let's start off our tour by going to The Big Room. . . . The room we happen to be in right now is The Big Room! The Big Room is where everything happens. . . . Mostly all the events will be here. . . . Most of the artist-mentors will be here. . . . Students . . . people . . . everyone you know . . . most of the time . . . sometimes. . . . You know . . . people hanging out . . . down the street . . . same old thing we did last week. Come on, follow me!!! Yeeehhhaaaww!!!

I looked around at the group of newcomers. Some smiled. Some laughed. Some looked side to side, searching for cues from others as to how to respond.

Later in the tour, Lewis led these newcomers to the unpartitioned office area where several of New Urban Arts' six staff members have desks. This office area is separated from The Big Room by a half wall, and, on most days, several young people can be found hanging out in the office area talking to staff. One staff member, Michael, was a former youth participant in the program. In 2012, Michael was the studio manager, and his responsibilities included taking attendance and maintaining the facility, among other roles. During the orientation, Lewis made it clear to the new youth participants that they were expected to question and undermine Michael's authority in the studio. Lewis pointed to Michael's desk: "That's Michael's desk. If you really want to get Michael mad, just pile paper on his desk . . . paperwork, you know. . . . He loves that kind of stuff, especially your registration forms. Make sure you don't put your name on the form. He loves that. Follow me!!! Yeehaw!!!" Rather than learning to respect authority and conform to bureaucratic norms, Lewis was teaching the plebeians to engage in playful, and relatively inconsequential, ways to undermine it.

Playing with undermining authority was a daily pastime in the studio, and unfortunately for Michael, he was often on the receiving end. Youth, for example, constantly confronted him over his position as the house deejay in the studio. Michael himself was often piping music into the studio that he hoped would have a calming influence, such as songs by The Beatles. Michael told me that he wanted to make the "hot mess" of New Urban Arts more manageable for him and safer and more productive for students. But this remote management tactic only worsened his problem because it caused youth par-

ticipants to pester him more, including constantly asking him if they could be the house deejay for a day. Oftentimes, young people just screamed across the studio to beckon him for assistance, *especially* when they did not need it. "Michael!!!" was a constant refrain in the studio, as young people screamed in excessively loud voices across the studio without the expectation that Michael would heed their calls.

During interviews with young people, I asked them to identify Loudests in the studio. The unequivocal choice was one young person who led the other orientation tour, Andre. Andre had a reputation in the studio for being very smart; several mentioned that he had, as one put it, "ridiculously high" standardized test scores in mathematics. But he also had the reputation for struggling to find a school that worked for him. When I asked Andre about his school situation, he gave me an ambiguous answer, which led me to believe that he was not regularly attending one. Andre was also a great piano player who played classical and popular contemporary music. He played the upright piano in the studio, which was located in The Big Room, almost every time he came to New Urban Arts, which was nearly every day. He riffed with lyrics and invited others to sing along. Smiles abounded when he played the piano and led sing-alongs. Andre's joy in the studio was rich; he still makes me smile thinking about him years later.

Andre pushed the boundaries of what was acceptable behavior in the studio. For example, Michael, the studio manager, purchased a bucket of new Bic pens for youth participants to use. The bucket was in the studio for only a day before Andre had disassembled a few dozen pens. He used the plastic shafts from the pens to blow bubbles out of hot glue. The bubbles then hardened into tiny luminous spheres. When I asked Andre why he did that, he smiled and said that he was experimenting with low-cost alternatives to glassblowing. Needless to say, Michael was ambivalent that Andre had destroyed so many new pens for his art project. Even though young people were trusted to use materials on their terms, some young people, such as the Loudests, tested the limits of that permission.

Andre's loudness was also embodied and kinetic. For example, he enjoyed putting things in his hair as a playful gesture. He put a pink and white polka-dot bow in his Afro-textured hair and called it his "gangster bow." On another occasion, he put dozens of pencils in his hair, which one youth member told me looked like the grotesque character from the film *Hellraiser*. When I asked Andre why he stuck pencils in his hair, he told me that it was his "sculpture project." I also watched Andre wrestle girls in jest before allowing them to beat him, much like Andy Kaufman used to do on television in

59

the late 1970s.[10] A tall and heavyset teenager, Andre pleaded in jest with others in the studio to help him after one wrestling match because he claimed he had been sexually assaulted. There was also the time he did "snow angels" in wood shavings on the floor after a woodcarving workshop. Several young people told me how much they looked forward to the early evenings when Andre led step aerobics in the studio, an exercise class I regrettably missed.

To understand why Loudests such as Andre and Lewis matter in the studio, I interviewed two young Latinx women whom I considered to be the Loudests of my era as the director: Alondra and Priscilla. Alondra is the young woman who came to New Urban Arts first as a devout member of her Pentecostal church. I remembered these young women for being audibly loud in the studio, bringing excessive and disruptive laughter to the studio each day. They were also the first participants to introduce spoken word poetry into the studio under the guidance of New Urban Arts' amazing program director at the time, Sarah Meyer. At public openings of art exhibitions at New Urban Arts, they performed "Random Acts of Poetry." They stood on soapboxes at spontaneous moments during gallery openings and recited their poems. I asked these two young women, Alondra and Priscilla, to theorize why the Loudests matter to young people at New Urban Arts.

Alondra: The loudness in the studio is great because it covers you up. You can just be you. You don't have to worry about what other people think.

Tyler: What do you mean by it "covers you up"?

Alondra: Some people are shy. You know, "I don't want to talk. I don't want to be myself." You know? But if everybody else is being loud, you can be loud, too, because nobody knows it's coming from you.

Priscilla: Yeah. See, that's interesting. Normally at school, we were the quiet people, we were the quiet kids. At school, it was just like, "That's the religious group. They are the church girls." My friends in high school were all church girls. And so we would go to New Urban Arts, and we weren't labeled like that. We started to become loud and other people were like, "Oh, there goes the girls again."

These two young women interpreted New Urban Arts as a place where they could experiment with identities that were different from those ascribed to them at school (i.e., "quiet kids," "the religious group," "church girls"). For

them, loudness created a playful environment without judgment or labels, where they could take risks forming new identities. The loudness relaxed social norms, thus offering them permission and the possibility to experiment with their identities without too many consequences. Indeed, amid this loudness, New Urban Arts, Alondra said, became the place where she discovered her new type as "a queer freak spoken word poet." Although her first impression was that New Urban Arts was a place for lonely people to go to entertain themselves with their loneliness, she stated that her last impression was that New Urban Arts was a place where young people could go and become "queer by the end of it." She was laughing when she made that claim. But I took her seriously.

These four examples of the Loudests illuminate varied motivations for this excessive behavior in the studio, behavior that can be understood as conscious and knowing redeployments of degrading representations of their identities.[11] Andre and Lewis provide two examples of boys who have undoubtedly experienced the social pressure to become men through engaging in overt challenges to authority and control, to take risks in challenging rather than conforming to oppressive norms. Andre, who appeared to be struggling to remain on track to get a high school diploma, was engaging in loud and physical behavior in the studio that could be used to explain why he was not succeeding in school. In other words, he was violating middle-class norms that white people like to see as their unique dispositional property (e.g., decorum, respect for authority, respect for property, etc.). In playfully and excessively conforming to the loud behavior of the underclass, he was reclaiming some sense of agency, in effect, by opting out of a social system that was pushing him out. At New Urban Arts, he could heal this injury of being pushed out by enjoying high status among his peers as the Loudest Human Being to Ever Exist, one responsible for creating a culture "where young people come together to make a lot, make together, and celebrate what they make until what they make ends upon the floor." Similarly, Alondra and Priscilla experienced pressure at school and at church to conform to particular performances of femininity: following patriarchal rules, being reserved and quiet, or being straight in the heteronormative sense. These performative discourses of straight femininity interfered, Alondra said, with her opportunity to be the person that she wanted to be. Becoming the Loudest Human Being to Ever Exist was a performance, a "conscious, knowing display," as Bettie would put it,[12] for her and Priscilla to transgress these heteronormative and patriarchal norms. In the studio, Alondra and some her peers could become "queer freak spoken word poets."

61

So, being loud, being excessive, in the studio at New Urban Arts provided these particular young people with the means to heal injuries that they experienced in other environments. And they were the catalysts that allowed others in the studio to be excessive for a moment too. And yet, becoming the Loudest Human Beings to Ever Exist risks reproducing their subordinate class futures if they participate in these cultural performances at the expense of adopting the respectable norms that are needed to graduate from high school. Alternatively, young people could choose to participate in the hot mess of New Urban Arts free from consequence precisely because the studio operates at a safe distance from other social institutions. The studio is located "beyond the borders of schooling."[13]

Indeed, this "hot mess" outside school mattered to its participants so much that I witnessed young people become concerned about its possible decline. In spring 2013, I had been observing young people participating in New Urban Arts for several months before leaders on the New Urban Arts youth governing council, the Student Team Advisory Board (STAB), started to express concern (note mischievous acronym). They were troubled by the fact that "chaos levels" in the studio, as one put it, were diminishing. To intervene, these leaders organized what they called "Get Loud Day." They planned stations in the studio where their peers could "Get Loud" in a variety of ways. These stations included shooting glitter from potato guns indoors, throwing darts at paint-filled balloons, writing on walls with yellow paint to reflect on how the studio helped them "get loud," playing in and dancing to their own fife-and-drum band, and making "animal noises" based on random prompts pulled from a hat. Examples of these animal noise prompts, which were created by Gabriela, included a vomiting chimpanzee, a lost whale, a hungry squid, and a pig finding out that it had been accepted to Harvard. Oink.

The aim of Get Loud Day, as far as I understood it, was to relax social norms in the studio through "chaos" so that young people could experience the pleasure that STAB members associated with New Urban Arts and allow young people to experiment with inventing new social identities. I only heard one STAB member critique the glaring paradox of Get Loud Day. Through creating a structured opportunity for social transgression, youth participants were expecting their peers to conform to the prescribed norms of loudness. In other words, young people in the studio were simply becoming authoritarian in telling other young people to be nonconformist. Nonetheless, with Get Loud Day and the models provided by the Loudests, it is important to recognize how dangerous it can be to dismiss these young people's loud behavior, or far worse, to use it against them as racist, classist, misogynistic, or

homophobic evidence of their biological inferiority or cultural deprivation. The Loudests are conforming to and exceeding social positions ascribed to an urban underclass: grotesque hell-raisers, gangsters, rapists, hip hop emcees, physically unfit youth, and so forth. They are troubling feminine and heteronormative rules that feel imposed and inauthentic to them. They find pleasure in these conscious performances of loudness. They create social bonds because of it, which is reflected in the fact that the majority of participants in New Urban Arts refer to the place as "family" and as "home."

So the Loudests create a sanctuary for youth, providing them momentary reprieve from the harsh and degrading representations that are used against them. At the most fundamental level, then, this hot mess provides a place where these young people can be alive as their best and most joyous selves for at least a moment each day, carrying those meaningful experiences forward with them for the rest of their lives. Based on my interviews with alumni that included Alondra and Priscilla, almost ten years after they participated in New Urban Arts, it seems to me that those experiences of the hot mess are still generative in their lives, which, in a classical Deweyan sense, is precisely what a good education should do.

WITS

Cassandra identified a third type in the studio with the same status as the Loudests. She called this type the "Wits." The Wits, Cassandra said, are "the most perfectly evolved specimens to ever grace the entire universe." She said that "witty adults can easily become annoying, but when teenagers are witty, they become deadly." She noted that it is "amazing to watch the tiny gears in their heads spin." The Wits most often "come in the form of writers," Cassandra observed, and "their cognitive skills are extensive." They have "deadly comedic force" that turns the studio upside down in laughter. They also have capacious cultural tastes. The Wits, she said, can speak about contemporary artists such as Ai Weiwei, as well as the first issue of *Spiderman*. They have a fondness for pick-up lines too.

"Hey, girl," Cassandra said, imitating a Wit. "Are you a lobster? Because baby, you make my lobs stir."

"If I could rearrange the alphabet, I'd put I and U next to one another."

And finally, "I'd like to be a Helix-44 so I can unzip your jeans."

Daniel, a youth alumnus of New Urban Arts who then became an artist-mentor, reflected on his time as a writer and a Wit with "capacious tastes" and "deadly comedic force." As a high school student, he met with a group of his peers in the studio to write poetry with the support of an artist-mentor. For

no reason in particular, members of the group started to tell Edgar Allan Poe and Shakespeare jokes one afternoon. Then they started to play around with the words "Poe" and "poetry." At some point, one of them blurted out the nonsensical phrase "Poe Ham Trees," which the group thought was amusing. For the student exhibition in the New Urban Arts gallery, this group submitted a drawing of trees with Edgar Allan Poe's face hidden in their trunks, with hams hanging from these "Poe trees." Their drawing was a visual representation of their random wordplay, "Poe Ham Trees." Then, for the opening of the exhibition, the group dressed up as Beatniks and walked around the studio scowling at people. These young poets were finding pleasure in tampering with the canon and dressing up as Beatniks in ways that adults would probably find annoying but was another "random act of poetry" that was highly entertaining for them.

In another example of the Wits, a group of youth participants formed a band in the studio, named "Broke Boyz EBT Swipe." As band names go, it does not roll easily off the tongue. But as Luis, an artist-mentor and former youth member of New Urban Arts told me, Broke Boyz EBT Swipe is "hilarious as a band name because it says it all. Its members are young, they are Black, and they don't have much." The band produced several tracks, which are available for listening on SoundCloud. For example, "Don't Stop Walken" features one youth participant singing the song, "Don't Stop Believin'" by Journey, while impersonating the actor Christopher Walken, who is known for his distinctive voice.[14] His spot-on impersonation is hilarious and clever.

Perhaps the most popular Broke Boyz track is "Twerk for Jesus," a witty song that plays with twerking, a now popular dance form that tends to feature women of color lowering themselves to the ground as they shake their bums and thrust their hips.[15] Twerking has its roots in the queer and bounce music scenes of New Orleans. Bounce music provides an energetic tempo, as well as a call-and-response lyrical structure, that keeps twerking on the move. I was told that "Twerk for Jesus" started as a joke in the studio one afternoon. The Broke Boyz were hanging out and freestyling in the studio when they started to discuss how "turnt," or excessively excited, they could get. One youth member, Isaiah, told me that they were going to get so turnt that folks in heaven were going to get turnt too. As this excessive dance party erupted on earth and in heaven, they predicted, Jesus would exit the pearly gates and come down to earth to party hard with the Broke Boyz.

"What is the most active activity that a young soul could do to raise the temperature in heaven?" Isaiah asked. "Dance. In the most hype ways possible, including, but not limited to twerking, grinding, and the nae nae."

As the Broke Boys riffed on Jesus getting hyperexcited, one of the members of the group implored the others to "Twerk for Jesus."

"The rest," Isaiah said, "is history."

"Twerk for Jesus" uses a fast-paced and punchy beat and the repetition of simple lyrics. The song is tough to transcribe but goes something like this:

Jesus say Jesus say aah
Jesus pray Jesus pray yo
Jesus pray Jesus pray yo
Jesus pray Jesus pray yo

Pray pray pray for Jesus
Pray pray pray for Jesus
Pray pray pray for Jesus
Pray pray pray for Jesus

Jesus in your heart
Jesus in your heart
Jesus in your heart
Heart Heart

And on it goes . . .

"Twerk for Jesus" is a witty semantic inversion of virtue and hypersexuality. Jesus, after all, is the paragon of virtue. It is therefore funny to think about him becoming excited as people on earth turn to this hypersexualized form of dance. Of course, twerking itself emerged as a pleasurable and critical response to standards of respectability used by white heteronormative dominant culture, which already deems women of color and queer people of color as inferior, deviant, hypersexual, or always sexually available. The Broke Boyz EBT Swipe continue in this same tradition, playing with dominant cultural standards that are used against them. Those standards presume that they lack virtue and that lack of virtue is the cause of being "Broke Boyz." And they do so with the excessive and rapid backbeat of New Orleans bounce.

I also took notice of Wits playing with those in positions of authority in the studio, much like Lewis suggested to newcomers when he told them that they should not put their names on registration forms because the studio manager, Michael, "loves that." For example, I noticed one afternoon that the desk of the executive director had been "bombed" with Post-it notes. One Wit had covered the desk with Post-it notes, each written with an amusing apho-

65

rism, pun, or question. It is worth listing most of her notes to illustrate "the tiny gears," as Cassandra put it, spinning in this writer's head.

- I like this desk. I feel official. You must feel official . . . officially AWESOME.

- There are more bacteria on your body than cells inside you.

- Have you ever plugged your phone charger into your belly button and pretended that your phone was a fetus?

- We should kill people who kill people because killing people is wrong!

- Bears have eaten people in the past. #fact

- In Turkey, they eat a lot of turkey. #fact

- If you drink too much water, you can drown.

- You're COOL BEANS.

- Don't go near bears, you can't trust them.

- Did you know that male seahorses give birth?

- MERCY.

- Plants.

- Wide ruled paper is poop.

- I ate Mac and Cheese today.

- Why do you have a rotten pumpkin on your desk?

- TO THE WINDOW TO THE WALL.

- COLLEGE RULED PAPER ALL DAY.

- Jibber Jabber.

- Did you know that when spiders are on crack they don't make their webs right?

- Rubber bands are like these cool bracelets made of rubber.

- DROWN IN IT.

- Stop trying to make fetch happen.

- If I had a chocolate I would give you one but I don't have one.

- Your computer is silver. Silver means future. You are from the future.

- New Urban Arts = secret illuminati society.

- Your head is the shape of a human head. That is not normal.

- Secretly . . . I'm an alien.

- I lied. Fish don't talk.

- You secretly like Justin Bieber and you don't even know it.

- Sleep spelled backwards is peels.
- "Give me a sign" Brittney Spears.
- I WANT PIZZA.
- Have you seen an eyeball pop out of someone's head? It's gross.
- I have an electronic device. Do you?
- Dust (*with an arrow pointing to dust on the table*)
- I laugh at my own jokes . . .
- I like eating fish babies.
- Being confusing is confusing.
- Fishy fishy fishy
- A crumb of some sort (*with an arrow pointing to a crumb on the table*)
- More dust
- Soft.
- Soft.
- Japan.
- Mouse. Feed it Cheese.
- Represent the inner you.
- Do lizards fart?
- Rollin with day homiez.
- Imagine if we didn't have cartilage.
- Imagine if we didn't have knuckles.
- Imagine if our eyes were in our ears.
- H8 +3rz m@h mo+1v@+orz.
- I'M ON THE EDGE OF GLORY!
- BEARDED MAN BEARD BEAR. You are secretly a bear.
- HA!
- SOULFUL SOUL.
- Jesus was born on Christmas.
- IT'S FUBUARI.
- CRANK THAT SOULJA BOY.
- Soft.

When the director found these Post-it notes covering his desk, he used shipping tape to laminate them and then he hung the collection of notes on the wall behind his office.

In many ways, the Wits point to a characterization that is applicable to so many young people who choose to come to New Urban Arts. As one artist-mentor put it in an interview with me, "The kids who come to New Urban Arts are the daydreamers and the time travelers. They look beyond the surface and are deeply critical and inquisitive about their surroundings."

The Wits trouble the racialized and classed stereotype that young people of color from working-class and low-income backgrounds are not creative geniuses in their own right. Moreover, they take pleasure in subverting authority through intelligent and writerly methods. The Wits are a troubling social group because their creative genius offers the crucial reminder—one that should not be necessary—that young people at New Urban Arts are not culturally deprived or inferior. Their social position cannot be explained by this impoverished theory of the underclass. What they do lack is material resources, economic opportunity, and freedom from symbolic violence.

Nevertheless, some of the young people from New Urban Arts are going to be upwardly mobile, partly because of their access to a selective admissions high school and partly because of the support they receive through New Urban Arts. The Wits strike me as one category of youth at New Urban Arts who are most likely, for example, to graduate from a four-year college. At New Urban Arts, sharing and acquiring wide-ranging and boundary-crossing cultural interests with others will be useful in their attempts at upward mobility.

The fourth and final group in Cassandra's typology also troubles representations of "troubled youth."

SILENT ~~VAN GOGHS~~

Cassandra named her fourth and final group in the studio the "Silent ~~Van Goghs~~." She crossed out ~~Van Gogh~~ because, she said, members of this group had not cut off their ears—at least not yet. Cassandra said that the Silents were "very skilled as artists" and "worked on the sidelines" creating art. They exhibited their "amazing artwork" at regular public gallery openings at New Urban Arts so that their artwork could "be gawked at in its pure awesomeness."

I brought up her definition of the Silents in interviews with other youth participants of the studio, and they would smile before identifying the same people. Thomas, the author of "Native Tongue," told me that they appreciated the Silents because the Silents are a "constant reminder of how important New Urban Arts is." Without New Urban Arts, Thomas said, the Silents would not have access to materials, space, and support. But with these resources, Thomas said, the Silents make "dope artwork" that would not be made otherwise.

An obvious example of a Silent is Monty Oum. Monty came of age in Providence at the turn of the millennium, and I met him soon after I founded New Urban Arts in 1997. He was part of a generation of Southeast Asian youth whose parents sought asylum and safety in Providence after the United States played a destructive role in war, genocide, illegal bombing, and political unrest in the region during the 1970s.[16] A high school dropout, Monty spent most of his days at New Urban Arts. In the studio, he worked silently, copying various characters from video games and *anime*, a genre of Japanese animation. New Urban Arts provided him with access to supplies, equipment, material, and guidance from artists. It also gave him a summer job through AmeriCorps Learn and Serve, a now defunct federally funded program, to teach his artistic skills to middle school students.[17]

Monty left Providence before having a breakthrough in his midtwenties. He discovered a way to hack different video games and extract their characters so that he could remix them digitally.[18] He produced new animations with these characters from different corporate franchises so that they battled one another in ways that could not have been seen otherwise. He uploaded one of these remixes, *Haloid*, to GameTrailers, a website popular with video gamers. *Haloid* became among the most-watched user-generated content on GameTrailers, with millions of views on YouTube.[19]

Following this amateur success, Monty was hired by Rooster Teeth Productions, based in Los Angeles and Austin. For Rooster Teeth, Monty created RWBY, an internationally acclaimed animated web series that now inspires costume play, or "cosplay," among its devoted global fan base. RWBY won a Streamy Award and an International Web Television Award for Best Animated Series in 2014 (see figure 2.2). With the odds stacked against him, Monty recorded these precocious achievements before his life was cut short at the age of thirty-four. A *New York Times* obituary reported his tragic death from an allergic reaction during a routine medical procedure in 2015.[20]

Perhaps no other graduate of New Urban Arts has demonstrated Monty Oum's record of creative achievement. But so many young people throughout the years have matched his dedication to his craft, working on the sidelines of the hot mess in the studio, and making their own magic. During the year that I spent in the studio in 2012, I asked young people to identify current youth participants who fit Cassandra's description for the Silents. One young person often identified was Brontë. Like Monty, Brontë was a cartoonist and a storyteller. Her cartoons featured anthropomorphic squirrels, foxes, chipmunks, rabbits, and other forest creatures who lived in an imaginary world that she titled "Pawvidence, Rhododendron Isle," an obvious wordplay on

69

Figure 2.2 Monty Oum at PAX 2013. Image is licensed under the Creative Commons Attribution-Share Alike 3.0 Unported License, https://creativecommons.org/licenses /by-sa/3.0/deed.en.

her hometown of Providence, Rhode Island. While participating in New Urban Arts, she wrote a thirty-thousand-word novella about Pawvidence, drew hundreds of comics, started to experiment with animated GIFs, and left behind countless doodles on paper scattered around the studio. For a project in which youth participants created mythical creatures, she made a stuffed animal "Dogicorn." This stuffed animal is a cuddly creature, half-dog and half-unicorn, with a pink blanket and pink eyebrows (see figure 2.3). The Dogicorn, Brontë wrote, is "a very kind creature who can cast spells and transform things with her horns." But Dogicorns are "very sensitive, and will cause destruction if they are the slightest bit insulted." Brontë exhibited the stuffed animal in the New Urban Arts gallery on a pedestal with a sign that read "Pet me please!"

Most of Brontë's comics and stories were about sibling rivalries and courtship. One of her characters, Phillip, was a mischievous squirrel who tormented his older sister, Phyllis. Phyllis has big hair and styles it with big bows. Phyllis hates Phillip. In one of the cartoons, Phillip holds his stomach and points at his sister after she has had her hair done. The caption of her cartoon

Figure 2.3 "Dogicorn" by Brontë, 2012. Permission New Urban Arts.

reads, "If I'm gonna die today, at least the last thing I am going to see is you looking like Gloria Gaynor"—a reference to the R&B singer known for her 1978 song "I Will Survive" (see figure 2.4). For Brontë's final exhibition at New Urban Arts, she digitally animated a blue puppy that puked a rainbow.

I asked Brontë what it was like to focus so hard on her artwork while she was surrounded by the hot mess in the studio. After all, it would be hard to concentrate while Andre was leading sing-alongs to Biz Markie's "You Say He's Just a Friend" or doing snow angels in wood shavings on the floor. She said that the chaos sometimes annoyed her, but she appreciated it too. She said that the chaos "loosened her up" and helped her "take creative risks" that she otherwise would not take. She said that the chaos at New Urban Arts taught her not take her artwork or herself so seriously.

It was easy to overlook the presence of the Silents in the studio. For example, I watched Alicia make art one day in the studio, hardly ever looking up, with her head low to the table, close to her pen, ink, and watercolor painting. She was working on a painting of a Sasquatch sitting cross-legged in the woods. The Sasquatch was looking down at the forest floor, surrounded by

Figure 2.4 Cartoon by Brontë, 2013. Permission New Urban Arts.

flowers and rabbits. When I asked her to describe what was going on in her painting, she said that the Sasquatch is a "misunderstood gentle beast." The Silents, like Alicia, were often shy introverts, and their artwork seemed to engage with this aspect of their lives. And yet, their artwork was a way for them to be loud. As Alicia put it in her artist statement for a student exhibition at New Urban Arts, her artwork "reflects things that I feel, parts of me that I hide, and jokes that I keep to myself. I am shy but never in my artwork."

When I was the director of New Urban Arts between 1997 and 2007, I always struggled with the expectation that donors and program officers from philanthropic foundations wanted to hear the Silents' stories most. Their stories do trouble the representation of urban youth as members of the underclass. The Silents are hardworking and smart. They seek out support and feedback as they develop their independent projects. They work on these projects to completion, and their projects are often original and of a high standard. The Silents are, in other words, model students in the arts and humanities.

But, paradoxically, representations of youth as the Silents can be used against other youth in the studio, particularly the Loudests. The Silents can be used to suggest that New Urban Arts is a place where young people develop a strong work ethic, a dedication to their craft, respect for materials, and a

docile demeanor. Through telling the stories of Silents to funders in grant applications and at fundraising events, I was packaging and selling New Urban Arts to satisfy expectations that the youth development program was curing and fixing youth of their underclass ways. This strategy, in other words, would simply reproduce the discursive logic that is used against youth from New Urban Arts. The Silents could function as a "model minority," a stereotype most often foisted upon Asian Americans in the United States,[21] which only reproduced the idea that those youth who did not succeed later in life were those who failed to develop the style and comportment of the Silents. Their stories could thus be used to allow those who remain invested in the conditions of racial capitalism to keep those conditions intact, shifting responsibility for social problems back onto individual people of color and their "culture." That is what happens when certain stories from the studio are omitted from the record, such as one young person blowing hot glue glass with broken Bic pens, doing snow angels in sawdust on the floor, or leading a step aerobics class.

So yes, I want to gawk at the awesomeness of the Silent ~~Van Goghs~~. I want to gawk at their record of achievement, and I want their artwork to be hung on the walls of New Urban Arts. But I am also ambivalent about those desires, knowing that they cannot be extricated from the racist and classist logic that is always at work in and through me. Telling the stories of the Silents becomes inevitably caught up in the white fabricated notion that poor young people of color need to work hard, assume responsibility, and take on a shy demeanor if they are going to get ahead, if they are going to be deemed human. Everything in me wants to fight this logic even as I stumble in doing so. As much as I want to gawk at the pure awesomeness of the Silents, I question the formation of my desire to do so and the implications when someone in my white position does.

73

CONCLUSION

In this chapter, I have presented four different types of students at New Urban Arts who together create the "hot mess" of New Urban Arts. Through New Urban Arts' relatively nonhierarchical structure, these young people come together to make a lot, make together, and celebrate what they make until what they make ends up on the floor. This hot mess is loud. It is messy. It is funny. It is random. And for adults, it can often be annoying.

But most young people in the studio, these types who tend to stick around, argued that the "hot mess" facilitates their creative practices. This finding is not surprising. After all, new practices and new ideas require doing things differently, asking odd questions, having strange answers, and gener-

ally showing a lack of concern for the way things are. Randomness can be useful to creativity because it can help people bypass rational and routine ways of thinking.

Indeed, I recognized the importance of introducing randomness and levity when I was the director of New Urban Arts. For example, I often took a pet ball of yarn for walks in the studio, waiting for "Yarny" to do imaginary bowel movements in different parts of the studio. I was also often asked by young people in the studio to do my rendition of the "fish flop," which was an intentionally bad and self-injuring gymnastic maneuver that entailed laying on my back, lifting my legs over my head in a pike position, and slamming the front of my body onto the studio floor. My irreverence was intended to model this behavior because I believe being irreverent, the willingness to tamper with norms in unpredictable and sometimes annoying ways, is key to creative risk-taking. Of course, I have the privilege of engaging in such risk-taking without my race or class location being judged.

Given the fact that schools are places that tend to value hierarchical organizational structures, convergence of thought, and predictable, manageable behavior, it is no surprise that young people desire a "hot mess" outside school where they can be random, irrational, and disrespectful of authority. And part of that desire is formed through the representation of youth of color in schools as people who need to learn to respect authority and be on task in order to get ahead as people who must "silence" themselves to "learn." So, paradoxically, the production of the hot mess at New Urban Arts conforms to degrading representations of young people of color from low-income backgrounds as "troubled." In other words, through creating a hot mess in the studio each afternoon, young people are reproducing the same behavior that is used against them as an explanation for why they need to be "transformed" through programs such as New Urban Arts.

But young people are not conforming to that demand at New Urban Arts. Their hot mess demonstrates a lack of respect for authority, from not filling out registration forms properly to screaming at Michael for assistance when assistance is not needed. Their hot mess demonstrates a lack of respect for other people's property, from destroying Bic pens for art's sake to doing sawdust snow angels on the floor. Their hot mess shows a lack of respect for the white Eurocentric canon when, for example, a group of young people make drawings that hang hams from Edgar Allan Poe trees, whatever that means. So, some people will inevitably interpret their "hot mess" as a mechanism through which young people of color from poor backgrounds reproduce their own subordinate class futures. From this perspective, young

people, particularly the Loudests, are simply failing to develop the skills and dispositions that they need to be upwardly mobile, including hard work, self-control, and respect for authority. They should learn, in other words, from the good creatives who have been fixed of their troubled ways, from the Silents, and perhaps the Wits.

The irony, then, is that as young people rework these degrading and dehumanizing representations as a way of healing the injuries they suffer at home, at school, at church, and on the streets, these cultural performances can be used against them. As Jillian Hernandez argued in her interpretation of the excessive aesthetic practices of queer women of color, such practices can incite violent backlash as much as undermine normative regimes.[22] In other words, such performances can inspire political and cultural backlash based on young people's excessive refusal to be respectable. Yet, at the same time, the excessiveness of the hot mess can be one way in which young people can pursue basic human aspirations such as pleasure, desire, recognition, and respect. These are the kinds of aspirations that young people might expect from an idealized conception of "family" or "home," which are precisely the terms that almost all young people who participate in New Urban Arts use to describe the place.

75

For young folks whose futures are far from guaranteed, whose social locations are constantly subjected to a barrage of attacks, the cultural politics of the hot mess can be key to forging bonds that sustain their lives and their political imaginaries. And this excessiveness of the hot mess, this seeking out of pleasure and possibility in defiance of white norms of respectability used as weapons against them, can become a useful cultural tool for youth activism in the gentrifying city.

3

CHILLAXING

Alicia developed big dreams for herself as an artist during high school while she participated in New Urban Arts. And she had the skills and the dedication to back up those dreams. She was one of the Silent ~~Van Goghs~~ in the studio, working quietly on the sidelines of the hot mess, producing work to be "gawked at in its pure awesomeness." She made the Sasquatch sitting on the forest floor, looking down, introspective. She said her creature was a "misunderstood gentle beast."

In the studio, Alicia painted great portraits of black girls. I read in one interview how she wrestled with questions of black girl identity in her artwork. In particular, she stated that she focuses on representing black love, innocence, and tenderness. That desire was easy to see in her work. For example, in one portrait that Alicia made at New Urban Arts, she represented a young, pensive black girl standing against a blank background. Her shoe is untied, and her trousers are ripped. Her arms hang at her side and she has a Band-Aid on her right hand (figure 3.1). She looks anxious. A thought cloud next to her reads, "Do I still have time to grow?"

———

Figure 3.1 "Do I still have time to grow?" Painting by Alicia, 2015. Permission New Urban Arts.

I asked Alicia what was going on in this painting, and she told me that she was quoting a Kanye West song. In the song "Streetlights," West portrayed himself riding in a taxi at night, looking at the streetlights as they pass by above him.

"Let me know," Kanye sings. "Do I still have time to grow?"[1]

Through her portrait, Alicia told me that she was asking herself the same question. Her options for life after school had not met her expectations. She did not know if she would gain acceptance to the art college of her dreams or receive the financing that she needed to attend it. She wondered whether she should have already established herself as an artist with a record of exhibiting in galleries, as an artist who sold artworks.

"Do I still have time to grow?" Alicia was asking herself. "Have the streetlights already passed me by?"

I saw several portraits by Alicia like this one, showing black girls sitting and standing, looking wistful and pensive, appearing vulnerable and longing. They stare into the middle distance seeking connection. Looking at these portraits, I see Alicia representing a range of feelings that black girls obviously experience. But whiteness as an entrenched relation of power is always at work attempting to deny this emotional register for black girls. Through its pathetic sense of itself, anti-blackness expects black girls to be compliant, enraged, or indifferent to pain because compliance obeys its power, rage illustrates a lack of self-restraint that legitimizes its white policing, and stoicism in the face of pain demands even harsher punishment. Whiteness thus restricts the emotional register of black girlhood in its symbolic interpretations to provide the justification it desires to assert its power and control. Through her portraits of black girl love, innocence, and tenderness, Alicia combats these racist and gendered representations of black girlhood by giving black girls the full emotional register that they already possess. In this painting, inspired by Kanye West lyrics, she represents the socially produced anxiety of whether she, as a black girl, has done enough, been productive enough, to not be left behind amid an uncertain future, amid a sense of time lost.

Alicia was not alone in using her artwork to reflect on her fear that she had not accomplished enough as a teenager. For example, when I observed the studio in 2012, I stumbled upon a series of self-addressed letters left behind by Laura. Laura, a white girl from a low-income background, was a senior in high school when she left these letters next to a manual typewriter on one of the worktables. Rhode Island's poet laureate, Rick Benjamin, who also helped support artist-mentors in the studio as they honed their pedagogic practice, had left typewriters in the studio as a way to prompt creative writing. Laura

used one typewriter to write ten versions of the same letter, and each letter appeared to be written in a moment of frenzy. Lines were askew, and letters were typed over one another. "Dear Laura," she wrote at the beginning of each self-addressed letter. "Live goddammit." Another letter continued, "This is my letter to myself. You've got to get back. You've got to get back to lief (that is: life) as you know it, life—not the passing of time. That's not what I was put in my stead for. I am an artist (strike THAT: Artist). This is where my letter begins: Live harder. You aren't happy, are you not complete?" In 2015, three years after she wrote these letters, I returned to Providence and interviewed Laura to ask her what she meant by them:

Tyler: So . . . live goddammit?

Laura: Live goddammit.

Tyler: What was that about?

Laura: It was my senior year and I felt like, "Oh well, I'm about to finish up this chapter in my life. I'm about to finish up childhood." So, I was, like, all right, I better put as much time and energy into making sure I have the best goddamn time of my life.

Tyler: The best time of your life?

Laura: It was very time-bound. . . . Live goddammit and the letters were about reinforcing this idea that, "Oh my God, I have limited time. I have limited resources. I have to do it now!" But now I'm trying to focus less on the time-boundedness of stuff. I used to have anxiety about, like, age. I used to have a lot of anxiety, sitting and thinking, "Okay, how many years do I have left before I'm thirty?"

Tyler: So, what was this time pressure about?

Laura: I don't know. It's just hard.

Tyler: What did you feel like you had to do with your limited time?

Laura: I don't know. I feel like, generally, for my entire life, I've sort of have had this, like, feeling that time is running out, like, I'm losing time . . . umm. . . . And sometimes at night, I do have to reassure myself like, "Oh I'm still young, I'm only twenty years old." That is such a weird thing for someone my age to be thinking about. I don't really know where it came from . . . but . . . um . . . but definitely time, it feels like a pre-

79

cious thing to me. That is why I've been trying to do more with my time lately.

Laura continued in the interview by saying that she had met so many artist-mentors through New Urban Arts who participated in the city's high-status underground punk scene. Laura was impressed with what they had accomplished so early on in life as musicians, punk rockers, and photographers. Laura thought that the window for young people from New Urban Arts to prove themselves, to make their mark as a part of this scene, was shorter given the fact that they were poor.

"I have to do it now," Laura said to me in an interview a few years after she finished high school. "I have to have the time of my life and make art that matters."

These examples show how two young people at New Urban Arts wrestled with what it means to be more productive with their time and their lives, what it means to transition from childhood to adulthood. Their perspectives illuminate a socially produced anxiety that appears to be manifesting itself through a *compression of youth*. That is to say, they appear to feel that they should have something to show for themselves as adults earlier in life. They are expecting the period of youth, often defined between the ages of fifteen and twenty-four, to end sooner. What interests me analytically about this youth compression is what it reveals about the sociohistoric formation that they have experienced as young people growing up in Providence and how this internalized temporality is entangled in the reproduction of social inequality.

These two young people identified several markers for a successful transition to adulthood, and these markers are associated with the creative. That is to say, they were experiencing a youth compression in relation to their emerging identities as aspiring artists and as aspiring members of Providence's high-status creative underground scene. Their aspirations were not what we normally associate with a normative transition to adulthood, such as getting good grades in school, graduating from high school and college, living on one's own, getting a secure job, and so on. For them, the markers of transitioning from childhood to adulthood include exhibiting in galleries, selling artwork, having the time of their lives, making art that matters, and getting into art school. They expected to show these accomplishments early in life to the point that Laura noticed how weird it was that she was awake at night wondering whether her window of opportunity was closing by the time she turned twenty.

These examples illustrate how two young people at New Urban Arts have learned to internalize this anticipated transformation from "troubled youth" into "creative youth." This compression produces an anxiety that is

represented in the blank stares of black girls looking out from paintings and the hurried lines typed across the page. As the Creative Capital foists precocious expectations on young people, to transform themselves as creatives, there is an obvious risk that young people internalize a sense of individual responsibility for these creative life outcomes rather than critiquing conditions that have demanded their "transformation" without providing economic opportunities or symbolic conditions that would make that "transformation" possible or sustainable. After all, Alicia wondered how she was going to go to art school without parents who could pay for it. This internalization of blame, this very recruitment of "troubled youth" as "creatives," can thus interfere with the formation of youth activists who challenge these uneven and unjust conditions of the gentrifying city.

The risk for youth arts and humanities programs such as New Urban Arts is that they become entangled in reproducing this social anxiety, this sense that young people should become more productive sooner as creatives. This problem is acute for creative youth development programs such as New Urban Arts because they are always being pressed to demonstrate "impact," to show that their participants are not being "left behind." For places such as New Urban Arts, gallery exhibitions, selling artwork, making art that matters, getting into art school, and even having the best time of life are all indicators of high-impact programs. In their quest for funding, programs must produce evidence that these outcomes are occurring, and they inevitably pass this pressure on to their students. In so doing, these programs become imbricated in summoning the kinds of creative citizen-subjects that the Creative Capital desires.

New Urban Arts is vulnerable to this entanglement because of the arts mentoring model that I established. Youth participants in the studio such as Alicia and Laura were partnered with artist-mentors from places such as Brown and the Rhode Island School of Design (RISD). Through their arts mentoring relationships, they become more aware of the cultural impact that has now become expected from creative youth in the city. Young people at New Urban Arts become more aware of the racial and class differences among creatives through these mentoring partnerships. After all, Brown University gave me a $4,000 fellowship to start New Urban Arts when I was twenty-one years old. Youth participants at New Urban Arts could do a lot of productive things for the city if they were given $4,000 to run projects as twenty-one-year-old creatives.

So, inevitably, the presence of Brown and RISD students as young creatives in the studio and in the city produces a social anxiety in their peer groups and across class lines, if not inflicting injury on young people in the city who learn that they will never have access to the same resources needed to give

81

them an equal chance as creatives (e.g., the tuition needed to go to art school). The production of this social anxiety becomes wrapped up in reapportioning blame on young people when they cannot meet the unrealistic, compressed, and socially produced expectations for young creatives in the city.

Given this creative youth compression and its related anxiety, I became quite interested in some young people at New Urban Arts who engaged in a cultural performance in the studio that challenged this temporality. Lewis, one of the Loudest Human Beings to Ever Exist, called this performance "chillaxing." I looked more deeply at this cultural performance in the studio precisely because I thought it might prove useful in complementing youth strategies to fight for creative youth justice in the gentrifying city. Youth activism must be aware of this social anxiety and its temporal conditions, and can work with them to oppose the reproduction of youth inequality through creativity.

"THAT QUIET TIME . . . WEARING BERETS AND DRINKING CAPPUCCINOS"

"Welcome to the Zen Zone!" Lewis said. Lewis, one of the Loudest Human Beings to Ever Exist, was giving a tour of the studio to the plebeians who had just signed up to participate in New Urban Arts. In his tour, he brought the newcomers to a corner in the front of the studio where there is a riser that separates the Zen Zone from the rest of the studio. On this riser, there was a couch, chairs, a coffee table, and a few plants. Youth poetry was also written on the glass storefront in acrylic paint. Lewis introduced the newcomers to this space:

> This is the Zen Zone. The Zen Zone is the place for you to do things when you don't feel like doing art. You can go in here and you can chillax, text your homies, your bromies, your chicas, or whatever it is that you kids do these days. Check your Facebooks. You can just, you know, mellow out. Sit on a bean bag. Talk. Conversate. Read books. [Lewis paused and then began speaking more slowly, drawing out his vowels.] The Zen Zone is more of that quiet time in the studiooo. It's cooool. You're wearin' berets and drinkin' cappuccinos.

The plebeians smiled and laughed. I did too. It was funny to listen to Lewis act as an authoritative adult, speaking to the "kids these days." Authority figures are not expected to give urban young people of color permission to chillax and text their homies, their bromies, and their chicas. That instruction would only conform to the representation of them as lazy, as members of the underclass who are not doing the work of lifting themselves up by their own bootstraps.

It was also funny to listen to Lewis represent New Urban Arts as if it were a Parisian café. Berets and cappuccinos, of course, invoke the Left Bank in

the 1950s and 1960s, where left-leaning philosophers had intellectual conversations at café tables on the sidewalk. Berets and cappuccinos thus signify highbrow intellectualism, cosmopolitanism, and relative affluence. His reference is comedic here because "troubled youth" are never represented as geniuses in their own right, as people who can profit in life by sitting around, thinking and talking on their terms. Indeed, two black men were arrested for simply sitting and waiting for a friend at a Philadelphia Starbucks in April 2018.[2]

Time for chillaxing at New Urban Arts was built into the relatively complex, and difficult to manage, temporal structure that I established for New Urban Arts in 1997. With New Urban Arts' first program director, Marcus Civin, we set the precedent that youth participants could join or leave the program at any time during the school year. They could also decide how frequently or infrequently they wanted to participate and for how long on any given day. At the same time, we guaranteed that artist-mentors would each be present two days per week for two hours at a time (3 to 5 p.m. or 5 to 7 p.m.). If youth participants wanted to partner with one artist-mentor in particular, then they would know in advance what day and time they should come to the studio. But artist-mentors would never know beforehand which youth participants would show up or when, which has always been incredibly challenging for most new artist-mentors to negotiate. Plus, a lot of youth participants come to the studio and choose not to work alongside artist-mentors. They work independently or with their peers.

In an interview with one former youth member, Theo described this temporal structure as "monochronic" and "polychronic." In reflecting on their experience (note gender-neutral pronoun), they said that the studio provides a linear program model in which young people can meet regularly with an artist-mentor throughout the year. In this sense, the studio was "monochronic," a bit like school. But the studio also provides a "polychronic" temporal structure in which young people can come and go as they wish, as well as participate on their terms. Those terms could include chillaxing in the Zen Zone, talking, conversating, and reading books while they text their homies, their bromies, and their chicas. As a result, there are always numerous events unfolding in the studio at the same time, and young people can choose among these events as they wish. Theo told me that studio is not a place that says to young people, "This is what it is and this is what everyone has to do at the same time."

Of course, Marcus and I did not invent this temporal structure through New Urban Arts. Its historical precedent is the "open classroom" education model from the 1960s, associated with, for example, educators such as Herbert Kohl.[3] But today, this flexible and dynamic temporal structure is more

likely to be found in elite private schools such as the MUSE School in Malibu Canyon, California, where students are expected to follow their passions and be nurtured into becoming "autonomous and innovative students."[4] Indeed, staff at New Urban Arts have noted to me that a flexible and exploratory program structure offered for free to children of the poor and young people of color can raise eyebrows concerning questions of rigor and impact. But if and when the same model is offered to children of the wealthy with high-price tuition fees, these staff suspected that those same people would not question its value. This disparity points to the social anxiety directed toward "troubled youth." Can "troubled youth" actually be "transformed" by sitting around and talking to one another without any adult intervention? Can "troubled youth" be autonomous and inventive by sitting around, reading books, and texting their homies and their chicas?

Young people chillaxed in the studio in a variety of ways and for a variety of reasons that mattered to them. For example, one young person, Leandra, established a ritual in the studio called "Tea Time." Leandra gathered other youth members and artist-mentors to chat and drink tea in the studio. During Tea Time, they discussed current events, ranging from the mass shooting at an elementary school in Newtown, Connecticut, to marriage equality. At New Urban Arts, engaging in these intellectual debates about public events affecting their lives, and creating their own forums for these discussions, emerged as a priority for their use of time in the studio.

Other youth described this chillaxing in more aimless and unpredictable terms. Theo told me that "some folks go to New Urban Arts with intentions and would get what they wanted done. I wasn't one of those. I would just show up, walk around to look for things to do, and then do whatever felt right." With this observation in mind, I reflected on the times that I spent as a participant observer in the studio, wandering around looking for things to do and activities to observe. One day, I kept bumping into Frankie, a youth member who seemed to be wandering around the studio as well. I stopped and asked him if he ever had the feeling of not knowing where to be or what to do in the studio. "Duh!" he said. "That's why I come here."

When I asked him what he meant by that, he said that he comes to the studio to experiment with new artistic forms and to meet people that he might otherwise never meet. Wandering around without a clear purpose, he said, allowed for that creative experimentation and improvisation.

Young people also told me that chillaxing at New Urban Arts was a deliberate response to their racist experiences of schooling. The reality was particularly true for students who attended the selective admissions college

preparatory school. Processes of social reproduction such as tracking were becoming visible to them within the school.[5] During an interview three years after she had left New Urban Arts, I asked Lunisol, the youth member who told me that "straight white men suck" on my first day back in the studio, to reflect on the importance of chillaxing in the studio. She said,

> I have talked to other people from New Urban Arts about this question of productivity. For us, it was about dealing with the traumas of confronting, for example, the racist attitude of a guidance counselor during the school day. We were being told, "You don't belong in that AP class." We would come over to the studio after school and we were shell-shocked. For me, it was like, "Nobody is going to ask me to do anything here now. I am just going to sit here and regroup." This is a means of survival, this being unproductive. I think it is good not to make sometimes. It's good to talk, and I think, talking sometimes at New Urban Arts, that was *enough* for me. Talking is just loving, and loving is beautiful.

For her, "not belonging" in that AP class thinly masks the racial and class prejudices at work determining what is being taught on different tracks and who belongs on what track. Derailing students of color from AP classes in a selective high school therefore institutionalizes racial inequality. In this injurious climate, talking becomes loving after school at New Urban Arts. I have read that line by Lunisol over and over to let it sink in because it is so difficult for practitioners in the youth arts and humanities field to appreciate that loving and talking *can be more than enough* precisely because we are expected to "transform" "troubled youth" during the limited time that we have with them each day. In other words, the field tends to already presume that talking and loving is never enough. That argument would never win in a grant application or a fundraising appeal. But I think it should in these bleak times.

When I heard Lunisol's perspective, I thought back to my time as director of New Urban Arts, when, almost daily, two girls sat by the window next to my office while I worked. I wrote grants and developed agendas for committee meetings while they sat there, looking back across the street at their school, staring at one another like two girls in Alicia's paintings, sitting there in silence, sometimes chatting, sometimes crying. They laughed too, sometimes while they were crying. We listened to Yo La Tengo playing from my computer speakers. We sat together but were apart. When an art exhibition deadline approached in the studio, the two of them would disappear from their perch near my office and embark on a short but intense period of art making, which always culminated in several strong contributions to each exhibition.

I never asked them to do anything other than that because those tender moments by my office seemed too important to them, whatever it was that they were doing, chillaxing every afternoon at New Urban Arts. I never even asked them what they were up to. I feared that asking them would raise doubts in their minds about whether I thought what they were doing was a legitimate use of their time, perhaps thwarting these moments of self-care. I kept to myself and continued to reflect on what it meant to be productive at New Urban Arts and what it meant for me, as a white person, to question whether they were being productive enough with their time in the studio. Years later, after hearing Lunisol's explanation of talking as loving and loving as beautiful, I thought of them. I called one up and asked why they sat by my office, doing nothing as if their nothing was enough. She mentioned the same experience of being excluded from an AP class by the school guidance counselor.

So chillaxing is healing from race and class traumas for young people of color, particularly young women of color and queer youth. The toxicity and trauma of social institutions for them, their everyday interactions that can quickly turn painful and/or violent, and the constant barrage of dehumanizing representations of their identities means that healing is a political strategy of recuperation, of preserving life that is always under threat and preserving life that is not deemed life.[6] But chillaxing is always already political for young people of New Urban Arts through their social position. I am never questioned when I chillax due to my whiteness and my maleness.[7] My race is never on trial when I simply sit in a café and wait for a friend; I am never going to be arrested for doing that.

Lunisol was also aware of how chillaxing was a struggle for some in the studio as they combatted internalized representations of themselves as, for example, lazy and worthless. During our interview, we discussed her repost of a quote by the African American actress Golden Brooks on her Facebook page, in which Brooks said, "Black people have been taught this idea that they have to constantly constantly constantly prove their worth and if there is a space of time where a significant amount of 'productivity' has not been made then we have fallen completely back into the realm of nothingness—valuelessness. It's policing ourselves so harshly and it's created out of internalized racism."[8]

In referencing Brooks's discussion of productivity and internalized racism, W. E. B. Du Bois's notion of a "double consciousness" becomes useful for understanding Lunisol's theorization of chillaxing.[9] Du Bois described the psychological conflict for African Americans as they look at themselves

86

through the lens of a white nation that holds them in contempt, unworthy of dignity and of life. From this perspective, chillaxing operates as a contradictory site for Lunisol. On the one hand, chillaxing is *enough* of a practice for her to recover from racist traumas. On the other hand, it is a practice where she has struggled with internalized racism because she was not being productive *enough*. Chillaxing then has two faces for Lunisol.

The need for young people of color to rest and to recuperate after yet another shell-shocked day at school can even be understood as a tax on them. In other words, while more affluent and white young people, for example, can use the after-school hours to enrich themselves further, poor young people of color at New Urban Arts sometimes need to use the after-school time and space as a means to sit and recuperate. They need to do nothing because doing nothing is doing everything that they need in that moment. But the time that young people of color must spend recuperating in the studio is time that they are not spending fighting to get ahead or struggling for justice. Chillaxing is thus a contradiction that is painful to acknowledge: It can both sustain *and* cost young people at New Urban Arts.

TRANSFORMING "TROUBLED YOUTH" IS A MATTER OF TIME

Programs such as New Urban Arts are under pressure to prove that they use time effectively to transform "troubled youth," that young people in creative youth development programs are doing something far more productive than chillaxing. Indeed, time has been key to the formation of the youth development sector, which includes arts and humanities programs such as New Urban Arts. In 1992, five years before I started New Urban Arts, the Carnegie Council on Adolescent Development issued a report titled "A Matter of Time."[10] The title of the report, "A Matter of Time," has a double meaning. On one level, the title was used to suggest the urgency of addressing challenges facing American youth at that historical moment. On another level, the title was used to suggest a correlative relationship, if not a causal one, between how young people spend their time at different times of day and the outcomes that they should expect in adulthood. Specifically, "A Matter of Time" warned against dangers facing low-income adolescents during the nonschool hours, particularly during the after-school period and particularly in cities. When this report was written, the dangers facing youth during the after-school hours were understood within the context of the AIDS and crack epidemics, which had become prominent social and health problems in 1980s cities. At that historical moment, "A Matter of Time" had a rather deprived view of youth as they confronted these dangers:

Lacking a vision of a productive adulthood and constructive activities to engage them during nonschool hours, [adolescents] veer into another course of development. Some injure their health by using tobacco, alcohol, and other drugs. Some engage in premature, unprotected sexual activity, which the presence of AIDS now renders deadly. Some commit acts of crime or live in neighborhoods where fear of violence pervades their daily lives. Although all adolescents face at least some of these hazards, those who live in urban and rural poverty areas face a higher level of risk. They are likely to have a lower level of personal and social support than their counterparts from more affluent families.[11]

This problematic characterization reproduces the logic of "troubled youth" as youth who lack personal and social support because their cultures are deprived. This representation ignores the fact, for example, that American teenagers from every social station have sex but face different risks because they have differential access to birth control and reproductive medicine. But this representation presumes that poor urban youth are "troubled," are inferior, for having sex too soon. The soundness of the argument, however, is not really the point. The argument is designed to produce social anxieties about the present and the future through pathologizing youth, which mobilizes support for policies and practices that are designed to regulate and police their behavior as much as support them, and demonstrates to publics that something indeed is being done about, for example, an urban crisis marked by HIV/AIDS and crime.

This moral panic about "troubled youth" became the primary justification for philanthropy to expand support for community-based programs that turned the unsupervised after-school period from one of risk into one of opportunity for youth. This report highly influenced the expansion of youth programs in the United States during the 1990s. If the report had not been published in 1992, I likely would neither have conceived of New Urban Arts nor received support in 1997 to launch it. And since New Urban Arts' inception in 1997, the state has exerted increased influence over youth programs. Moreover, these programs have had to turn to the state for financial support because their students cannot pay tuition. As a result, the state has been able to exercise greater control over expectations for how young people in cities should spend their time during the after-school hours.

In 2003, more than a decade after "A Matter of Time," Providence mayor David Cicilline held a press conference at New Urban Arts to announce the launch of a private/public partnership, the Providence After School Alliance (PASA). This partnership was launched to support and improve after-school

programs for youth in the city. The new mayor needed to make his mark on education. But public schooling did not provide a viable site for him to do so because of the encroachment of federal and state education policy, and, some would suggest, the intransigence of the local teachers union. So the after-school space provided a convenient and largely unregulated forum for him to make an impact on youth. The added rationale for intervening in the after-school sector was because, at least as the story was often explained to me when I was the director of New Urban Arts, Cicilline had inherited a highly corrupt and ineffective Parks and Recreation department from the previous mayor, Buddy Cianci. So he created a public/private initiative both to reform and to work around this department that needed to do a better job serving youth in the city.

The fact that Cicilline chose New Urban Arts to announce his new youth initiative was therefore symbolic. The mayor could use New Urban Arts as a setting to suggest what he meant by high-quality youth programs in the city. The possibility that the organization might receive more public attention and support meant that we welcomed the mayor into the studio to hold his press conference. But the city did not invest much in terms of financial resources into the program. Instead, Cicilline created a new initiative that competed with programs such as New Urban Arts for philanthropic funding, as well as introduced evaluative tools that were then used to evaluate the quality of programs such as New Urban Arts. The Wallace Foundation provided funding nationally for cities to build these citywide after-school systems overseen by new public/private partnerships, which, unlike public school systems, are not accountable to taxpayers and voters.

In a policy brief shared with youth organizations, Cicilline's new initiative, PASA, and a new partner organization, the Rhode Island After School Plus Alliance, argued that after-school programs in the city could no longer "babysit" children in the city but rather needed to become enriching holistic programs with their own goals and objectives.[12] To promote holistic youth enrichment in programs across the city, PASA introduced a standards-based auditing tool to measure the quality of after-school programs in the city.[13] Soon afterward, funders of after-school programs in Providence, such as the United Way, began to require youth programs that received funding to be evaluated with this tool.

The PASA standards-based auditing tool for adolescent programs makes specific assumptions about what is desirable with respect to staff and young people's usage of time. In other words, the tool holds certain beliefs about what should be considered "constructive activities" for "troubled youth" so that they can develop a vision for "productive adulthood." According to the tool, high-quality after-school programs are those in which

89

- staff start and end session within ten minutes of scheduled time;[14]
- staff have all materials and supplies ready to begin all activities (e.g., materials are gathered, set up);[15]
- staff explain all activities clearly (e.g., youth appear to understand directions; sequence of events and purpose are clear);[16]
- there is an appropriate amount of time for all of the activities (e.g., youth do not appear rushed, frustrated, bored, or distracted; most youth finish activities);[17] and
- the program activities lead (or will lead in future sessions) to tangible products or performances that reflect ideas or designs of youth.[18]

On one level, these indicators appear harmless. They reflect a fairly traditional approach to after-school programs in which adults design, structure, and direct activities for youth. Young people engage in an arc of performance from design to execution, follow the directions of staff who provide clear instructions, begin and end their activities within an appropriate amount of time, and produce tangible products and performances that reflect their ideas. It reflects a generally accepted understanding of what makes a good classroom.

But these indicators clearly do not value the more complex "monochronic" and "polychronic" structure of New Urban Arts, which allows youth to chillax after school because they have good reasons to do so (e.g., a troubling guidance counselor, the Newtown school shooting, the need to discuss marriage equality, etc.). Moreover, through troublemaking, Gabriela pointed to the problem that she has with the expectation that poor youth of color always need to be "on task, following directions." So, for Gabriela, young people should always be troubling the ways in which authority figures, including funding bodies, expect them to be on task at a particular time based on the assumption that they have not acquired the cultural resources needed to succeed, to not be left behind. And through the hot mess, young people were interested in the unpredictability and randomness—the excessiveness of New Urban Arts—to strengthen social bonds and to sustain their work in troubling their social identities. These crucial aspects of young people's cultural production at New Urban Arts is at odds with these temporal indicators of quality.

These tensions reflect the underlying problem of after-school program reform. These reforms are rooted in individualized assumptions about the social problems facing youth. They assume and expect that "high-quality" programs should affect youth by teaching them the skills and dispositions they need to have a successful and productive adulthood at the precise moment that the opportunity for young people to succeed and to be productive in a traditional

economic sense does not await them. These reforms invisibilize the systemic problems of, for example, rising student debt and declining wages that lie on their horizons. These are problems that youth programs cannot solve no matter how "high-quality" they are, and the belief that "quality" is the solution for them distracts from those more complex structural economic issues. Moreover, these standards ignore the need for "unproductive" self-care that young people require after another traumatizing day at school due to, for example, racist interactions with certain staff or the denial of access to AP courses.

It should come as no surprise then that program staff at New Urban Arts have struggled to reconcile the demands for productivity by the state and the demands for autonomy and experimentation of youth. Indeed, staff members asked me when I began this research project if I could produce evidence that would demonstrate New Urban Arts' impact and prove its program quality so that the organization could push back against what one called "Big Brother." Her use of the Orwellian term "Big Brother" suggests the ways in which staff at New Urban Arts feel they are under surveillance from the state. Indeed, a program consultant who reported to one of New Urban Arts' funders told me that PASA's quality-standards assessment tool was ineffective in evaluating New Urban Arts. It could not produce any data because the tool was not designed to capture what was actually taking place in the studio, shaped by its monochronic and polychronic structure. After her site visit, some staff were concerned that the failure of this tool to demonstrate the program's impact would threaten future funding. As a result, staff felt pressured to make the program conform to these imposed quality standards.

Staff members at New Urban Arts are not alone in experiencing these tensions and pressures. In her educational research on youth centers, Jennifer Teitle has shown how program staff have reorganized their youth programs in response to the pressure for demonstrable results—from decisions concerning keeping old furniture that might interfere with funders' expectations for a clean, safe learning environment to staff who pressure young people to comply with new externally imposed expectations for what "troubled youth" should be doing to appear productive.[19] Her research shows how auditing tools in the after-school sector can reshape programs in the tool's own image, as staff and youth are constantly revising their programs to be assessed by auditing tools in this quest for philanthropic approval. Teitle argued that this "audit culture coerces the transformation of autonomous organizations into auditable communities."[20] In her analysis, Teitle draws on Foucault's panoptic theory of governance to claim that youth programs are regulating youth behaviors in ways that conform to the desired and distantly managed expec-

tations of the state.[21] This finding resonates with Soo Ah Kwon's notion of "affirmative governmentality," in which she has observed and theorized the ways in which the state regulates youth activism programs, and the behavior of youth of color, in order to mitigate the oppositional force of their political activism.[22] In this research, it is clear that chillaxing does not conform to the private/public construction of quality.

The panoptic power of audit culture in youth programs presents risks to New Urban Arts. One risk is that young people who need and want "monochronic" and "polychronic" temporal structures may find that they lose aspects of New Urban Arts they want most. Indeed, two youth members, Lewis and Dania, for example, told me in interviews why they started to come to the studio much less frequently in 2013. They were both key figures in the studio, active leaders in every facet of the organization—recruiting youth members, giving studio tours, meeting with donors, interviewing and selecting artist-mentors, and exhibiting and performing artwork. They were also youth members who identified as queer and had been kicked out of other youth programs in the city for being disruptive. I reached out to interview Dania because I noticed that she had stopped coming to the program. During the interview, she told me that she stopped coming because, she said, New Urban Arts was becoming "too rulezie." She said that she was being made to feel guilty for not working with artist-mentors on art projects. She said that the space was becoming less open to "laying on the floor and staring into space or screaming unusually."

The other youth member, Lewis, said that he was being asked to give tours to potential donors. He said that he felt like a "show puppet" during these tours because he felt compelled to hide the weirdness of New Urban Arts' studio from these donors. He said that it was vital that New Urban Arts remains a "weird space." If it cannot show off its weirdness, Lewis said, then it does not deserve funding anyway. There was also some evidence that young people in the studio were starting to police other youth members' productivity. I heard some rumblings from youth members that newcomers had to earn the right to hang out and be silly in the studio. That is, they had to put in the time and the work, to prove themselves as artists, before earning the right to participate in the hot mess or chillax. These examples show that young people's creative practices can be reshaped by the state through subtle and self-regulating ways, and that this result may have disproportionately negative effects on youth who struggle most to find social institutions where they fit in, where they are not "silenced" as they "scream unusually."

A second risk from audit culture is that the storefront studio becomes a site where young people begin to internalize the far too simple—and, Lu-

nisol and Gabriela might argue, racist and classist—view that if only they worked harder and followed the clearly provided directions from adults better during and after the school day, then they should expect to transition from "troubled youth" into "productive adulthood." This simplistic view only recapitulates the theory of the underclass—that is, if they learn respectable styles and comportments determined by the state, including a temporality of productivity and achievement, then they will be deemed human, they will be deemed to have rights to life and profitability. The second half of this book shows that the cultural political economy of Providence does not provide any evidence to support that claim.

So protecting the qualities that so many young people at New Urban Arts desire requires thinking about productivity in ways that are not measurable and assured by categories of audit, as Teitle argues,[23] but those that awaken possibilities for life that are not tidy and predictable but messy and expansive. Productivity for young people at New Urban Arts may mean talking that is loving and loving that is living because talking and loving are beautiful. It may mean lying on the floor and staring into space and screaming unusually. It may mean reading books and texting homies and chicas while acting like they are wearing berets and drinking cappuccinos. Yes, chillaxing is contradictory because it reproduces their position as members of an underclass as much as it refuses the "constructive activities" that are intended for them. But, as Lunisol might put it, chillaxing is *at least enough for now*. This approach to "productivity" refuses the notion that young people at New Urban Arts need to be "on task" or "following directions" in order to get ahead. In other words, this approach to productivity refuses the proposed fix for young people based on their subjectification as members of an underclass under the rubric of "high-quality" youth development programs.

Ruth Nicole Brown, a key thinker in black girlhood studies, provides a good example of a leader in youth programming whose creative pedagogy refuses this logic of youth development. Brown celebrates black girl genius through her youth programs. She refutes the notion that black girls are people who need to be redeemed and resurrected, solved and fixed—in short, individually "developed" based on a normative, racist, classist, and sexist conception of what development means or why it should happen.[24] Instead, Brown describes her social justice program for black girls, Saving Our Lives, Hearing Our Truths (SOLHOT), in ambiguous terms. To Brown, SOLHOT is "a collective workplay across black girl differences that make places out of our dreamworlds so we can be free, together, and unfree from those who we want holding us into forever."[25] As I read her books on SOLHOT, I was struck by how Brown

93

does not offer a description of when SOLHOT meets, where it meets, how many people meet, or what its young girls do there.[26] That is to say, as Brown represents SOLHOT, she unravels SOLHOT. She has refused to allow her program to be pinned up against a wall as a thing, thus making it harder to audit. By shielding SOLHOT from audit through ambiguity, and through celebrating black girl genius as feminist fugitivity, Brown is producing a "collective work-play" that allows black girls, black femmes, and black gender-nonconforming participants to be in pedagogic and political flight, together. The focus is on making places where they can be free, together, and unfree from those they want holding them into forever—not "developing" black girls based on a normative trajectory of black girlhood constructed by white patriarchy.

When young people sit in the window of New Urban Arts, caring for one another while listening to Yo La Tengo, reflecting on how they are going to negotiate and escape from the racism of their school guidance counselor, I see them engaged in similar collective workplay. In chillaxing, I see the politics of freedom and the politics of refusal that I read in Brown's work with SOLHOT. This refusal also resonates with Stefano Harney and Fred Moten's proposed method of pedagogic resistance in what they call the "undercommons."[27] Informed by the black radical tradition, Harney and Moten theorized spaces for learning where marginalized people come together to establish an independent settlement, a marooned space for learning, as it were, that resists surveillance and steals back a sense of productive time that cannot be calibrated and measured. Moten refers to the kind of activities that he anticipates in the undercommons as "study":

> When I think about the way we use the term "study," I think we are committed to the idea that study is what you do with other people. It's talking and walking around with other people, working, dancing, suffering, some irreducible convergence of all three, held under the name of speculative practice. The notion of a rehearsal—being in a kind of workshop, playing in a band, in a jam session, or old men sitting on a porch, or people working together in a factory—there are these various modes of activity. The point of calling it "study" is to mark that the incessant and irreversible intellectuality of these activities is already present. These activities aren't ennobled by the fact that we now say, "oh, if you did these things in a certain way, you could be said to be have been studying." To do these things is to be involved in a kind of common intellectual practice.[28]

Indeed, young people at New Urban Arts were often their best selves in the studio when they engaged in these everyday activities that do not need to be

ennobled or reduced through the self-regulating practice of audit. In the studio, there is a common intellectual practice that is always already present. Lewis already sees that intellectuality of New Urban Arts when he says that young people can sit in the studio and wear berets and drink cappuccinos—which are white markers of intellectuality and leisure. Their intellectuality, however, is hard to see and impossible to measure because it does not look like anything but "being in a kind of workshop, playing in a band, in a jam session." Sometimes, often the best times, New Urban Arts does not look like anything but some young people sitting on a porch and other young people working together in a factory.

The problem, from my point of view, is the failure of people on the outside looking in, often white adults such as myself, to recognize this incessant and irreversible intellectuality precisely because we often cannot see past the social location of these youth as "troubled youth." We cannot see their talking as intellectual. We cannot see these youth as daydreamers and time travelers. And that is why our tools that we design to audit quality in youth development programs cannot produce data when young people are chillaxing in the studio, doing the talking and the loving, the sitting and the staring, the laughing and the crying. When I look back on my own record as the founding director of New Urban Arts, who played a key role in shaping the pedagogic conditions of the storefront studio, including its temporal structure, I am confident that I did play a positive and productive role in creating "monochronic" and "polychronic" conditions where young people can be productive on their terms, where they can "study" and "chillax."

My fieldwork for this project taught me that young people in the studio are indeed developing and theorizing creative cultural practices that they might sustain throughout their lives. These cultural practices that I have presented in this book challenge and exceed their subjectification as "troubled youth" as much as they conform to it. Supporting young people as they developed these creative practices was my aim when I started New Urban Arts. Due to the efforts of so many, I think it is safe to say, now more than two decades after its founding, that that aim is being achieved.

But I get only so much satisfaction from that finding after I analyze my role at New Urban Arts in relation to the cultural political economy of the Creative Capital in the next three chapters. With that in mind, I will demonstrate in the conclusion of this book how these three cultural practices developed in the storefront studio of New Urban Arts can buttress youth activism to resist gentrifying cities.

95

4

WHY THE CREATIVE UNDERCLASS DOESN'T GET CREATIVE-CLASS JOBS

In the second half of this book, I turn to the ways in which my leadership has played a contradictory role for youth within the particular historical context of the Creative Capital. My contradictory leadership manifested in part through the pedagogic model that I initially developed at New Urban Arts, which is called "arts mentoring." In this chapter, I show how arts mentoring is very much intertwined with the Creative Capital's desire to transform "troubled youth" into "creative youth" in ways that produced contradictory effects for young people themselves. Understanding these contradictions requires analyzing the pedagogic model I established for New Urban Arts amid the cultural and economic conditions of Providence. Those conditions, as I have argued, place competing demands on programs such as New Urban Arts, its leaders, and the youth themselves. Acknowledging my own contradictions is useful in working toward creative youth justice in gentrifying cities. Through an analysis of my own entanglements in the cultural political economy of Providence, we can arrive at a deeper understanding of how and why the cul-

tural practices developed by youth at New Urban Arts can and must contribute to that activist project.

Each year, youth participants of New Urban Arts lead the selection process for new artist-mentors. Dozens of people apply to become artist-mentors by submitting a written application and participating in a group interview with youth participants. The participants that conduct the interviews tend to be individuals who have participated in the program for several years. After the interviews, these young people select their corps of artist-mentors for the year. This youth engagement in staff hiring at New Urban Arts is often recognized as a marker of its quality in the creative youth development sector, and it illustrates the nonhierarchical nature of New Urban Arts that is so cherished by its youth participants.

In the first interview that I attended as a researcher in 2012, the applicant for the artist-mentor position was clearly a member of the high-status creative underground scene of Providence. Her head was shaved on both sides with long dyed hair on top. She was white and had a septum ring, wore tight black jeans, had several tattoos, and carried a messenger bag. Each high school student on the committee took turns asking her questions about why she wanted to become an artist-mentor. One youth member asked her how she learned about New Urban Arts, and another youth member asked her how she handles chaos and messiness. The conversation started to turn when Laura, the youth member who wrote the letters to herself stating that she needed to "live goddammit," asked everyone at the table to name their favorite word for a disease. Laura offered "lupus" as an example.

Everyone laughed and proceeded to name their favorite word. I contributed to the conversation with "impetigo," which, incidentally, is not a disease but a bacterial infection that I used to get as a kid.

When it was her turn, the applicant said, "Rabies, because of all the nasty toxins."

"So," Laura then said to the applicant in a deadly serious tone as the group laughter ended abruptly. "What we really want to know is . . ."

Laura paused.

"What are your DIY ethics? How punk rock are you?"

Everyone at the table started to giggle while trying to maintain their composure because, after all, this was an official job interview.

"I'm pretty punk," the candidate replied without missing a beat. "Somebody told me that this was going to be a question. So I had time to think about it."

"Oh, you know an insider!" another youth member on the interview panel said.

"Yeah, an insider!" she replied before continuing to describe herself. "All the stuff that I do is very much 'Do It Yourself.' I never say no to anything. I've learned to make basically everything by hand. I make my own paper. I print my own stuff. I learned to build bikes. I design my own clothes. Even though I love to draw and that's where it comes out most often, there's no holds barred with anything else. I really like to use my hands."

The committee of youth participants smiled and nodded in approval.

Providence could legitimately brand itself the Creative Capital in 2009 because of young people such as this applicant. These young artists in the city had established a thriving underground scene in Providence for more than a decade. This applicant had all the markers of this scene. She made her own clothes. She built bikes. She printed her own stuff. She had a punk style, from her messenger bag to her septum ring. This scene came into prominence in Providence in the 1990s when I was an undergraduate at Brown University. At the time, the Fort Thunder artist collective, started by Rhode Island School of Design (RISD) graduates, established a local noise music and printmaking scene that attracted international notoriety. People who now participate in this scene in Providence have high status in the city, and they have historically tended to be graduates of RISD or Brown. That is to say, this scene tends to feature white youth from relatively class-privileged backgrounds who have overtly rejected the norms associated with their upbringings. This rejection occurs through conscious and overt cultural performances, such as dressing down, living in undeveloped industrial loft spaces, making art and music, and not choosing traditional career pathways that are normally enabled by their college degrees.

This interview illustrates how some young people from New Urban Arts have already learned to perform the talk that is required to participate in this high-status group in the city, whether it is an ironic discussion of names for a disease or how DIY and punk rock one is. This example shows how New Urban Arts can be a place where some young people develop access to cultural resources that are needed to participate in this scene. They learn to participate in this scene and be at ease with it—as evidenced by their line of questioning and their laughter—even though they lack the educational credentials and racial and class privileges that are historically associated with young people who have participated in this scene. In other words, New Urban Arts can be a place for some youth to be "transformed" from "troubled youth" into

the "creative youth" that are associated with Providence's image as the Creative Capital.

However, I suspect this transformation is not the one that is normally envisaged in the field of creative youth development. Transformation through creativity is more likely interpreted as a pathway to upward class mobility, defined in terms of access to four-year colleges and better-paying jobs. This brief example shows how this "transformation" can also mean learning to be at ease in a cultural scene that has been coded as high, white, and affluent—even if the material conditions of that scene are not entirely dissimilar from living in poverty.

In 2015, I conducted several interviews to ask young people if they participated in this scene and how New Urban Arts prepared them for it, if at all. I interviewed Lunisol four years after she graduated from high school, and four years after she stopped participating in New Urban Arts. Lunisol was the youth participant who, on my first day back in the studio at New Urban Arts as a researcher in 2012, questioned my project and expressed her doubts about my position as the founder and as a straight cis-gendered white man. Lunisol's parents emigrated from the Dominican Republic. She attended the selective admissions college preparatory high school in Providence and understood New Urban Arts as a place to heal the racial and class injuries that she endured at school through talking and loving. She was also the first member of her family to go to college. At the time of our interview, she was about to graduate from an elite art college and had accepted an offer from another art institution to pursue her master of fine arts. Throughout her postsecondary educational career, Lunisol, like dozens of alumni of New Urban Arts, posted requests on social media sites asking people to donate money for her food, rent, and school supplies, revealing the material difficulty of attempting to move up the class ladder. Given these economic challenges, Lunisol's educational trajectory is an example of precisely the kind of impact that is so often desired from programs such as New Urban Arts.

During our interview, Lunisol looked back on her time at New Urban Arts with some ambivalence. She was thankful for her experiences at New Urban Arts. But she also questioned her relationships with artist-mentors in the studio, people who were being credited by the city, as the city's cultural urban renewal plan put it, with driving "redevelopment in neighborhoods and city streets," breathing "life into our aging industrial infrastructure," and serving as "catalysts for civic engagement."[1]

As Lunisol looked back on her relationships with these artist-mentors

four years after graduating from high school, she described to me how she idolized them at first. She said,

> I wanted to be part of that. I'm thinking that I'm going to, like, live broke [laughing]. I'm going to live broke in a loft in some sort of space and I'm not going to have a real job because I want to stick it to the man. I'm going to go to all of these urban punk shows where everyone is beating each other up, and everyone is drunk and high because it's so cute. I'm going to make this space where we all love each other, and everything's great, even though there is no heating in our abandoned warehouse, and we are all dying of frostbite in the winter.

In this difficult passage, Lunisol referenced several additional markers of the creative underground scene in Providence. These creatives live as collectives in underutilized factory buildings. They choose not to have "real" jobs. They put on punk shows in these once abandoned industrial spaces. Here, according to Lunisol, they make a space where everyone loves one another, which includes, according to her, "beating each other up." While these creatives in Providence's underground may not get real jobs, they earn cultural status in the city through adopting these markers of creativity. And Lunisol had learned to want to be part of this high-status scene. Moreover, New Urban Arts had clearly become a place for her where she had learned what it would take to participate in this underground and achieve this cultural status. But she also recognized that this new citizen-subject made available for her to "choose" through New Urban Arts, through growing up in the Creative Capital, entailed living "broke."

Other alumni had far more positive viewpoints on this scene and their roles in it. In 2015, I also interviewed Laura, who had asked the applicant her favorite word for a disease and how DIY punk she was. Laura identified as white and poor. When I asked Laura what the Creative Capital meant to her during our interview in 2015, she said that, during high school, she would hang out both in New Urban Arts' studio and on Thayer Street, a commercial district in the affluent, predominantly white neighborhood of Providence that tends to appeal to students from the nearby campuses of Brown and RISD, as well as teenagers living in the city. Laura said that hanging out on Thayer Street was "so cool" because "you're seeing gender-nonconforming people, people with cool haircuts, happy kids, sad kids, and angsty kids that you can relate to." These types were similar to those who stuck around in the "weird space" of New Urban Arts, and some of those types were artist-mentors from Brown and RISD. Laura also said that whenever she tells people that she is an

artist living in Providence, she is then often asked whether she went to RISD. Laura told me that she has had nothing to do with RISD and considers the institution "pretty fucking classist" because it offers "essentially no financial aid whatsoever." By contrast, she said that she admired New Urban Arts because it made her feel like she could be part of the Creative Capital even though she never had a chance of attending RISD because of her family's financial situation. Through arts mentoring, the studio provided Laura with access to the social and cultural capital that was necessary for her to participate in this underground scene even if she lacked the economic capital required to go to RISD.

At the same time, Laura acknowledged that this underground scene in Providence was encoded as a white scene. As a result, Laura reported to me that it was perhaps natural for her to assume that she should have access to this scene because she was white. But she said that she appreciated that there were other youth members from New Urban Arts "who were just so drastically different from me who were feeling those same things. In retrospect, I think that is really cool." Laura was referring to young people of color from the studio, such as Lunisol, who felt they could become part of Providence's creative scene.

Theo, another former youth participant of New Urban Arts, offered a similar interpretation of their experiences (note gender-neutral pronoun) in Providence and New Urban Arts. In 2015, I interviewed Theo, a Latinx gender-nonconforming individual a few years after they graduated from high school to ask what the Creative Capital meant to them. Theo said that their understanding of the Creative Capital was that this new vision for the city privileged affluent and white people on the East Side where Brown and RISD are located. They said, "[The Creative Capital] is for Brown and RISD students who move to Providence as students and then try to stick around and make it as artists in the city. The city is supposed to provide them access to cheap rent so they can make art. It's for the East Siders and it's very divisive."

Here, "East Siders" could signify Brown and RISD students. It could also signal the affluent residents who live in the neighborhood where those two institutions are located. These residents, who are much more likely to be affluent and white, are also more likely to attend Providence's museums and theaters, which Theo called the "bougie art scene" later in the interview.

Theo said that they did not think of this bougie art scene when they thought of the Creative Capital. They said that Providence is the Creative Capital because of its creative underground scene, which, they argued, is populated with "real artists," including both artist-mentors and youth alumni

from New Urban Arts. Theo described the creative underground as "really rad," "the most amazing artsy experience ever," and "beautiful and really wonderful to experience." Theo participated in this scene and described their enjoyment in attending punk shows in "old factories that are now someone's house." By contrasting the "bougie art scene" of Providence and this "real" underground, Theo showed their contempt for what they saw as the vulgar materialism and tasteless preferences of the "East Siders."

Theo also noted that "most people do not have access" to the "really rad" underground in Providence. But Theo said that they gained access to these spaces through relationships with artist-mentors at New Urban Arts. Like Lunisol and Laura, Theo learned from these "real" artists about upcoming events in old factory buildings. While Laura argued that this underground scene was white, Theo had a different perspective. They said that this creative underground was beautiful because it featured a lot of young people of color. This scene, according to them, was "not very white." Theo felt part of the scene as a young person of color. At the same time, Theo's perspective also supports Laura's claim that there were people in the studio "so drastically different" from her that were "feeling those same things." In other words, young people of color such as Theo were able to access this underground scene, and feel they could be a part of it, through their participation in New Urban Arts.

From Theo's perspective, young people of color who participated in this high-status cultural scene, which Laura thought was coded white, were not betraying their racial identities by, for example, acting in a way that might be coded as white and therefore inauthentic. Instead, they were transforming the scene through their very presence and participation. Theo contrasted this Providence underground with the one that they encountered in Boston as a college student, which they described as a "white hipster scene." Theo wondered if the main difference between these two scenes in Providence and Boston was New Urban Arts, a place that provided young people of color with access to relationships with artist-mentors. In the process, these young people participated in a creative underground that affirmed their existence as white youth, young people of color, gender-nonconforming youth, angsty kids, happy kids, sad kids, and so on. Theo and Laura went further, and both argued that young people from New Urban Arts have played a role in *transforming* this scene so that was is not simply a "white hipster" scene. The creative scene now recognized and reflected their presence and their identities through their transformational work.

Theo noted that they felt part of this dynamic scene because its punk music was politicized. Its musicians, Theo said, were "very vocal about their

politics and really radical and really affirming of my identity and my existence in a way that other spaces weren't." For example, Theo mentioned Downtown Boys, a punk band, which was becoming well established in Providence as I was interviewing young people about the Creative Capital. Named by *Rolling Stone* magazine as America's most exciting punk band,[2] Downtown Boys sings about economic justice, the prison industrial complex, racism, queer justice, and so forth. Its frontwoman, Victoria Ruiz, foregrounds her Chicana identity in the band's music.[3] A few of the band members, both current members and past ones, have been involved in New Urban Arts as artist-mentors.

From these three youth perspectives, one can then begin to see how some young people at New Urban Arts are actually transformed as "troubled youth." These young people are troubling representations of themselves as members of an underclass, representations that might presume that they lack the social, cultural, and even economic capital to participate in this high-status creative underground scene because they are not white or did not go to Brown or RISD. Relationships with artist-mentors formed through New Urban Arts become a conduit for gaining this social and cultural capital. These relationships with artist-mentors teach some of them how to talk the talk and look the look of this high-status group of creatives in Providence. Moreover, artist-mentors support young people and affirm their identities in the studio as they become "very vocal about their politics," which is evident in artwork produced through their support and guidance, such as Thomas's poem "Native Tongue" or Gabriela's headless sculpture. For some young people, then, New Urban Arts had played a role in cultivating the embodied "habitus" that is necessary for them to participate in and belong to this high-status underground scene.[4] This "corporeal ease," as Shamus Khan describes Bourdieu's concept,[5] is the bodily knowledge necessary to carry oneself within a particular social world, a form of tacit knowledge, often unnoticed and unnamed, that distinguishes oneself as a member of that world and plays a role in the reproduction of social stratification. As such, through the arts mentoring model I established, New Urban Arts is a place where the social order of the Creative Capital becomes inscribed in and through the bodies of some youth participants. Through arts mentoring, New Urban Arts is teaching a *creative style of living*, whereby some young people, for example, are going to choose to live broke in a loft and not get a real job because they want to stick it to the man. From this perspective, New Urban Arts is place that does indeed "transform" "troubled youth" into "creative youth."

But Lunisol questioned whether this "choice" to become creative entailed reproducing her subordinate class future. Indeed, Lunisol began to question

this performative desire to live in an abandoned warehouse where she might die of frostbite in the winter. She said,

> Some of the artist-mentors [at New Urban Arts] talked about how they were struggling so hard and wouldn't be able to eat tomorrow and would have to go to Price Right [a discount grocery store]. But they were living in broken-down houses and going to Whole Foods [an up-market organic grocery store].
>
> When I started to get to know them better . . . as I was about to graduate from high school, I asked them how they could do it. . . . How could they live like this? How could they work on commission, give away their artwork, give out posters for free, *and* eat at Whole Foods?
>
> Then I learned that their parents were there to support them if they fucked up or if shit got too hard. I learned that that they had these college degrees at places like Harvard and RISD that they could fall back upon.
>
> We didn't have conversations about how they were able to live like this. If we had brought that up, if we asked them, "How could they do this?" Then the questions become: "What does that look like for us?" "Would we have idolized you in the same way?" "Would we have looked up to you?" "Would we have even built that relationship with you?"
>
> Looking back at it, I'm thinking that they are living that life, and I can never live that life . . . I mean . . . that *is* my life . . . that *is* my reality . . . but without the Whole Foods [laughing].

After this illuminating portion of our interview, Lunisol told me that she still was thankful for her relationships with artist-mentors from New Urban Arts. She said that they were "real gems." She noted how much she learned from them and how much they supported her. Still, Lunisol emphasized the fact that she never had *the choice* to live in poverty like these bohemian creatives. She inherited her poverty as a child. Choosing this creative lifestyle that would give her higher status in Providence—working on commission, giving away posters for free, going to punk shows, living in an abandoned warehouse without heating, and not getting a real job—did not feel like an option for her because she had not inherited a private safety net from her parents. She did not have parents who were there to support her if she fucked up or if shit got too hard.

From this perspective, the transformation from "troubled youth" to "creative youth" entails reproducing the same material conditions of poverty. For Lunisol then, she would not be crossing a class boundary in a purely eco-

nomic sense, but rather she would be reproducing her own poverty by becoming creative. Curiously, that would be a performative choice that the Creative Capital could not refuse because there simply are not good paying jobs for those who do undergo this creative transformation.

WHEN STICKING IT TO THE MAN DOES NOT STICK IT TO THE MAN

In learning the creative lifestyle of the underground scene through New Urban Arts, Lunisol mentioned that she learned to value the prospect of "not getting a real job" and "sticking it the man." Then she realized that this choice would reproduce the subordinate class position that she had inherited as a child. Along similar lines, Laura recounted a discussion that she had with an artist-mentor from RISD at New Urban Arts. Together, they questioned the intentions of the city government in celebrating arts education as key to the futures of young people in the city. Laura said that she and her artist-mentor discussed a conspiracy theory in which Providence's creative city strategy was designed to secure the political power of those who profit unevenly from creative capitalism. Here is how she described this theory: "The government wants us all to be artists so that we don't take them down. That is brilliant. We'll become broke starving artists and feel powerless. Or, we will become rich, successful artists who are unrelatable and don't give a fuck about the communities where we come from."

This conspiracy theory provides a strong indication of the class anxiety that Laura feels in the Creative Capital. She fears being broke and powerless or becoming wealthy and unethical.[6] While it is easy to think about "conspiracy" in terms of an Oz-like figure working from behind a curtain, another way to think about conspiracy is that various institutions and individuals are working independently on their own agendas in ways that shore up dominant economic and cultural interests.[7] In this case, Laura and her artist-mentor are beginning to connect the dots between different facets of the Creative Capital that are working against them. That includes the desire for the government to educate youth to become creatives, or "starving artists." That desire is entangled in the fact that the labor market in Providence has not been able to support many transformed creatives who want good paying jobs. In other words, the labor market in Providence needs young people to "choose" to become starving artists, to be satisfied with the cultural status that comes with participating in the high-status underground scene, while at the same time living in an abandoned warehouse without heat in the winter. These are precisely the kind of citizen-subjects that the dysfunctional labor market of the Creative Capital needs.

Of course, that is not what government policy states. The creative city policy discourse in Providence appears to presume that young people in the city will have a better chance of getting a "real job" in the creative sector if they develop creative skills through programs such as New Urban Arts. This policy aspiration reflects a gradual historical shift in government support for the youth sector and workforce development.[8] In 1973, for example, president Richard Nixon signed the Comprehensive Employment and Training Act, which, among other things, provided summer jobs to low-income high school students in public agencies and private not-for-profit organizations to teach the marketable skills needed to acquire an unsubsidized job (while also providing indirect cash assistance to poor families). By the 1990s, funding for youth work experiences had diminished significantly. The new trend, reflected in the Workforce Investment Act of 1998, the year I founded New Urban Arts, was to prepare youth for successful adulthood through teaching general skills and mentoring rather than restricting youth to particular job training experiences. The city's government's expectation that young people should become creative to succeed, to become upwardly mobile, is based on the assumption that that general skill is needed for them to thrive in a labor market where they are expected to have multiple careers and employers. This workforce development strategy still, however, hinges upon the assumption that there will be "real jobs" in the creative sector waiting for "troubled youth" once they are "transformed."

Creative Providence, published in 2009, did acknowledge that it outlined "some bold outcomes that may take decades to realize."[9] And I am writing this book less than a decade after the plan was introduced, and less than two decades after Providence was branded the Renaissance City. Nonetheless, it is worth assessing whether "getting a real job" is a viable option for young people such as Lunisol if and when they decide that they do not want to become a "starving artist" with high status but no heat. After all, what good are creative workforce skills for young people if there are few jobs waiting for them that demand those skills?

Creative Providence reported that its creative sector has had an "astounding" economic impact on the city.[10] This creative sector includes businesses in the arts, design, media, and technology sectors. The 2009 plan reported that there were 1,231 arts-related businesses in Rhode Island's first congressional district, which includes neighborhoods on the north, south, and east sides of Providence.[11] These businesses provided 6,318 jobs according to a report from Americans for the Arts published in 2008.[12] More recent data by the Americans for the Arts showed that, as of January 2012, Providence County, which

includes all of the city, was home to 1,722 arts-related businesses.[13] These businesses employed 8,509 people at that time, and accounted for 4.67 percent of the 36,871 total businesses located in the county, and 2.6 percent of the 326,699 people employed.[14]

One could argue that these arts-related businesses occupy a small proportion of the labor market. The counterargument is that 2.6 percent of the labor market is significant, because more than one-quarter of Providence's jobs in 2012 were provided by local universities, hospitals, and schools.[15] This counterargument is a reminder that the diversity and availability of employment options in Providence are limited. So this relatively small proportion of the labor market in arts, media, and technology—2.6 percent—could qualify as significant. Moreover, creative skills are also relevant to working at local universities, hospitals, or schools.

It is also true that the arts-related sector in the area has been growing. But it is difficult to gauge this growth because the methodology for tracking these businesses is relatively new. At the same time, we do know that the industry that provided the most local jobs in this sector in 2012 was "crafts" (2,408 jobs, approximately 28 percent of arts-related jobs).[16] This fact reflects Providence's history as a major manufacturing site for goods such as jewelry and silver. But jobs in the jewelry sector in Rhode Island declined from 32,500 in 1978 to just over 3,000 in 2014.[17] The Rhode Island Department of Labor and Training projected this industry's continual decline in the region.[18] In other words, the major employer in the arts-related sector was projected to decline. Other sectors in the arts would have to grow much more rapidly to compensate for those losses. Given this reality, the arts-related sector of the creative labor market in Providence likely does not provide a good chance for Lunisol or other "transformed" youth to get a "real job" as creatives.

Media and technology also have severe limitations as a strategy for creatives who want a "real job" in Providence. Providence does not have a history of technological innovation and it is competing regionally with Boston's Route 128 Technology Corridor. In his assessment of Providence's future as a creative city, Richard Florida noted that technology, which was one of his key variables in ranking creative cities, has been "frankly the region's weakspot."[19] Rhode Island ranked thirty-seventh among the fifty states in technological innovation using metrics such as the number of patents issued to residents, the deployment of broadband services, a record of high-tech business formation, and federal health and science research grants received.[20] Moreover, the Rhode Island media landscape contracted after *Creative Providence* was implemented due to shifts in digital media, with the local newspaper cutting

107

jobs as it was bought and sold, and the alternative weekly newspaper, the *Providence Phoenix*, publishing its last issue in 2014.[21] New media companies have not emerged locally to replace the loss of these jobs.

Susan Christopherson and Ned Rightor have also pointed to evidence that suggests that taxpayer subsidies for relocating film and television production to Providence have not produced "real jobs" in these local industries.[22] The Rhode Island Department of Revenue calculated that a film and television company would need to spend $3.57 in additional expenditures for each dollar in taxpayer subsidy in order for the state to break even on its public investment. A generous multiplier is $2.00. As Christopherson and Rightor put it, "The implication is that the Rhode Island tax incentives have to generate extraordinary purchases and job creation to make back the tax money lost in financing entertainment media productions."[23] They also point out that the stable jobs in the media industries remain in major media centers, such as Los Angeles or New York, while the people actually engaged in local media production through these tax subsidies are employed precariously.[24] So state efforts to attract media companies in Providence both did not produce "real jobs" and also took away from taxpayer investments in other areas that might benefit "troubled youth," such as investments in school infrastructure or art and music teachers in the Providence public schools.

In 2012, there was also a public scandal in Rhode Island over the state's efforts to lure jobs in the video game design industry to Providence. The quasi-public Economic Development Corporation approved a $75 million loan guarantee to 38 Studios, a game design company started by Curt Schilling, a former pitcher for the Boston Red Sox.[25] The loan was based on the promise of 38 Studios bringing 450 jobs to Providence by 2012. That year, 38 Studios defaulted on its state loan, laid off its entire staff, and declared bankruptcy.

Despite these setbacks, I understand why Providence would still tout its creative sector in 2009 as "astounding." The city was trying to promote its creative sector to attract investment and grow it. However, the reality is that this strategy so far has not produced a viable pathway for some young people from New Urban Arts, if any, to work in the local creative sector. Lunisol would therefore have struggled to find a "real job" as a creative in this sector. As a result, "sticking it to the man" by not getting a "real job" was never really an option for her or other "transformed youth" in Providence.

Lunisol, Laura, and other youth from New Urban Arts would have had more luck finding a job in the low-wage service sector in Providence, perhaps the kind of jobs that Lunisol would have in mind if she chose to "live broke." Jobs in this sector have comprised a relatively large and growing share of the

labor market in the Providence region. This trend is not unrelated to the vision for Providence as the Creative Capital. The Creative Capital is ultimately a place-marketing strategy designed to refurnish the city with a new image, an image of youth and creativity, which has been key to transforming the city into a consumer-oriented lifestyle destination for upmarket eating, shopping, and so forth. Laura considered the relationship between this symbolic economy and the low-wage labor market in Providence as part of her conspiracy theory. She said,

> When we talk about creativity in Providence, we have to talk about tourism, because that is the ultimate ramification of it. If the government wants people to come to Broadway and eat at Julian's [a funky bistro on the West Side near New Urban Arts] and go to the Columbus Theatre [a restored theater in the same neighborhood], then the tourists are going to have to stay someplace. Where are they going to have to stay? There are three hotels in Providence that have a living wage. The rest of them don't, and most of them stay at the rest of them.

Laura's analysis is backed up by evidence. Twenty percent of all jobs in the Providence region in 2014 were in the service sector, and hotel and food services accounted for 25 percent of the 6,700 new jobs created in the area between 2010 and 2014.[26] Between 2012 and 2022, food service jobs are expected to grow by 19 percent in Rhode Island.[27]

The replacement of higher-paying manufacturing jobs in Providence with lower-paying hotel, food, and other service jobs has correlated with declining income in the Providence region. The lowest average annual wages in Providence have been in hotel and food services. In 2014, those jobs provided an annual average income of $18,796.[28] That income is $5,000 beneath the federal poverty threshold for a family of four in Providence. The growth of this low-wage sector provides one reason why the median annual income in Rhode Island, when adjusted for inflation, declined from a peak of $62,870 in 2003 to $54,891 in 2014. At the same time, the top 1 percent in Rhode Island, whose average annual income is $884,609, took in 15.6 percent of all income in Rhode Island in 2013.[29] That number approaches or surpasses historical highs from 1917 to 2013.[30] At the same time, the unemployment rate of Latinx workers in the Providence region was 25.2 percent in 2012. This rate was the highest unemployment rate of any Latinx community among all metropolitan regions in the country, and two and a half times the white unemployment rate in the same area.[31]

The growth of the low-wage service sector in Providence reproduces

structural inequalities based on race, class, and gender. This point is relevant to my study because, in 2013, nearly two-thirds of the "troubled youth" at New Urban Arts identified as female, and 83 percent of participants identified as young people of color. Seven out of ten students who sign up to participate in New Urban Arts qualify for free or reduced lunch at school. Women and communities of color are more likely to be represented in the low-wage service sector. In 2015, 42 percent of the US labor market made less than fifteen dollars per hour, and women and people of color were overrepresented in these low-paying jobs.[32] More than half of African American workers and close to 60 percent of Latinx workers made less than fifteen dollars per hour.[33] Cashiers and retail salespersons had the highest number of workers who made less than fifteen dollars per hour, and food preparation and serving occupations, including fast food, had the highest concentration of workers making less than fifteen dollars per hour.[34] As a result, cities that move to low-wage service industries rely upon exploiting the labor of communities of color and women, as well as undocumented workers—which, in the case of Providence, recapitulates its history of labor exploitation based on race, class, and immigrant origin.

In explaining her conspiracy theory, Laura also pointed me toward efforts by the state government to suppress wages in the service industries at the precise moment that they have turned to creativity and tourism as an economic development strategy, which played a role in producing these low-wage jobs. In Rhode Island, the Democrat-controlled state government passed a minimum wage local preemption law in 2014.[35] This law blocked local municipalities such as Providence from raising their minimum wages. The minimum wage in Providence, as of 2016, stood at $9.60. Efforts by the state legislature to raise the minimum wage for 2017 were delayed.[36] Although it is difficult to prove, local lobbying efforts from, say, corporate hotel chains expanding in the area have likely had an influence on this suppressed minimum wage. The city and state have suppressed the wages in the service industries and therefore have contributed to an economic system that extracts wealth from a labor force at the precise moment that the region needs low-wage workers to support the transformation of the city into an upmarket lifestyle destination.

So, as Laura's conspiracy theory suggests, the trouble with the Creative Capital is that the capital cannot refuse a creative underclass, the "troubled youth" who are legible as those who have been transformed into good creatives. These creatives legitimize the image of the Creative Capital and yet they do not demand "real jobs." They demand only the high status that comes

from living in an abandoned warehouse without heat, which reproduces the impoverished material conditions that they inherited as children. Moreover, the Creative Capital needs young creatives as baristas, barbers, and barkeeps who work in these low-wage service industry jobs that are produced through Providence's new image as a Creative Capital. My contention is that young people of color who are legible as creatives in Providence are best poised to compete for these new service industry jobs when they transmute an image of youthful creativity. That image is desirable to affluent white people when they return to the city to shop, dine, and stay in hotels because they are searching for ethnic and creative props to fashion themselves as politically progressive and racially enlightened. In returning to the city from the spiceless (white) suburbs, they are searching for what Stuart Hall called the "spectacle of ethnicity."[37] So the Creative Capital profits from the competition from "troubled youth" who might choose to make it as "starving artists." This reserve army of creative labor, a creative underclass, makes it possible for employers to keep wages low, wages that have been suppressed by state government and surely lobbied by service industries moving into the city.

WHEN STICKING IT TO THE MAN BECOMES ENTREPRENEURIAL

There is one important wrinkle to the argument that Providence reproduces racial and class inequality through its transformation of "troubled youth" into "creative youth." The expectation today must not necessarily entail creatives finding "real jobs." Indeed, creatives are now expected to invent jobs for themselves as entrepreneurs. Indeed, creative labor in the twenty-first century is expected to be far different from the rigid and pyramidal structure of corporations, factories, and armies of the nineteenth and twentieth centuries. Those hierarchies were suitable for the efficient organization of repetitive, mindless, and physical tasks, the kind of alienated labor that, Marx explained,[38] distanced workers from the production of goods and services that they made and delivered, which made work itself less humane. By contrast, creative workers are expected to work best when they are organized in flexible and flat organizational structures, where they can flourish as inventors and problem solvers, critical thinkers and collaborators. According to the logic of the creative city, creatives are also expected to congregate in certain cities and navigate these structures with ease, making goods and services that are manufactured in other parts of the world, pushed from servers to personal computers and mobile devices, or performed on the local stage.[39]

This new consensus about the organization of work in creative cities has placed new demands on the educational preparation of young people as

creative workers. Young people are expected to develop this specific set of creative skills and habits so that they are prepared to produce these new goods and services as entrepreneurs. While *Creative Providence* does not specify what it means for youth to become the next members in the city's creative workforce, the skills and habits of creative workers are often associated with those who work at the convergence of the arts, design, and technology sectors of the economy. Specifically, to succeed in the labor market as creatives, to create jobs for themselves, young people are now expected to be

· prepared to engage in "individual and small scale, project-based or collaborative notions of commercial and non-commercial media production,"[40]

· at ease within flattened organizational hierarchies that are designed to encourage divergent thinking,

· adept at sharing knowledge across disciplines in order to solve problems that working within silos inhibits,[41]

· prepared to challenge authority and disrupt norms—before paying any dues in staid corporate hierarchies,

· able to thrive in open office designs where individual cubicles have been replaced with minimally partitioned rooms,[42]

· willing to put in long hours for the sake of their projects and also comfortable blurring the boundaries between work and leisure, popping back and forth between the laptop and the ping pong table,

· eager to seek out co-working and hot-desking arrangements where they can enjoy the spillover effects of being around other creatives while simultaneously avoiding making capital investments beyond the life of their current gig, and

· highly mobile, searching for the next hive of creativity where their ingenuity will thrive amid the local buzz.[43]

It is important to recognize that this model of production associated with the creative industries reproduces social inequality. In their analysis of how the UK creative industries do so, Doris Ruth Eikhof and Chris Warhurst argue that this model of production includes "irregular income and high employment insecurity, low or unwaged entry level jobs, network-based recruitment practices, and above-average requirements regarding workers' temporal availability and geographic mobility."[44]

Due to this model of production, the creative industries have increas-

ingly favored those with higher education degrees, which serves as a proxy for those with privileged socioeconomic backgrounds. The data suggest that the creative industries have a systemic bias toward those who are born better-off.

But preparing youth for life and work in the twenty-first century is not simply about teaching young people to participate in this systemically biased model of creative production. It is also about teaching them a new orientation to citizenship. For example, Providence's 2009 creative city plan argued that creative learning is essential to preparing students to "participate fully as *citizens* and members of the 21st century global workforce."[45] As *Creative Providence* put it, these youth are expected to breathe life into the city's infrastructure and act as catalysts for civic engagement.[46]

In *Creative Providence*, these creative citizen workers are expected to be entrepreneurs with politically progressive principles. The plan stated that creative entrepreneurs should be expected to use their creativity to meet the pressing challenges of the twenty-first century, including developing sustainable ecological practices and building an equitable education system.[47] John Clarke, a professor of cultural studies, has pointed out that this brand of citizenship has become a hallmark of the contemporary discourse of creativity.[48] Creative entrepreneurs are expected to have a conscience and to solve the grand challenges of the twenty-first century while at the same time to create their own gigs rather than find established jobs or expect the security of a life-long company job.[49]

It is hard to argue against forming a legion of dynamic self-employed creatives who make a city in their positive image, who are up to the challenge of solving climate change or inequitable school systems. No one wants to deny a vision for a city that allows young people to participate in playful, inventive, and autonomous forms of work in open-designed and shared studios. And it is easy to wax nostalgic about the idea of industrial labor, while ignoring its dangers and alienation. But the expectation that young people become creative entrepreneurs with consciences marks a subtle but seismic shift in how society conceptualizes individuals' relationship to work, to social class, and to the state.[50] Today, when young people are being asked to join a twenty-first-century global citizenry and creative workforce, they are being asked to be responsible for

- solving the problems of the world rather than expecting the state to intervene and solve them,
- shaping their own careers rather than expecting companies to provide them,

113

· providing their own safety net (or inheriting one) rather than receiving one from the state or the corporation,

· going it alone in society even if they are collaborating.

With this individualistic orientation to society, these creative entrepreneurs are not expected to organize and collectively challenge the "precariousness" of their new work lives, which include insecure and irregular labor patterns, no matter whether they are paid well or paid poorly.[51]

Rather than not getting a "real job" and "sticking it to the man," as Lunisol put it, the actual expectation for creatives is that they create their own "real jobs" *and* stick it to the man. Creative labor is now fashioned as rebellious and disruptive, anticorporate and antibureaucratic, even if it is shorn of much personal fulfillment or conviviality, or political antagonism and utopian thinking.[52] Max Haiven has argued that creativity has therefore become "privatized,"[53] or reduced as a concept and deployed to organize subjective experience and social relations in service of capital accumulation, primarily through enhancing consumer lifestyle experiences and driving property development. From this perspective, the state has become invested in articulating creativity to individualized, market-based ideas in order to support capital accumulation and consolidate its own power. Transforming "troubled youth" through creativity thus entails teaching youth to adopt a "privatized" orientation to creativity, to become creative entrepreneurs who accept personal responsibility for their own futures. But the discourse of creativity is so effective at masking its own entanglement in the reproduction of social inequality because of our positive emotional attachments to the word.

There is some evidence that this discourse of creativity in Providence has been effective in recruiting "troubled youth" in becoming creative entrepreneurs. Indeed, several young people from New Urban Arts have tried to make it as creative entrepreneurs during and after participating in New Urban Arts. Some have become freelance DJs; others have aspirations of running food trucks. Some have started fashion design and consulting businesses. Others have opened their own photography businesses to varying degrees of success. Each of these efforts is commendable, and in fact, these stories have been celebrated in Providence's local newspaper as evidence of New Urban Arts' positive impact in transforming "troubled youth" as creatives.[54] But the reality is that *Creative Providence* has expected poor young people of color to choose creative entrepreneurship at the precise moment that their parents were facing bleak economic times, only worsened by city and state policy.

As such, the reliance on creative entrepreneurship as an employment

solution in Providence has only enhanced the profitability of those, such as myself, who have inherited the capital necessary to withstand the high risks of failure that are associated with entrepreneurship. I launched New Urban Arts when I was twenty-one years old, backed by the social and cultural capital that comes with attending Brown University, and the economic capital it took to get there and the financial investments of the institution in my own public service. Since then, I have built a successful career based on this track record. One could say that I am continuing to cash in on this history by writing this book; my cultural status is enhanced by the prestige that comes with book publication through the academy. I could not have had this career trajectory without my access to elite educational institutions and their social networks, inherited wealth, as well as my legibility as a potentially successful nonprofit executive—which are all a product of my own investment in my whiteness.[55] Of course, I worked hard in starting New Urban Arts and in writing this book. But I would have had to work much harder as a person of color to prove that I could launch and run a nonprofit when I was twenty-one years old, which, in and of itself, requires, I think, an incredible sense of white male entitlement. And I would have had a much harder time enduring the economically difficult times of starting a nonprofit if I had grown up poor.

So the creative policy environment in Providence and Rhode Island has not acknowledged the fact that developing twenty-first-century skills through creative learning is not an equalizer in the creative city because developing these skills *is not all that is necessary* to survive and prosper in these dysfunctional labor markets. Moreover, given the view today that anyone can be creative, this focus on creativity in urban renewal has only mobilized a brand of capitalism that has legitimized the erosion of support for those who are poor. In other words, when the poor fail to succeed in the creative city, their failure must have been caused by the fact that they have remained "troubled" not "transformed." So being creative in Providence has simply become a euphemism for the practice of survival for far too many people. For Lunisol, the reality of being young, poor, and creative meant already living in a house without heat during the winter—dying of frostbite, as she put it—without resources or support available to her when shit got hard or she happened to fuck up.

But the perspectives and experiences of Lunisol, Theo, and Laura also complicate this neoliberal critique of creativity, work, and citizenship. New Urban Arts has never been concerned with cultivating individuals who see themselves as privately responsible for their own futures based on the market value of their privatized creativity. Through arts mentoring at New Ur-

115

ban Arts, while living through this conjuncture of the Creative Capital, some young people have come to desire living in a collective, and thus committing to radical politics that affirm their nonnormative identities. A collectivist and more politically radical orientation to creativity is also alive and well in both Providence and New Urban Arts' studio, and the studio is a place for some people to access and identify with this social scene in the city that affirms this emerging orientation to social life, culture, and politics.

At the same time, this collectivist orientation to creativity is also contradictory in the Creative Capital. It produces uncompensated cultural labor for the city through transforming some "troubled youth" into creatives, who help populate the city with a "real" image of creativity, as Theo put it. These "transformed youth" join already "creative youth" in building bikes, making stuff with their hands, and giving away posters for free. Together, they generate the buzz that the Creative Capital repackages and uses to promote itself through place-marketing campaigns. At the same time, the creative underclass is satisfied with earning the high status of the cultural underground and acquiring the newfound dignity of rejecting "real jobs" that never existed for them in the first place.

So it seems that the organization of social power in Providence would be quite satisfied with young people of color, gender-nonconforming youth, and poor youth "choosing" a collectivist, utopian bohemian lifestyle in abandoned warehouses without heat (until capital is ready to develop those warehouses). These "transformed" youth do not need to choose a privatized or market-oriented orientation to creativity to satisfy the Creative Capital's market demands. Their choices as a creative underclass can both legitimize the image of the Creative Capital as inclusive and trendy, and also grease the local labor market with more desperate low-wage workers in the service industries who project the look and feel of creativity and ethnic difference.

If cities such as Providence are expecting to profit from poor young people of color who choose not to get a real job and breathe life into the city's aging industrial infrastructure, then a living wage or, better, universal basic income, is going to be necessary to level the playing field for those who have not inherited the private safety net needed to endure sustained periods of high risk and high uncertainty as transformed creatives. If and when these policy conditions are met, young people who choose to participate in New Urban Arts might be in a position to look back at their important relationships with artist-mentors, whom Lunisol considered "real gems," without asking, "Would I have idolized you in the same way? Would I have looked up to you? Would I have even built that relationship with you?"

116

Until those conditions are met, the conviviality of New Urban Arts will always be met with ambivalence from some youth participants later in life when shit gets too hard for them and/or they happen to fuck up. Until then, the arts mentoring model I developed will have to negotiate the contradictions of empowering some young people to embrace a creative lifestyle that affirms their nonnormative existence and transforms the cultural landscape of the city, while at the same time "empowering" them to "choose" to reproduce their subordinate class futures and service the cultural and economic demands of white capital accumulation in the creative city. That "line of tendential force," as Stuart Hall would describe it,[56] must be resisted.

117

5

AUTOETHNOGRAPHY OF A "GENTRIFYING FORCE"

After returning to New Urban Arts in 2012 to begin this research project, I started to notice how several alumni of New Urban Arts were discussing gentrification of their neighborhoods in Providence. A few alumni, for example, noted on social media how young white people were jogging on the South Side, a sight that they had never seen in their neighborhood. Another youth participant noted that challenging gentrification in Providence was an important yet complicated task for her. She said that she benefited as a young person from nonprofit organizations in the city, but at the same time she felt that these organizations were also "gentrifying forces." New Urban Arts under my leadership was one of the organizations that she had in mind. Her account challenged me to reflect on the contradictions of my white educational leadership at New Urban Arts with particular reference to racist real estate practices. Like my critique in the previous chapter of how the model of creative production reproduces social inequality, this analysis is also necessary to inform youth activism in the gentrifying city.

As much as people might believe that American cities are experiencing a great recovery in the early twenty-first century, American cities have actually shrunk since 2000. The share of

Americans living in cities declined by 7 percent between 2000 and 2014.[1] As cities have shrunk, high-poverty tracts have moved away from the downtown core and spread out both across cities and into the suburbs. As cities have become less populated and the suburbs have become poorer, cities have also become home to more young, rich, childless, highly educated, and white people. Individuals aged twenty-five to forty-nine who are in the top tenth of the income distribution were 11 percent more likely to live in an urban neighborhood in 2014 than in 2000.[2] Moreover, affluent and white residents are now 33 percent more likely to live in higher-density urban neighborhoods than fifteen years earlier.[3] These statistics point to the fact that pockets of cities are gentrifying or have already been gentrified as cities have shrunk. The rising poverty in suburbs points to the displacement of low-income people from urban neighborhoods, and the stagnant incomes of those who already lived there. So cities are becoming gentrified in the sense that higher-income households are replacing and displacing lower-income households. As cities gentrify, upwardly mobile and often white people bring their own ways of life and aesthetic preferences with them into cities.[4] In other words, the gentrification of cities is not just a question of economic and residential displacement but also the displacement of how cities are, and might otherwise be, lived. These cultural ways of life tend to shore up the economic and political interests of white people who are more likely to own property and profit from real estate speculation after decades of what bell hooks calls "real estate racism."[5]

Clear and conclusive evidence that Providence is gentrifying, or has been gentrified, is difficult to find. It is true that the population of Providence has become more nonwhite since New Urban Arts was founded in 1997. But there are demographic shifts across certain tracts in the city that align with perceptions of gentrification by alumni of New Urban Arts. In her analysis of gentrification in Providence in 2017, Fay Strongin interviewed seventeen community development, housing, and planning practitioners in Providence and found widespread agreement that neighborhood change in some of the city's neighborhoods qualified as gentrification, even as these processes of change have moved slowly due to real estate boom and bust cycles.[6] Strongin compared demographic change across the city's thirty-nine tracts and compared those changes to neighborhood types considered to be gentrified. In her analysis, Strongin found that twelve of the city's thirty-nine census tracts are "potentially gentrifying."[7] Six of these potentially gentrifying neighborhoods surround New Urban Arts' studio, and eleven of the twelve tracts are where the majority of New Urban Arts' participants live.[8] New Urban Arts is also based on the border of Federal Hill, a neighborhood with the most indi-

119

cators of gentrification among these twelve tracts.[9] These indicators include the young adult share, the share of adults with a college degree, the nonfamily household share, the white share, average household income, and the share of Latinx residents.[10] Gentrification is often dismissed as a social problem based on the assumption that these shifts are "natural," shaped by the rational self-interests of people choosing where to live. But it is important to recognize that these emergent patterns of gentrification are by design and are inflected with historically enduring racist social patterns.

When I arrived in Providence in the mid-1990s, I often heard the city described in negative terms. Race and class were often unstated but implied in the everyday speech patterns that I encountered. Providence was "dangerous" and "seedy," "gritty" and "rough." It was also known as the "armpit" of New England. As a young, affluent, and white kid who went to a leafy private school while growing up in the suburbs of Columbus, Ohio, these subtle messages were reminders to stay on College Hill, the neighborhood overlooking downtown Providence. These messages were coded references to the disinvestment of the city as manufacturing moved elsewhere, as well as the people of color and poor people now living in the city whom I had become taught and habituated to see as culturally deprived and as threats to my white existence.[11]

I do not want to downplay the social challenges facing the city at that time.[12] After all, my roommate while I was a student at Brown survived being shot randomly in what was likely a gang initiation. Several youth participants at New Urban Arts often reported in its early years their own struggles with keeping themselves out of the grips of gang violence. My analytical concern, however, is how discourses around youth, race, and violence have been used to mobilize an urban reconfiguration in Providence that tended to privilege the social, cultural, political, and economic interests of upwardly mobile and white people—including the right to live. These discourses produce what Gramsci called "common-sense,"[13] which combines elements of both truth and ideology to build contradictory coalitions that reward dominant interests.[14] For example, one could imagine an urban script that attempts to address, for example, the scourge of gang violence, without using it as leverage to reward people like me. But that has not been the strong tendency in Providence. Instead, that social crisis was seized as an opportunity to shore up the interests of whiteness, and the discourses of youth and creativity have proved highly effective in that regard.

For example, Richard Lupo, an owner of a music venue in downtown Providence for decades, criticized the fact that people framed the city as dangerous and disordered in relation to youth. "In 1992, it was scary to stand on

Westminster Street at 10 p.m.," Lupo said, as he described the dominant way of thinking about Providence in the early 1990s. "Cars would go by with four or five scary youths."[15] Lupo argued that this racist and classist representation of Providence as a dangerous and disordered place was articulated to youth. In other words, "youths"—a euphemism, I think, for young people of color—were seen as running interference on property developers' accumulative desire. These youth were to blame for the city's seedy image and they needed to be managed as a result if the city was going to attract capital investment to support property development. Indeed, these "troubled youth" needed to be transformed, managed, and relocated. Relatively affluent and white creatives from Brown and RISD, such as myself, needed to move in.

When the once great proponent of creative city politics, Richard Florida, visited Providence in 2003, he argued that Providence exported too much of its college-educated talent from Brown and RISD. He thus advocated for strategies to retain young creatives from these highly selective and private institutions of higher education.[16] According to this script, more affluent creatives from these institutions, such as myself, would then launch dynamic start-ups and host art events, thus attracting inward investment, tourism, and additional creative workers. In retrospect, this script was designed to reconfigure the city precisely for the benefit of people such as myself, and at the expense of low-income and working-class communities of color who lived in the city prior to the city being rebranded as artsy and creative. I was hailed, as Althusser would argue,[17] to a particular place in the social order of the city, living my life as one of the desirable white creatives committed to the common good, transforming the city's image to attract capital investment. My founding and leading of New Urban Arts was entertainable only as an option for me and for others because Providence wanted creatives to transform "scary youths" hanging out downtown. Leveraging support for New Urban Arts in the aughts was always tied to this taken-for-granted sense that youth in the city needed to be kept off the streets, perhaps even kept out of downtown, and that it was desirable to transform the style and comportment of youth of color so that they seem less scary to white people as these new urban consumers were beckoned back to the city to live, shop, and dine.

So the structural conditions were set for me to become a gentrifying force the moment I arrived in Providence for the first time as a college student in 1994. My success as the founder of New Urban Arts—the very possibility of New Urban Arts' existence—depended upon the subject position of the young white man as a creative force for good in the city. And my sense of who I was and what I could do was constituted by these swirling discourses

of youth and creativity that were always stitched to questions of race and class. As much as I set out to serve young people of color through New Urban Arts, I was already entangled in racist cultural and economic processes.

This finding became clear to me when I started fieldwork for this book project in 2012. During this fieldwork, I reconstructed a chronology that shook me. But, over time, the analytical challenge for me was how and why I told this story now, in this book, in ways that did not simply recapitulate my own possessive investment in whiteness.

A FADED AREA FINDS FRESH APPEAL

I met Mariana in 2003 during her freshman year in high school. Mariana, whose parents immigrated to the city from the Dominican Republic, lived in the West End neighborhood where New Urban Arts has been located since 1998. When Mariana's mother drove her home from middle school, she used to notice New Urban Arts and wonder what it was. Then she met one of New Urban Arts' staff members who volunteered at her middle school, and this volunteer encouraged Mariana to join the studio once she started high school. The summer before high school began, Mariana found herself walking to the studio to check it out. She stopped several times on her way to the studio, and each time, she turned around to go home. She was afraid to go to the studio by herself. But one day, she turned herself back around again and forced herself to walk into the storefront studio for the first time.

On her first day in the studio, Mariana learned about a mural project that I had commissioned at New Urban Arts. A young artist who was an undergraduate at Brown University had received funding from the university to run a mural project at New Urban Arts during the summer. The purpose of the mural was to challenge stigmas associated with the West End and to celebrate the cultural vibrancy of this predominantly Latinx neighborhood. In other words, the mural was designed to trouble representations of the neighborhood as culturally deprived and deficient.

In a letter to youth members and their families, the young artist leading the mural project described how the production of the mural involved library research on Providence history and culture, interviewing residents in the neighborhood, photographing the city and its people, and painting a mural based on what they learned. The artist wrote that the mural was an excellent opportunity for young people at New Urban Arts to create a highly visible work of public art that positively affected the community. She explained that youth members would learn how the neighborhood has changed over time. These youth members would also reflect on what defines its landscape

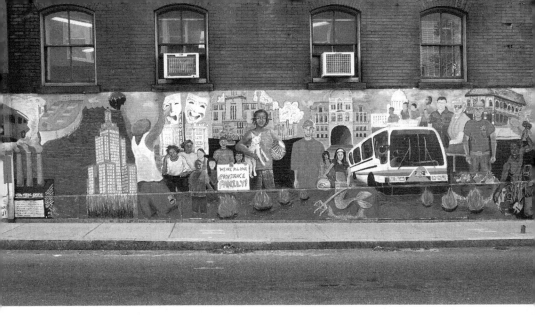

Figure 5.1 Photograph of mural by Mariana and her peers at the corner of Dean and Westminster Street, 2003. Photo by the author.

and culture, what they value most about the neighborhood, and what they consider to be the neighborhood's most pressing challenges. Recognizing the potential benefits of this mural to the street corner at Westminster and Dean Streets, I approached New Urban Arts' landlord and asked the company to consider forgiving one month's rent in return for making the mural and beautifying the neighborhood. New Urban Arts struggled to pay its $2,000 monthly rent at the time. The company agreed to the deal, and I was ecstatic.

With this artist and her peers, Mariana walked the streets of the West End that summer. She interviewed her neighbors, took photographs, and re-searched the neighborhood's history as she and her collaborators developed and completed the mural. As figure 5.1 shows, their finished mural features several portraits of residents living in the neighborhood, standing before a few of the city's architectural landmarks and proud symbols. Mariana loved the experience of making this mural.

"I came to New Urban Arts every day after that. I loved it," Mariana said years later in an interview with me. "I was working on a mural, and the mural became really important to me. This was *my* neighborhood."

Two years after completing the mural, in 2005, a photograph of it ap-peared in the Travel section of the *New York Times*. The *Times* article, written by Bonnie Tsui, is titled, "In Providence, Faded Area Finds Fresh Appeal."[18] The photograph in the newspaper features two young Latinas smiling and walking home from school in front of the New Urban Arts mural. In the arti-

123

cle, Tsui celebrated the transformation of the West End from a "faded" neighborhood, as she put it, into a trendy enclave for young creatives. The article beckoned tourists to New Urban Arts' neighborhood, to Mariana's neighborhood, promising a creative and newly revitalized area, home to hip and cool coffee shops, boutiques, and lofts. The article suggested to readers—and potential real estate buyers—that they were in competition with "artists from elsewhere in the city" who "have flocked to the neighborhood in recent years looking for the last affordable loft spaces."[19]

The article suggested that the revitalization of the West End was, as Tsui put it, "community-led."[20] The meaning of "community" here is no doubt a euphemism for people of color, mainly Latinx people, who lived in the "faded" neighborhood prior to the arrival of these artists and loft buyers. The *Times'* image of New Urban Arts' uplifting mural, accompanied by the two young Latinas walking home from school in front of it, represented this "community." The mural provided an image of diversity that new residents in the neighborhood would desire, what Stuart Hall has called a "spectacle of ethnicity."[21] That is to say, these smiling young girls of color and the mural backdrop behind them became ethnic props that appealed to affluent, highly educated, politically progressive, and/or white people being summoned back to the neighborhood—people like me. This rhetoric and the image worked together to suggest that "the community" was welcoming, if not leading, these neighborhood changes. This rhetoric of "community-led revitalization" appeals to the liberal politics of these new urban consumers and residents. In other words, they can imagine themselves as antiracist and antisettler even as they gentrify the neighborhood. This article represented residents as if they should expect to participate in neighborhood renewal that is welcomed, indeed *led*, by the low-income and working-class residents of color living in the neighborhood, including young people such as Mariana.

In 2008, three years after this article appeared in the *New York Times* and one week before her graduation from high school, Mariana and her family were displaced from their apartment in a duplex house in the West End located only a few blocks from the mural. An old brick mill building next to their apartment, where her family members had once worked in low-wage jewelry assembly jobs, was being converted into luxury-branded lofts. Their duplex was razed to make way for the lofts' parking lot. The arrival of people who were called to the neighborhood by the *New York Times* led to her family's displacement. And Brady Sullivan, a New Hampshire–based property developer, which purchased the building for $2.4 million, sold the loft building

124

Figure 5.2 Picture of Grant Mill, 2018. Permission Will Heublein.

a decade later for $13.4 million.[22] Figure 5.2 shows the building in 2010, now named "Grant Mill," after its conversion into lofts.

The troubling irony of this story is that Mariana did what I had hoped for her, and what the conventional creative city script called for her to do. She improved her neighborhood through making a mural with her peers. She developed new skills by executing a large-scale project from conception to completion. In the process, she and her peers transformed the landscape of their city, their "faded" neighborhood, and, as *Creative Providence* would have it, "transformed" herself into someone who loved the creative offer of New Urban Arts. Yet Providence turned against her.

As I have reflected on this story over the years, and my own role within it, I have debated with myself and with other people about questions of proportion and causality. How much was New Urban Arts, under my watch, responsible for Mariana's eviction? Of course, it is impossible to know whether Mariana and her family would have been evicted from their home if the mural had not been made. It is impossible to know whether Mariana and her

family would have been evicted if youth participants at New Urban Arts had been led in making a mural that did not provide the West End a tidy and comfortable image of ethnic diversity. It is impossible to know if Mariana and her family would have been evicted if the *New York Times* had opted for a different and more critical narrative of cultural urban redevelopment. And it is worth noting that New Urban Arts has moved away from engaging youth in making public murals over the past few years because the organization is concerned about the role of these cultural artifacts in gentrification. But I think it is safe to say that Mariana's family probably would have been evicted even if New Urban Arts had never made the mural or if a photograph of the mural had not appeared in the *New York Times*. So I could be fairly questioned for making too much of this story.

I have not only been questioned for insinuating causality. After I reconstructed this chronology, I went back to some of the youth participants in this research and asked them what they thought about this story. I suppose that I expected them to be surprised and outraged by my discovery. But that is not what I heard. Gabriela, for example, the theorist of troublemaking, responded with a resounding, "Duh." In other words, while she did not know the specifics of the story, she already understood its general contours. That is to say, she understood already that when young people of color do something positive in their neighborhood, there is a tendency for whiteness to steal the fruits of their labor to expand its power. She suggested that I do my homework and look into the critical knowledge already present within communities of color about gentrification. As I have already noted, James Baldwin in the 1960s described "urban renewal" as just another word for state-sponsored "negro removal" as he examined changes in San Francisco at the time.[23] And bell hooks, writing in the 1990s, described these urban renewal projects as "state-orchestrated, racialized class warfare."[24] In other words, Gabriela was suggesting that I should not congratulate myself for discovering a phenomenon that has already been well-documented and theorized from a critical race perspective. Indeed, if anything, I should recognize how my late arrival at this critical understanding is a historical product of my willful white ignorance.

Moreover, Gabriela wanted to know why I felt compelled to tell this story, to write about this story in this book. "Did I feel guilty?" she asked. With this question, Gabriela was engaging with the politics of representation in this book and the affective labor that white people do when confronted with causing racial injury.[25] This labor always has the paradoxical effect of taxing people of color and protecting the interests of whiteness. In this case, I could be

telling this story to seek forgiveness from the young people that I hurt, thus absolving me of the guilt that I feel. I would then be centering on my feelings while distracting myself from the actions that it might take to attempt to disinvest whiteness of its power and profitability, to repair its injustice of stealing land.

Resolving white guilt might not be the only self-serving motivation in play here. For example, I could be positioning myself as one who is now operating outside the racist logic of urban renewal, as one who possesses the critical consciousness needed to transform these conditions. In this case, I could be representing young people of color such as Mariana as those who suffer from "false consciousness," who need my clairvoyance to see the injustice of the Creative Capital. Here again, I would be reproducing a white gaze that is only capable of seeing people of color as less than, as objects of history, as people defined by pain and suffering. My research encounters with young people of color shows that this dynamic is not the case. They were educating me.

There is a third problematic "move to innocence" that might also be in play here.[26] I could be rerepresenting myself as someone who now sees the totality and near inescapability of my white-inflicted racist violence. In this case, I would be telling this story to signal my virtue, showing that I can see the racial injury I have caused. I would then be showing that I have overcome "white fragility" and can withstand the criticism that I deserve.[27] I would be suggesting that, now, I am "woke," standing on the right side of history, performing the right kind of white politics. The circularity of this white reflexivity would also be self-serving because it still distracts from repairing injustice, from disinvesting whiteness of its power and profitability.

Of course, I would never claim to know my "true" motivations in telling this story. My point is that each of these options—resolving guilt, reasserting critical consciousness, and performing wokeness—are all self-serving cultural scripts that are available to me and other white people when confronted with the racist injuries they cause. These scripts are inevitably recruiting me, being inscribed on and through me as I write this line. Nonetheless, awareness of these cultural scripts does count as knowledge, knowledge that can be generative of political action. Indeed, acknowledging the circularity of white reflexivity has clarified for me the need to write this book in this way, to analyze how I have been recruited by white creativity, and to commit to a book project that might contribute to youth activism in the gentrifying city. Working toward this cultural political strategy against the gentrifying city will benefit from an extended analysis of how this displacement by Mariana and her family was by design.

127

In 2001, two years before I commissioned Mariana's mural at New Urban Arts, the state of Rhode Island passed legislation that provided economic incentives to rehabilitate historic property.[28] Effective January 1, 2002, state income tax credits were awarded to property developers for up to 30 percent of qualified rehabilitation expenditures on historic properties. Qualifying properties had to be listed on national or state registers of historic places or located in a historic district. Through these tax credits, the state of Rhode Island provided $460 million in subsidies to 277 projects between 2002 and 2007. One of the qualifying projects was the 2005 loft-conversion next to Mariana's home in the West End.

This building was eligible for state tax credits because it was included in the first thematic historic district in the United States.[29] Old red brick industrial buildings in Providence are not uncommon, and after artists began settling in them in the 1990s, it became clear to developers that there was a market for retrofitting them for urban loft living.

To both fuel and satisfy this demand for loft living, these buildings were placed in a noncontiguous historic district known as the Providence Industrial and Commercial Building District (ICBD).[30] This thematic district provided the means to subsidize the redevelopment of industrial buildings across the city associated with the image and lifestyle of the creative city captured in Tsui's article. The ICBD was constructed as a district based on the historical value of these buildings, as well as the speculative profitability of their aesthetics, not one based on place or proximity. The displacement of Mariana and her family occurred because they lived next to one building that was included in this thematic district, not because they lived in a neighborhood targeted for investment. The physical separation of the buildings themselves make the effects of state-orchestrated, racialized class warfare seemingly more random and harder to resist.

The local appeal of living in these buildings was so strong that Lunisol, for example, mentioned it as a signifier of cultural status in the city when she was debating the lifestyle choices available to her in Providence as a creative. Another participant in New Urban Arts told me that her American Dream did not entail a suburban house behind a white picket fence but rather a spacious red brick loft with good city views. For her, class mobility meant moving into a loft in an increasingly affluent and white urban neighborhood, not the white suburbs. These examples show how the "transformation" of "trou-

128

bled youth" entailed the construction of a class fantasy to live in this thematic district.

A problem with the state tax credits used to subsidize the property developments in this thematic district was that their developers were likely to have been incorporated outside of the state. For example, the developer of Mariana's building, Brady Sullivan, was incorporated in New Hampshire and therefore did not pay state income tax in Rhode Island. Brady Sullivan could therefore not profit from public subsidy unless there was a workaround. State law in Rhode Island solved this problem by allowing out-of-state property developers to sell their tax credits to brokers who, in turn, could sell these credits to Rhode Island–based individuals and corporations seeking to lower their state income taxes.[31] These tax credits were sold at a discount to incentivize this transaction. In other words, to solve the problem of subsidizing out-of-state property developers, the state of Rhode Island, much like numerous other states in the United States,[32] established not only a thematic district based on an aesthetic but also a complex financial market for the transferable tax credits based on this image and idea. This financial market has provided subsidies to socially connected and wealthy individuals, brokers, and financial advisers in Rhode Island who could take advantage of this complex market.[33] This financial market reasserted the power, resources, and opportunities of affluent people, which, in Rhode Island, also means they are more likely to be white.

The city of Providence provided additional tax stabilization agreements to property developers in Providence. Property owners of these historic commercial and industrial buildings were provided relief from their city property taxes in addition to receiving state income tax credits. These municipal agreements were contingent upon property developers guaranteeing the addition of affordable housing in Providence and hiring local contractors and women and minority-owned businesses. Yet, in 2014, Providence's internal auditor found that the redevelopment projects that received property tax stabilization agreements in Providence were not monitored and were not in compliance.[34] While low-income families such as Mariana's were expected to have greater access to affordable housing through these agreements, this opportunity never came to fruition in the ways that were promised, which is unsurprising.

Despite these shortcomings, the city of Providence proceeded to extend these tax stabilization agreements for these property owners at the height of the Great Recession (2007–9). These extensions were awarded because these property owners had, as a city ordinance put it, "suffered serious financial

129

setbacks and hardships as a result of the collapse of the real estate and financial markets over the past several years."[35] Through these extensions, one major downtown property owner in Providence, Arnold "Buff" Chace, paid less than $1 million in property taxes over the span of fifteen years. Without these tax stabilization agreements, Chace would have paid an estimated $9 million.

Chase, a member of a well-established New England family that owned the textile manufacturing company Berkshire Hathaway that was purchased by Warren Buffet, was a major donor and supporter of mayor David Cicilline, the key figure in rebranding Providence as a creative city. It is plausible that Chace and his team contributed to the drafting of state law and city ordinances that provided these tax credits and subsidies. Nonetheless, according to the local news reporting of Michael Corkery, Chase saw himself as an urban benefactor, a person saving the city from urban decay.[36] Indeed, Chace thought of the development of his property in Providence as a civic duty, and therefore himself as a person who would preserve and restore Providence to its historic majesty.[37]

Of course, the rationale for these subsidies is that property development would not happen without them. Without state-subsidized property development, the city and state's tax base would remain suppressed so that neither the state nor the city could provide adequate services to the public, including public education. Another argument is that taxpayers should expect to receive a financial return on the investment of tax dollars. Grow Smart Rhode Island, a nonprofit organization dedicated to "sensible alternatives to suburban sprawl and urban decay," argued that $1.0 million of historic tax credits leveraged $5.35 million in total economic output in Rhode Island.[38] The cost of the credits to the taxpayer was then recouped through added income taxes and sales tax revenue generated by new residents, workers, and consumers. Chace, who avoided paying $8 million in city property taxes, was a founding board member of Grow Smart Rhode Island.

The argument that providing Chace welfare is good for the city does not use good logic. It depends upon a false choice. The argument that urban property development would not happen without taxpayer subsidies and self-rewarding markets sets up a choice between property development with subsidies or no property development at all. But as a taxpayer with a commitment to young people and the common good, *I am for sustainable property development in Providence and I am against Mariana's displacement*. But holding these two options together is not permitted through the construction of this false choice: one is either for or against creative property development.

The fact that tax credits may well leverage economic output also does

130

not specify who wins and loses from that output, or how those gains and losses might be divided unevenly across different social groups and space. In other words, some taxpayers in Rhode Island benefited from the subsidies, but others did not, and these costs and benefits can be predictably correlated with factors that include race, gender, class, and residential location in proximity to buildings subsidized for property development. The displacement of Mariana and her family from their home, adjacent to one such subsidized project, is a useful illustration of this unevenness. The fact that there were financial returns to Rhode Island taxpayers overall provides little solace or financial assistance to Mariana's family when, in fact, public policy created the conditions for her family's displacement.

To make matters worse, as I have already stated, the state of Rhode Island was also passing a minimum wage local preemption law at this time, which blocked municipalities such as Providence from raising minimum wages. The minimum wage in Providence, as of 2015, stood at $9.60. This step was taken as Providence continued its long transition from a higher-wage industrial economy to a lower-wage service sector economy. Businesses in this sector of the economy needed low-wage labor to make a profit and pay rents to their landlords, which, in the case of downtown Providence, was often Buff Chace.

Moreover, the total expenditures for cash assistance (federal and state) for families living in poverty in Rhode Island decreased from $126.5 million in 1996 to $35.6 million in 2014—a decrease of 72 percent.[39] During that period, the state of Rhode Island decreased its share of contributions for cash assistance to poor families from $51.5 million in 1997, the year New Urban Arts was founded, to *zero dollars* in 2015.[40] Austere state policy seemed to have little sympathy for poor families that suffered from "serious financial setbacks and hardships," including being displaced from their homes. Perversely, this hollowing out of the welfare state depends upon representations of people in cities as members of an underclass. This logic maintains that the style and comportment of the underclass, which is framed as the cause of their lower socioeconomic position, can be changed only by weaning them off state dependency—thus the all-out assault on welfare assistance since the 1990s.

This erosion of the welfare state in Rhode Island for poor people, the expansion of welfare for gentrifiers, and the state interest in transforming "troubled youth" are not unrelated. Engaging "troubled youth" in public art projects is now often termed "creative placemaking."[41] Creative placemaking is considered a productive activity for both transforming "troubled youth" and transforming the disinvested city. In their report on creative placemaking for

the National Endowment for the Arts, Ann Markusen and Anne Gadwa Nicodemus argue that creative placemaking contributes to "creative places," which provide "training grounds for area youth" by incubating "the next generation of creative workers and entrepreneurs."[42] They continue that these youth participants develop "marketable skills and job savvy" by working "with artist mentors, gaining valuable professional experience and aptitude in their chosen artistic discipline."[43]

So, through creative placemaking, "troubled youth" are expected to play a constructive role in their neighborhoods. The implicit assumption then is that urban blight is caused by "scary youths'" who destroy their neighborhoods and deter investment. Alternatively, through creative placemaking young people can acquire the cultural skills and dispositions that they need to get ahead. But the story of my leadership at New Urban Arts shows that the expectation that creative placemaking will lead to the prosperity of young people at New Urban Arts and will enhance the livability of their neighborhoods *for them* is a highly problematic assertion. Creative placemaking has become a tool that represents them as troubled and their spaces as placeless, while deploying their undercompensated or uncompensated cultural labor in support of the speculative and subsidized investments of real estate developers and property owners, and in support of whiteness.

Gabriela's notion of troublemaking has been useful to me in thinking how to oppose this white-centered urban reconfiguration. People who have profited from their position as white creatives must trouble the ways in which we have been summoned to live our lives as particular subjects in twenty-first-century cities. We must trouble our position as people who desire living in "faded" areas, who want to be creative, who feel compelled to start nonprofit organizations, while at the same time allowing the politicians who represent us to suppress the minimum wage, hand out welfare to the wealthiest among us, and reduce cash assistance for poor families to zero. As Gabriela might put it, we need to start fucking up what it means to be white creatives, and we need to do it quickly. We must ask ourselves what it would take for us to disinvest ourselves from this subjectivity, from white creativity as supreme, as a source of profit. And we must ask ourselves what it would take to redress the injustices caused by stealing cities for our own creative benefit, without simply resorting to the facile move of repositioning ourselves as those who are now more race and class conscious. Refusing to do creative placemaking, as New Urban Arts has already begun to do, seems to be one step in the right direction. Supporting youth of color as they protest white conquest of cities is another.

6

"IS THIS REALLY WHAT WHITE PEOPLE DO" IN THE CREATIVE CAPITAL?

In the previous two chapters, I have discussed how the dynamic model of production in the Creative Capital, as well as its racist real estate practices, have reproduced racial and class inequalities. In this chapter, I turn to how shifts in consumer patterns privilege the cultural and economic interests of upwardly mobile and white people. This analysis is informed by both my interview with one youth alumnus and artist-mentor, as well as my own experiences moving through the city as a white consumer. Engaging with the dynamic consumer culture of the Creative Capital is necessary to inform youth-led political strategies that might oppose gentrification in the name of creativity.

In 2015, I spoke at length with one former youth participant, Luis, about how Providence had been gentrified through this creative city script. Luis's family immigrated to Providence from the Dominican Republic. He had been a steady presence at New Urban Arts for nearly a decade, first as a youth participant then as an artist-mentor. Luis is an important perspective to include in this account of youth in the creative city. When I discussed the Creative Capital with Luis, he did not see himself as a young person

who fit into the high-status creative underground scene of Providence. He did not feel that he belonged to this group even though he participated in New Urban Arts as a youth member for years. Here is how he explained his position in the Creative Capital and in this research:

Tyler: When you look back on the last decade in Providence, and you think about changes to the city as the Creative Capital, what do you think about Providence and what it means for you?

Luis: The thing is I don't . . . I don't know how to define myself within that. It's interesting for what it does mean for me. But I think most of my identity is really tied to New Urban Arts.

Tyler: How are you defining yourself through New Urban Arts?

Luis: Well, that's the thing . . . I don't think I'm gonna be your guy. There are several other people involved in this place who have very much made this city their city by being people of color and infiltrating those scenes and then like being really well respected in them. They are recognized in those communities as people of substance, who make work and do that kind of thing. I think their idea of a Creative Capital is different because they're actual creatives. I am just a guy who stuck around and didn't really say no to much and now I'm here. You know what I mean?

Tyler: What do you mean when you say that you didn't "say no to much"?

Luis: I don't know. . . . It's like, "Hey you! Do you want to do this thing?" And I'm like, "Yeah sure." And now, I'm like, I'm in year four of arts mentoring at New Urban Arts! So, it's different for me. I see these actual working artists who have big goals. They're actually working towards them, whether it is in a political punk rock band or as a photographer in the city. Those are those people.

 I'm not that person, I'm somebody who can come to New Urban Arts because it's neutral. It's not really downtown until you cross the bridge and you're not deep in any neighborhood. You're just kind of centered here. I get to work with youth here, which is really great. Then I get to go back to the

South Side where I live and stay there. So that's what I mean by, like, I'm not that guy.

In this revealing passage, Luis said that he does not know how to define himself within the logic of the Creative Capital. He preferred to tie most of his identity to New Urban Arts. He then suggested that he did not think he was "gonna be my guy." In other words, he did not think he would provide me the information about the Creative Capital that he thought that I wanted to hear. Instead, he implicitly pointed me to the "actual working artists" affiliated with New Urban Arts, those with "big goals," including those who are "in a political punk rock band" or are "photographers." These people of color, according to Luis, "infiltrated" the creative underground and have become recognized as "people of substance" in the Creative Capital. By contrast, he represented himself as a guy who was given opportunities at New Urban Arts that he could not turn down. He became an artist-mentor at New Urban Arts, for example, and he had the opportunity to help young people who wanted to go to college and pursue art degrees with their college portfolios. He later told me that he thought he had been "fucked" by this college application process when he was in high school, and he did not want the same thing to happen to young people from a similar background. So he helped them with their portfolios for their applications to art schools.

135

Luis also represented New Urban Arts as a "neutral" place—a place that was not downtown or too deep into any neighborhood. New Urban Arts is located geographically in a somewhat unique place in the city—not far from downtown but separated from it by Interstate 95 (a highway that cuts through the center of the city), and not far from the neighborhoods where young people who attend New Urban Arts live, but positioned at the starting point of three major roads that branch out and divide Providence into four different neighborhoods. As such, New Urban Arts is not semantically tied to those neighborhoods or their residents. It is "neutral." By contrast, downtown Providence has been branded the Downcity Arts and Entertainment District. Federal Hill is known as the historic Italian neighborhood. The West End is a gentrifying neighborhood that has become a white hipster haven over the past two decades. And Olneyville is another low-income neighborhood with old red-brick factory buildings where the creative underground scene has taken residence since the 1990s. The South Side is a neighborhood largely populated with people of color and recent immigrants, but has been gentrifying, according to several young people based on the newfound presence of white joggers. Rather than being pegged to any of these places symbolically, for Luis, New

Urban Arts was a place where he could become "just kind of centered" as an artist-mentor, working with youth. He was not, for example, a creative associated with the Olneyville scene. After working at New Urban Arts, he went home to his place in the South Side. His sense of identity was tied to the neutral location of his work and his South Side home.

While Luis stated that he did not know how to define himself in relation to the Creative Capital, he also said, "It's interesting for what it does mean for me." Luis began to notice cues for when he might get priced out of his home on the South Side. For example, he saw what he described as "the first white guy at a *chimi* truck." A *chimi* is a Dominican-style hamburger, and food trucks line up on Broad Street in the South Side to sell them. He noticed that the bodegas in his neighborhood, which used to be cash or food stamp only, were now accepting credit cards. He understood that there needed to be enough of an affluent clientele base with credit cards to justify the commercial cost of credit transactions. When I asked him what these changes meant for the South Side, he said, "I don't want to pay more than five bucks for a chimi. . . . I don't want to pay more than two dollars per pound for *platanos*. That shouldn't be a thing, you know. That's what that means. When I start seeing kale and cumin at fucking bodegas, I know something is up." Luis's perspective shows how the Creative Capital is haunting him. The prospect of gentrification by white people is threatening his way of life, his home, his access to affordable chimis and platanos.

Luis believed that the city's dynamic consumer culture was part of this state-orchestrated script for racialized class warfare. Here is how our conversation unfolded when I asked Luis to explain the Creative Capital to me:

Tyler: So, are you familiar with the idea of the Creative Capital?

Luis: Vaguely. . . . It started during Cicilline's run as mayor. So, basically, we have RISD on College Hill, and RISD attracts art students. These art students stick around and start moving into, you know, various neighborhoods, places like the West End. . . . It is an issue of gentrifying these neighborhoods. Providence started getting this underground music scene and these funky little restaurants like Julian's and shit . . . where it's just like, "Oh, we're white and we can do these things because Providence is totally cool." I don't know, I don't know what that means. I don't know anybody who lives on Knight Street anymore. You know what I mean? What is now E&O, was, like, *not* E&O.

Tyler: What's E&O?

Luis: It's this little dive bar that people seem to enjoy. Next to it was a skate shop, and now the skate shop is gone and it's a barbershop, which makes more sense to me. But it was interesting to me, to see the dive bar, next to the skate shop, down the street from, like, the fuckin' artisan pizza place. . . . So, I think the Creative Capital. . . . It's just weird. Downtown is completely different. Now there's Civil, which is a skate shop that I love . . . Sura, the sushi place . . . the Small Point Cafe is there . . . the Teriyaki House is there. . . . There used to be a furniture store. And Craftland is there now. So, there's a lot of new businesses, which is great for the city, but none of this shit was here just, like, three or four years ago. And I don't know if it's because of this Creative Capital push. . . . But what's the collateral, right?

Like other young people I interviewed from New Urban Arts, Luis was well aware that the Creative Capital was primarily invested in getting RISD and Brown graduates such as myself "to stick around" and "gentrify these neighborhoods."

He also noted how these young people help to produce a cultural divide between him and them through their consumer patterns. For example, he described the South Side as a neighborhood for Caribbean Hispanic (Puerto Rican, Dominican), Southeast Asian (Laotian, Cambodian), African American, and African (Cape Verdean) people since the 1970s. He pointed to Sanchez Market on Broad Street as the historic "stopping point for white folk" on the South Side in the recent past. And then, he said, he started to notice how white people were reaching further and further past Sanchez Market until they started coming from "both directions" on Broad Street. When he started to notice white people biking up and down Broad Street in both bike lanes, he told me that he started to ask himself, "What are you doing? Who? What?"

Indeed, I was part of this wave of young white people who started to move into these neighborhoods looking for rents that were affordable to us, while signifying our new cultural status by living in neighborhoods that we thought were up and coming, diverse and hip. I moved to a house just off Knight Street in the West End, a predominantly Latinx neighborhood, which fits into a racist and colorist pattern of white people moving into Latinx neighborhoods, not predominantly black ones, based on the assumption that

they are safer, better, and so on. Luis argued that these white people bring "fuckin' artisan pizza places," "dive bars," and "funky little restaurants" into these neighborhoods, his neighborhood. In observing this trend, Luis said, "When you see white people on bikes in the South Side, you start thinking to yourself, 'What's the timeline for when I might get priced out?!'"

Not only did Luis provide an inventory of these new bars and restaurants opening up in his neighborhood, he described the rapid pace of their arrival ("Downtown is completely different." "None of this shit was here just three or four years ago."). Luis also attempted to interpret the meanings of those changes ("I don't know, I don't know what that means."). His primary conclusion was that these new patterns of symbolic consumption in Providence privilege white people and their cultural status as cool people. As he put it, white people can go to these funky little restaurants and dive bars, and think to themselves, "Oh, we're white and we can do these things because Providence is totally cool."

Yet he argued that privileging white people in the city and their desire to be cool produced "collateral" damage. For example, he mentioned that he did not know anyone who lived on Knight Street (a street in the West End near the E&O dive bar) anymore. He appeared to suggest that he had lost his social network tied to that particular street. He mentioned the one shop that made sense to him, the barber shop, which actually provided the services, and perhaps social relationships, that he needed and wanted. But, with some exceptions, such as the skate shop, he argued that most of the shops were not meant for him. Moreover, the rapid arrival of the new shops, bars, and restaurants meant that he was at risk of getting priced out of his neighborhood as he was forced to pay more for chimis, platanos, and, ultimately, rent.

Later in the interview, I asked Luis how residents on the South Side—who lived in the neighborhood before the city was branded as creative—were expected to participate in the Creative Capital.

> Tyler: What is the expectation of the Creative Capital for people living on the South Side? What are they supposed to do in the Creative Capital? How are they supposed to participate?
>
> Luis: I don't think they have to do anything for the Creative Capital. I think it is capitalizing on things that they already do. If you go by Broad Street, you'll notice that now there are all these new street signs and banners. You know, where it's like the Providence creative branding or whatever and then it's like "Broad Street, The Food." Have you seen these? And

there's an illustration of, you know, the food. And it's like "Broad Street, The Culture." "Broad Street, The Music."

You know, there are communities of color here who have brought with them their practices and art and minority-owned businesses who care for those things . . . Asian fish markets, bodegas, whatever. And you know, these spaces get that reputation . . . like, here's this thing. But we knew that. This branding is for other folk who may not have known that.

Tyler: You know that because you have lived there?

Luis: Yeah, like I knew that, I knew Apsara (a Southeast Asian restaurant) was the shit because it's down the street. You know what I mean? I don't think that people in my neighborhood have to do a damn thing. I think the city is trying to, you know, capitalize on that, that there is this thing that they didn't have to really fight for. You know what I mean? It's not the same as like the bougie ramen place downtown, you know?

Tyler: Right. It's the "ethnic" Apsara.

Luis: (*Laughing.*) That's right, the "ethnic" Apsara.

Tyler: This is where you can get the "real" ethnic food in the Creative Capital.

Luis: Exactly, that's exactly it. I think that's the thought process behind that. You know?

Tyler: So, you can get your bougie hipster gluten-free kale over in this neighborhood, and then you can get your real ethnic chimi sandwich and your Apsara spring rolls over in that neighborhood?

Luis: Yeah. Pretty much. It's hilarious. (*Laughing.*) It just sounds so absurd right? "Broad Street, The Food." It's like, what are you? (*Still laughing.*) When you look at a place like La Sonrisa [Dominican restaurant] or at Pho Paradise [Vietnamese restaurant], like, first glance you think nothing of these places because they're not, they're not Julian's [hip bistro in the West End]. There's no kitsch, right? It's very matter of fact. And then when you walk in and you actually have the food, it's when it hits you . . . "Oh shit, this is great!" It's always funny

when you run into people who act like they discovered it. (*Laughing.*) You know what I mean? I'm pretty sure you're not the first person to have pho at the Paradise.

In this passage, Luis argues that people of color in the South Side do not have "to do anything for the Creative Capital." What they have done, Luis suggests, is already introduce cultural practices from their home countries and ethnic traditions, and they have "fought" to build minority-owned businesses in these neighborhoods before they were branded in ways that he thought were absurd. Luis thought that these branding efforts in his neighborhood were attempting to "capitalize on things" that people venturing into his neighborhood did not have to fight for. This capitalization was primarily for the benefit of "other folk," presumably white folk such as myself, whose cultural status becomes elevated in the Creative Capital through our self-presumed discovery of authentic Vietnamese noodle soup (pho), aided by the city's own branding efforts.

Three themes feature in Luis's analysis of consumer patterns in the Creative Capital that privilege whiteness. He discussed white people desiring "matter-of-fact" ethnic restaurants, artisanal restaurants, and funky, hip restaurants with ironic kitsch. I analyze each of these themes more closely to probe how consumption structures the symbolic conditions in ways that make white people feel cool while they gentrify neighborhoods. I also consider my own professional trajectory and social interactions in relation to these new symbolic conditions associated with white creativity. This thematic analysis is not meant to be exhaustive of new consumer patterns in the Creative Capital, and it is important to recognize that consumer patterns are dynamic, and therefore this analysis is always in need of being updated. But critical interpretations of these consumer patterns and the racist and classist patterns they represent are useful in understanding how and why they should be resisted in order to support racial and economic justice for youth living in gentrifying cities.

"MATTER OF FACT" ETHNIC RESTAURANTS

In my conversation with Luis, he pointed to white people arriving in his neighborhood and acting like they had "discovered" places such as Apsara and Pho Paradise. He said that he already knew that these restaurants were "the shit" because, in the case of Apsara, it was located down the street from his house. He described these ethnic restaurants as "matter of fact." He argued that the aesthetic sensibility of these restaurants contrasted with the hip

bistros and dive bars such as Julian's, which were kitsch. For Luis, the juxta-position between "matter of fact" ethnic restaurants and kitsch bistros is sym-bolically significant for white people coming into the neighborhood to dine and drink. In the case of the former, "real" ethnic restaurants, as I put it, are culturally desirable because they provide the opportunity for white people to taste what they think is authentically different.

In her essay, "Eating the Other," the critical race and feminist scholar bell hooks critiques the white consumer desire for "real" ethnic difference. She draws metaphorically on the ancient religious practice of people ripping out and eating another person's heart to embody that person's spirit or spe-cial characteristics.[1] hooks writes of "eating the Other" to speak of the ways in which white people assert their cultural supremacy by, for example, consum-ing the cultural practices of those that they have *othered,* while transforming themselves in the process. These white people make themselves "vulnerable to the seduction of difference" without relinquishing their position of domi-nance.[2] They can experience their essentialized conception of otherness while at the same time signaling that they remain installed in a position of superior-ity. My white desire to start New Urban Arts and to write this book could be critiqued along similar lines. In other words, one could suggest that I started New Urban Arts (and even wrote this book) to locate myself in proximity to young people of color, to "taste" their difference, while also trying to elevate myself above them as a white savior founder of New Urban Arts or race-class-conscious author of the *Creative Underclass.*

The city of Providence has, as Luis put it, "capitalized" on this white de-sire to eat the Other through its own place branding efforts. Through "Broad Street, The Food," the city has attempted to lure white people down Broad Street from both directions so that they can "discover" otherness. Of course, the counterargument is that the city attempted to build the market capacity of minority-owned businesses through its marketing efforts to attract new consumers. From this perspective, the marketing campaign is not racist; it is just that consumers with more money to spend happen to be white. But that argument misses the fact that the consumer marketplace is never "natural." It is a product of history, a history of racial capitalism.[3] State-orchestrated marketing campaigns cannot operate outside that history despite their best intentions. So, as much as these place-branding efforts are designed to spur consumer investment in low-income neighborhoods, this marketing is always already in entangled in a system of relations that privilege whiteness and open the doors to white-led gentrification.

DIVE BARS AND FUNKY LITTLE RESTAURANTS

In his analysis of consumption in the Creative Capital, Luis noted how funky little restaurants and dive bars are desirable to white people because these establishments have kitsch, not because they are "matter of fact." Kitsch works through an intentionally low-brow aesthetic, which allows people to reassert their culturally elevated status through demonstrating their understanding of the intention to be low-brow. When I asked several young people from New Urban Arts about places in the city that represented this ironic hipster taste, several of them pointed me to Ogie's Trailer Park, a restaurant that opened recently in the West End and is located up the street from New Urban Arts' studio where many of them grew up.

Ogie's Trailer Park traffics in the image and identity of low-income white people living in trailer parks, perhaps from Appalachian country. Restaurant goers can drink one of sixty-six types of canned beer while they eat a "Granny Boo's Badass Bacon Burger" or "June Bug's Seasonal Salad of the Moment." This sort of restaurant, as well as the "dive bar" that Luis mentioned, provide symbolic experiences in which upwardly mobile and white people in Providence can perform a lower-class white identity while at the same time distancing themselves from an identity that they believe to be culturally deprived. They can thus experience this identity while mocking it, making themselves superior to poor white people through classist irony. When Luis talked about the "little dive bar" that white people seem to enjoy—E&O—he was referencing this tendency of relatively affluent white people to slum it, to disavow themselves, perhaps, from the vulgar materialism of "bougie" people on the East Side while also maintaining their superiority over poor white people living in flyover country.

This use of irony has played out in symbolic social interactions with respect to race, which helps to illuminate the relationship between ironic class-based consumption and gentrification. After moving back to Providence in 2012, I quickly found myself slipping back into a specific form of ironic racist banter that I learned as an undergraduate at Brown University. Lindy West describes this discursive mode whereby white people use racist language as a joke, to "prove we're not racist by acting as casually as racist as possible."[4] This "hipster racism" is a way for white people who think they are race conscious to transgress the constraints imposed by political correctness. We can say racist thoughts that we are structured to think through self-aware racist jokes, which we think would normally be stated by people who are culturally beneath us.

I found myself resorting to this racist speech strategy once within days of returning to Providence in 2012 after a five-year absence. In doing so, it became obvious to me how Providence is a particular place that is structured in racial dominance through these kind of ironic performative speech acts, which privileges the position of white graduates from Brown and RISD. After all, I did not resort to this kind of speech act while studying at the University of Cambridge from 2007 to 2012, where, needless to say, conversations about race were absent in my chosen circles. Moreover, this ironic racist discourse was different from the overt white supremacist language that I learned growing up in Columbus, Ohio in the 1980s. But in Providence, I had discovered that this kind of ironic speech act had a special kind of currency, which perversely suggested to us our racial progress while at the same time keeping interpersonal and structural racism intact. When I resorted to this device once when I moved back to Providence in 2012, I apologized for the pain that I caused another person, and I realized that I was nowhere close to where I needed to be in terms of reeducating myself with respect to race and racism.

Eating and hanging out at Ogie's Trailer Park shows that hipster classism, not hipster racism, still remains acceptable in terms of everyday consumption in the Creative Capital. People can elevate their cultural status by mocking the poor. But at Ogie's Trailer Park, poverty is articulated to white people living in trailer parks, not to people of color living in the neighborhood. In this way, hipster classism obscures the role of upwardly mobile people and white people who are gentrifying the neighborhood at the expense of poor people of color living next to Ogie's Trailer Park. The ironic register of Ogie's Trailer Park would be less plausible to white consumers—at least I think—if it drew on culturally deficient stereotypes constructed by whiteness for people of color living on that same street. That symbolic consumption would make their own position as racist gentrifiers more visible and therefore less tenable. Instead, when white people want to consume "ethnic" difference in the Creative Capital, they want to consume the "real" thing, not an ironic rendition.

ARTISANSHIP

In his observation of consumer changes in the neighborhood, Luis noted the "fuckin' artisan pizza place" down the street from the dive bar and the funky little restaurant. An artisan pizza place is one that serves high-priced and handcrafted pizza with fresh ingredients, perhaps cooked in a wood-fired oven. Luis was clearly deriding the pizza place as "fuckin' artisan." Luis also mentioned another example of artisanal consumption in Providence, namely

143

the store Craftland. Craftland features handcrafted work such as screen-printed baby clothes and posters, handmade jewelry, holiday cards, and home decor items. What Luis might not have known is that I played a role in launching Craftland in order to support New Urban Arts. Indeed, Craftland began as a holiday craft sale in New Urban Arts' studio.

The purpose of Craftland was to provide a source of revenue for emerging artists, designers, and craftspeople in Providence, while fundraising for New Urban Arts. After a few years, Craftland, which is no longer affiliated with New Urban Arts, opened a permanent location in the newly fashionable shopping district in downtown Providence. On the one hand, Craftland could be considered a well-intentioned strategy to raise money for New Urban Arts. On the other, it could be critiqued as a "gentrifying force" that introduced the cultural tastes and preferences of affluent and white people moving into the West End and, later, downtown. This contradiction speaks to the very bind that I faced as a nonprofit leader at New Urban Arts given the fact that its youth cannot pay tuition. With fierce competition for philanthropic dollars, and minimal public funding, I was forced to turn to the marketplace to support New Urban Arts. One way to do that was to capitalize on, and contribute to, the new symbolic economy of Providence as a creative city and a city of artisanship.

After I left New Urban Arts, its new leadership started a new holiday sale, "Cardboard Pancakes." This sale sells artwork produced by youth participants, artist-mentors, and alumni, as well as local artists. Luis himself has produced craft goods to sell through Cardboard Pancakes. One year, he stamped pieces of cardstock with snowflakes and sold them as stationary. When I asked him why he did that, he said he was trying to make stationary look "bougie." In other words, Luis was making a product that appeared artisanal, or was artisanal, to appeal to consumers living in, and visiting, the Creative Capital.

In her article "Art, Design, and Gentrification" (2015), Rebekah Modrak critiqued what she called "bougie crap" and its relationship to gentrification. Modrak defined "bougie crap" as "a design aesthetic of calculated authenticity and elements of hand-craft or personalization to suggest that the product is motivated by these values and not by crass economic gain."[5] Through this motif of artisanship, consumers signal their honorific status by purchasing handmade crafts, not machine-made items produced on distant shores and sold in generic box stores. Modrak noted that these products often claim a connection with both rural and urban traditions of manual labor and work.[6]

For Modrak the arrival of this bougie crap produces a two-tiered cul-

tural and economic divide between those who can afford these products and those who cannot. When affluent people move to a neighborhood marked by higher levels of poverty, they consume "bougie crap" that is accessible only to themselves.[7] This imposition registers to those who lived in the neighborhood, before it became creative, that the economic and cultural quality of their neighborhood is changing and, for them, may soon disappear. Luis, it seems, was well aware of this calculated authenticity as he tried to make money for himself and for New Urban Arts. So Luis himself was confronting the competing demands of the Creative Capital—raising money for himself and the creative education of his peers while at the same time contributing to a symbolic economy that altered the cultural and economic fabric of the city at their expense and for the benefit of "bougie" people.

In summary, Luis's analysis of shifting symbolic consumer patterns points to the fact that Providence has become a city where white people feel entitled to do things, including shopping for bougie crap and dining in authentic "ethnic" or "artisanal" restaurants as they gentrify neighborhoods, because Providence is cool and creative. This manufactured social understanding of the city as cool and creative, which Luis believed reasserted white entitlement and cultural supremacy, is at odds with a city meant to serve the cultural and economic interests of "troubled youth." Of course, the counterargument is that this injection of consumers into the West End and the South Side attracts much-needed capital investment into those low-income neighborhoods, which would then expand the property tax base and the city's capacity to deliver public services to young people such as Luis—a kind of "trickle down" creative city politics. But Luis did not trust this script, and for good reason. Instead, he laughed about the absurdity of the city's efforts to rebrand his neighborhood and he feared the velocity of the changes near his home. After all, he did not want to pay five dollars for a chimi before being displaced from his neighborhood.

REBRANDING THE LIVELY EXPERIMENT

Luis could not stop laughing when he discussed the city's efforts to rebrand Broad Street as a place for white people to consume ethnic culture, music, and food. He said that this branding campaign was "for other folk" who did not live in his neighborhood. "Other folk" is an obvious reference to people who are white and/or affluent. This particular marketing campaign on Broad Street was part of the city's effort to alter the dominant way of thinking about different neighborhoods in the city and drive inward capital investment.

As mayor David Cicilline unveiled his creative city plan for Providence,

his administration hired a marketing firm, North Star Destination Strategies, based in Nashville, Tennessee, to lead a rebranding exercise for the city. North Star Destination Strategies describes itself as "community brand avengers" in their promotional materials online—a firm that is "saving the world one community reputation at a time."[8] Their list of clients includes Miami County, Ohio ("Home. Grown. Great."); Brookings, South Dakota ("Bring Your Dreams"); Greater Lansing, Michigan ("Where culture and creativity come together"); and Cape Girardeau, Missouri ("Where the river turns a thousand tales").[9]

For Providence, North Star opted to focus on the city's history of being a "lively experiment," a reference to Rhode Island's founding state charter that promised religious freedom through the separation of church and state. According to North Star, the essence of Rhode Island's capital city, Providence, is its "openness . . . to experimentation, improvisation, self-expression and independence. In fact, original thinking is the mantra of Providence. Whether you're talking industry, art, education or lifestyle the people of this dynamic capital city don't want to be pigeonholed into a solitary way of thinking."[10]

Along with a new brand and logo, Providence launched a public relations and marketing campaign that solidified this new image of the city as a creative lifestyle destination. This campaign was designed to transform the image of the city from a dangerous city populated with "scary youths" into a city where upwardly mobile and white people could feel safe and secure as they experienced this sense of themselves as dynamic, self-expressive, and independent. But given that the city was not producing many jobs in the creative sector, people were going to experience this sense of creativity through consumption, not production, in the Creative Capital.

Jamie Peck, who is a professor of urban and regional political economy, as well as a critic of creative city politics, has argued that cities have turned to rebranding exercises through the conventional creative city script precisely because this strategy is inexpensive.[11] In other words, city officials have tried to alter the image of their cities through cheap marketing ploys because they do not have the resources needed to invest in infrastructure and public services. Indeed, the city of Providence has had a structural budget imbalance, caused by both disinvestment, which led to a diminished property tax base, and existing expenditure commitments to police officers, firefighters, and teachers. This imbalance led to Moody's Investors Service cutting its outlook on Providence's credit rating to negative in 2015, which made it more expensive for the city to service its debt.[12] In 2015, the city of Providence approved expenditures of over $678 million in its annual budget. The majority of those expenses were pegged to three sources: the police department ($68.6 million;

10.11 percent), the fire department ($70.1 million; 10.34 percent), and the public schools ($345.1 million; 50.88 percent). Together, spending from these three entities comprised 71.33 percent of the total approved budget.[13] In stark contrast, the Department of Art, Culture and Tourism, the agency responsible for shepherding *Creative Providence*, had an approved budget of $629,000 (0.92 percent). This disparity points to how little the creative city strategy has cost Providence (other than the tax subsidies to wealthy landowners and property developers). Rebranding the city as creative was a cheap municipal strategy designed to drive upmarket property development with the hope of expanding the property tax base and, in turn, increasing the city's capacity to provide better resourced public services.

The contradiction of this strategy is obvious to see. In a planning session for Federal Hill, a historically Italian neighborhood, Cicilline stated that the neighborhood could be, as Ian Donnis reported, "a local version of Boston's Newbury Street—a place marked by astronomical rents and high-end boutiques—while also citing goals for the area of a good public transit, parks, and mixed-income residences."[14] So, on the one hand, Cicilline wanted to transform a working-class neighborhood into an upmarket neighborhood to generate much-needed property tax revenue. And on the other hand, he was trying to deliver better public services, including transit, parks, and access to secure, low-income housing. Those two aims, which are structured through local property tax policy, are difficult, if not impossible, to reconcile for mayors of American cities. There will always be "collateral" under this model for low-income publics, which, given the problematic and racist history of the United States and the city, are more likely to be communities of color. Moreover, majority white communities have long exploited this tax policy to reassert their position as beneficiaries of better resourced public services, such as public schools.[15]

Nonetheless, media coverage in Providence has both amplified the city's self-promoted image as the Creative Capital and obscured these contradictions and collateral damages. For example, in 2005, in an article in the *New York Times'* Travel section titled "In Providence, Faded Area Finds Fresh Appeal," Bonnie Tsui celebrated the West End for its coffee shop, high-end home furnishing store, and handmade stationary store, as well as a "bohemian-bistro" and a vintage home furnishing store on nearby Broadway. As I already pointed out, this coverage of the West End highlighted new hip consumer patterns in the neighborhood and claimed that those changes were led by the "community." This absurd representation of the community leading its own displacement is designed to mask the collateral damage to "the community."

147

In 2008, Elizabeth Abbott published an article titled "In Providence, Progress in Reviving an Urban Desert" in the *New York Times* Commercial Real Estate section.[16] This article described a $300 million development project on a nearby 18.5-acre industrial complex, with plans for as many as five hundred condominium and rental units and nearly two million square feet of commercial and retail space.[17] Like the vocabulary of "a faded area finds fresh appeal," the phrase "reviving an urban desert" suggests that making a city more upmarket, and inevitably more white, is progress, an improvement over the days of "faded areas" and "urban deserts." These representations suggest that no one actually lives in, for example, an "urban desert." That place is placeless. The collateral damage to young people and their families living in these neighborhoods is also obscured by this construction of urban space as placeless. These representations thus support Luis's claim that rebranding the Creative Capital is about convincing white people to believe they get to do things in the city and feel cool doing it, which requires invisibilizing the racist collateral damage caused by their own actions.

Magazine rankings have also glorified this new urban transformation. In 2013, *Travel and Leisure* ranked Providence as the fourth most "hipster city" in the country. According to the magazine, Providence now stands on "the cutting edge of culture" and embraces "simple, retro charms."[18] The magazine took special note of a chic downtown hotel located in a former brothel that features "peekaboo bathrooms." In 2014, *Travel and Leisure* ranked Providence America's "Favorite City," noting that its downtown has "gone from seedy to hip," where the nation's oldest indoor shopping mall is now a retail hub with "micro-loft apartments." Its downtown Westminster Street is now a Europeanesque "boulevard" with boutiques, galleries, and wine shops. In these rankings, Providence has been recognized as a culinary capital where people can "queue up for a table at North, a modern Asian hot spot by James Mark, a David Chang protégé, or book at Birch, an ambitious chef's counter with a focus on local ingredients (whelks, quahogs, foraged herbs)."[19]

Social media also contributes to this new and now dominant way of thinking about Providence as a city where white people get to be hip and do cool things. Zagat, for example, compiles on its website individual user reviews of different venues in Providence and makes them available through Google Maps searches. These reviews provide a glimpse into the meanings of new venues in Providence for its new consumers. For one bar in the West End, users note that it is a "speakeasy-esque bar" where "learned barkeeps" impress a "cool" clientele "of all stripes."[20] Another restaurant nearby, according to Zagat, is a "hip outpost" for "cutting-edge small plates."

Through these various representations, affluent and white consumers are positioned as if they are headed into a lawless frontier, acting as pioneers who are titillated by the risk and the adventure that comes with hanging out in former brothels, sneaking into speakeasy bars, and encountering people of "all stripes."[21] People who move through the city with relative impunity—that is, white people—are privileged, whereas "striped" people become mere ethnic backdrops for white pleasure and self-proclaimed racial tolerance. "Striped" people are reduced to "spectacles of ethnicity."[22] The problem with this spectacle, Hall argued, is that it is a "willful diversion" from the "deeper structures of institutionalized racial disadvantage operative in housing, education, employment, wages, working conditions, and welfare."[23] The supremacy of politically progressive white people, such as myself, is reasserted through this spectacle because we can signal our virtue, as antiracist, by locating ourselves in proximity to people of "all stripes" amidst this new urbanism without ceding any power, resources, or opportunities. These representations show how the Creative Capital is invested in the unbridled enjoyment of white people as a special property right.[24]

Property developers' own branding efforts have also amplified this image of the city as a place for white people to do cool things. For example, the Armory Revival Company, once New Urban Arts' landlord, started to develop old industrial properties in low-income neighborhoods that they touted as a "celebration of the city's industrial past."[25] They claimed that physical sites in low-income neighborhoods were becoming places "where artists converge, businesses and nonprofits thrive, neighbors gather, and the community celebrates."[26] Here is another problematic and euphemistic use of "the community" that is somehow celebrating its own displacement. After all, one of Armory Revival's realtors was caught on videotape telling a pair of prospective renters that an "us and them" atmosphere existed between the inhabitants of one refurbished mill and those who lived in the surrounding "ghetto."[27] The realtor told the renters that the company would have "bought out pretty much everything that we can buy—so, in two years, five years, we'll pretty much have made this a really cool neighborhood to live in."[28] In this case, there was no shame in promising white people the opportunity to live in a really cool neighborhood, while those living in the "ghetto" would be pushed out over time.

These problematic representations in the media and by property developers have supported the city's inexpensive rebranding exercise through the conventional creative city script. Together, they have been successful in transforming the dominant way of thinking in and about Providence, from an ag-

ing city that is populated with "scary youths" to a youthful city for upwardly mobile and white people to be cool and to consume difference without having to worry about collateral damage these actions cause to people living in the "ghetto." Such an approach to place-based marketing is clearly at odds with supporting low-income youth of color who lived in the city before the city became creative in the white public imaginary. The city's approach to funding the arts has also been key to this cultural reconfiguration of Providence.

ART WORKS IN THE CREATIVE CAPITAL

When Luis was giving me a symbolic tour of restaurants and bars in Providence, he also brought up Providence WaterFire, a public art installation and spectacle created in 1994 by the artist Barnaby Evans. At WaterFire, people gather around cauldrons of fire that are floating on rivers in WaterPlace Park, the park that mayor Buddy Cianci developed in the 1990s as a part of his "Renaissance City" renewal project. WaterFire occurs regularly throughout the year, but mainly in the summer. People gather in the evening alongside the riverbanks to look at fires burning in a row of cauldrons floating down the center of the river. They listen to dry firewood pop, as well as classical and world music projected from outdoor speakers. WaterFire has become a symbol of the city's renewal and its creative brand. Indeed, an image of Providence Water-Fire graces the cover of Providence's creative city plan.[29] This event is powerful symbolically for the city because water and fire suggest birth and baptism, rebirth and renewal. But Luis interpreted WaterFire differently:

> So WaterFire is a way to get white people downtown to see these torches lighting these baskets of fire along the river. It's something out of a fucking Stanley Kubrick movie, right? There is somber music playing and a bunch of people staring at flaming water. . . . I guess the point is that, since all these people are in the city, then they can go to restaurants or go to the mall. That's how you generate more income. Maybe it was because I was a teenager, but I remember thinking to myself the one time I went, "Is this really what white people do?"

For Luis, downtown was now a place where white people could go to be cool, playing their part in a weird Stanley Kubrick film. Indeed, another young person that I interviewed said that they—note gender-neutral pronoun—were terrified the one time that they went to WaterFire to see a mass of white people engaged in this fire ritual, which, they said, felt threatening to them as a gender-nonconforming young person of color. But not all young people from New Urban Arts shared their perspectives about Providence WaterFire. Some

150

young people have mentioned to staff at New Urban Arts that WaterFire is a good option for a free date night. One young person also said to me in an interview that WaterFire is a symbol of Providence's creativity. As a result, WaterFire was important to her because it helped her identify as a creative from Providence.

My intention, of course, is not to single out Barnaby Evans and Providence WaterFire as I share these contrasting perspectives. After all, some of these same criticisms could be levied against me and my leadership at New Urban Arts. I transformed a storefront shop in a low-income neighborhood into a studio gallery space with hardwood floors and white-painted walls. This studio gallery design served the needs of the program, but it also appealed to my own aesthetic sensibilities and some of the artist-mentors I recruited to participate in New Urban Arts. I did not consider how the design of the studio space imparts class- and race-based messages. I did not consider how New Urban Arts could function as a gateway into the neighborhood for future white gentrifiers, inviting more and more young creatives into the neighborhood until they transformed the social, cultural, and economic fabric of nearby neighborhoods. So both New Urban Arts and WaterFire were entangled in rebranding different parts of the city, suggesting to white people that these areas were now safe spaces for them to come and do things because Providence is totally cool, because they are totally cool.

But Luis's perspective is important because it sheds light on how municipal funding of the arts has helped to reshape the symbolic meaning of the downtown area. As I have pointed out, New Urban Arts rarely, if ever, has been a recipient of public funding from the city precisely because it does not contribute to tourism. It helps "troubled youth." By contrast, both the City of Providence and the Providence Tourism Council sponsor Providence Water-Fire. And this funding approach by the city exemplifies the dominant approach to public funding of the arts during the past decade.

Rocco Landesman, the director of the National Endowment for the Arts (NEA) between 2009 and 2012, announced "Art Works" as the new slogan for this national public agency that provides grants and steers national cultural policy. This slogan suggested that art works are hard at work, as the NEA put it, "empowering creativity and innovation in our society and economy."[30] For the city of Providence, empowering creativity and innovation has meant stimulating the economy through sparking consumer spending because, in actuality, the city has not produced "real jobs" in the creative sector.[31] As Luis put it, the point is to get these white people into the city so they can spend money at the restaurant and the mall. Laura added to this observation when

she said that the Creative Capital is designed to get people to stay in the city's hotels, which most likely do not pay a living wage to its employees.

So, creative place-marketing and funding the arts have been designed to work in tandem to drive consumer spending in the city for the benefit of these consumers. Indeed, Angel Taveras, the mayor who succeeded David Cicilline in 2011, and who was also one of New Urban Arts' founding board members, argued that the growth of Providence's consumer economy through tourism was key to Providence's future after the Great Recession.[32] In his plan for "Putting Providence Back to Work," Taveras noted that the demand for Providence's hotel rooms has been driven by its image as "a hipster city," which draws tourists and visitors to Providence's restaurants, vibrant nightlife, and thriving arts and culture scene.[33] In 2012, hotel occupancy rates in Providence reached a record high, increasing from 63.8 percent in 2010 to 67.9 percent two years later.[34]

The theory for how and why tourism is significant in postindustrial economies depends upon what is called economic-base theory. Americans for the Arts, a national arts advocacy organization in the United States, explained this theory, and its relevance to arts organizations, as follows:

> A common theory of community growth is that an area must export goods and services if it is to prosper economically. This theory is called economic-base theory, and it depends on dividing the economy into two sectors: the export sector and the local sector. Exporters, such as automobile manufacturers, hotels, and department stores, obtain income from customers outside of the community. This "export income" then enters the local economy in the form of salaries, purchases of materials, dividends, and so forth, and becomes income to local residents. Much of it is respent locally; some, however, is spent for goods imported from outside of the community. The dollars respent locally have a positive economic impact as they continue to circulate through the local economy. This theory applies to arts organizations as well as to other producers.[35]

According to this perspective, the arts are economically significant in postindustrial cities because they can help redress the decline in export income due to the decline of manufacturing. The arts stimulate export income by producing new symbolic associations for the city, such as creativity, which then attract visitors and tourists who bring their money from elsewhere. They spend money locally at arts venues, restaurants, the mall, and new shops featured in travel magazines and newspaper articles.

Providence, of course, has needed this new source of export income. The city experienced a sustained decline in manufacturing employment as a result of global capital's never-ending desire for cheaper and more desperate labor elsewhere.[36] Rhode Island ranked third among states for the highest rate of manufacturing job loss between 2000 and 2012 (42.4 percent), and Providence experienced a 7.1 percent loss of manufacturing jobs during that same period.[37] This city was so vulnerable to the uneven effects of offshoring because so much of its industry was low-skilled, thus making the jobs easier to relocate elsewhere. As a result, turning to the arts to drive tourism and export income has become an important economic development strategy in Providence.

Americans for the Arts has suggested that investing in the arts has produced good economic returns for the city. For example, the organization published a report that analyzed the economic impact of nonprofit arts and culture organizations, such as Trinity Repertory Company, Providence's Tony-award-winning resident professional theater.[38] In 2010, according to Americans for the Arts, these nonprofit arts organizations in Providence spent $84 million and generated $106.1 million in event-related spending from their audiences.[39] This combined spending of $190.1 million was eight times greater than the median of similarly-sized cities.[40] Americans for the Arts estimated that this combined income could be expected to support over 4,500 full-time equivalent jobs by generating $107 million in household income to local residents and producing $19.0 million in local and state government revenue.[41] The data were used to provide evidence that public and private funding for arts and culture has been an investment, producing a return in the forms of jobs, local wealth, and municipal revenue.

But much like the financial figures on public investment in historic buildings with a creative aesthetic, these figures do not indicate who benefits and who loses from this return on investment. This public funding privileges these publics that have money to spend to travel, that have a possessive desire to assert their cultural status by going to the theater or symphony, or speakeasy bars and kitsch bistros. If we listen to young people at New Urban Arts, we can clearly see how they believe that the primary beneficiaries are young people such as myself who came to the city to attend Brown and RISD, the "East Siders" who participate in the "bougie" art scene, and the visitors to the city who stay in hotels that do not pay a living wage to their employees. From their perspective, this new symbolic economy is in conflict with supporting the cultural tastes and preferences of "troubled youth" who choose to participate in programs such as New Urban Arts. By the time expanded public

services for youth might come to the Creative Capital, they might no longer be able to afford to live in the city or see their shared ways of life represented there.

Fighting for their futures in Providence will require a far more politicized conception of culture in the Creative Capital. The city will have to move away from inexpensive rebranding exercises and funding artworks that especially drive tourism and consumer spending, thus enabling upwardly mobile people and/or white people to feel edgy as pioneers or race-conscious discoverers of difference. It will have to stop producing a symbolic economy that reasserts white people's sense of entitlement to gentrify the city without having to worry about the racist collateral. But the fact is that successive mayoral administrations in Providence will have to negotiate the contradiction of expanding the property tax base and providing public services to low-income communities. Moreover, they are dependent upon the financial donations of affluent and white landowners and property developers who are invested in their own profitability and self-interested sense of civic duty. As a result, this politicized conception of culture will not come without direct political action, and such action can and should be complemented by the cultural strategies developed by young people at New Urban Arts.

Conclusion

A few years after New Urban Arts was founded in 1997, I was invited to give the keynote address at the National Young Leaders Conference in Washington, DC, an event hosted by the Congressional Youth Leadership Council. The conference is designed to spark civic engagement among students about to graduate from high school. The conference auditorium for that speech was filled with young people who had similar socioeconomic backgrounds to mine. During that speech, I told the aspiring youth civic leaders in the room that our entrepreneurial leadership in the nonprofit sector was going to level the playing field in our lifetimes. It is the only speech that I have ever given that resulted in a standing ovation. My message resonated with these young people at that particular moment. Like me, they were discovering a trajectory in life that allowed them to reassert their privileged social status while at the same time committing to the common good through the emerging practice of social entrepreneurship. I think it was unclear to most of us in the room that day how and why we were being summoned to live our lives in that particular way. Or, as I have argued through this book, we were invested in not knowing.

The discourse of social entrepreneurship was taking off at places such as Brown University in the 1990s. Indeed, Brown had established itself as a national leader in institutionalizing entrepreneurial students engaged in public service. In 1986, the president of Brown, Howard Swearer, established one of the first endowed public service centers at universities in the country, placing Brown at the forefront of what the Swearer Center has called a

"revolution" in higher education.[1] The Swearer Center, much like other university public service centers, provides a variety of public service opportunities locally, nationally, and abroad. As a first-year student in college in 1994, I began to venture into the city's public schools through Swearer Center mentoring programs. As an upper-level student, I then took on paid leadership opportunities to facilitate the volunteering of my peers in similar programs, before winning a fellowship from the center to start New Urban Arts. This model of institutionalized public service opportunities has been replicated nationally.

At their best, public service centers such as the Swearer Center play a productive role in forging solidarities of praxis between college students and their community partners, putting both in a position to produce ideas together that contribute to more informed activism. Peter Hocking, the director of the Swearer Center when I was a student at Brown, and a key figure in advising me as I started New Urban Arts, was a strong advocate for this orientation. I have tried to write this book in that tradition. At their worst, however, these institutions invest in the cultural and economic status of race-class privileged young people as they extract time, labor, and ideas from marginalized communities. In my experience, these public service institutions can be complex places where both processes are playing out simultaneously.

As I participated in the Swearer Center in the 1990s, the emerging trend in public service was social entrepreneurship. Aspiring and privileged civic leaders, trained in the methods of public service, were launching and directing private nonprofit organizations and site-managed charter schools. It became the fashionable thing to do, unlike, for example, working in local, state, or national government or taking to the streets to protest injustices reproduced by social institutions. We were being recruited to look for a third way.

For those of us at Brown interested in education in the 1990s, our entrepreneurial efforts were undoubtedly influenced by Ted Sizer, a professor of education at Brown.[2] At the time, Sizer was pushing forward an ambitious national high school reform agenda influenced by the progressive educational ideas of John Dewey. His "Coalition of Essential Schools" was committed to transforming comprehensive and vocationally oriented public high schools into small, intellectually rigorous learning communities.[3] I met Professor Sizer during his office hours in 1997 after reading one of his books to discuss my ideas for New Urban Arts. My idea for this youth-led and studio-based learning community was surely influenced by this locally significant conversation about small site-managed schools and the power of democratic learning spaces.

What was invisible to me then, or what I was invested in not seeing, was how this vision for social and educational entrepreneurship safely fit within the political viewpoint that the state is ineffective in providing equitable opportunities through, for example, district-managed public schools or even the redistribution of opportunity through public welfare. Market-based reforms have become rampant in all aspects of social life, including education, and it needed social entrepreneurs to play the part. In other words, the very possibility that I could make it as a social entrepreneur, that I imagined myself as such, fit comfortably within a discourse that has diminished support for the poor and has allowed racial injustice to fester and persist. The discourse of social entrepreneurship advanced through the efforts of elite universities, enhancing the status and profitability of its young civic leaders even as their wider political and economic commitments were being undermined. I am but one example of this broader social pattern.

After reading an early draft of this book, one reader asked me whether I still believed in New Urban Arts and the power of its programs. Had I changed my mind about the youth arts and humanities program that I started two decades ago as a social entrepreneur? As I conclude this book, I should state unequivocally that I believe in New Urban Arts more than ever. Yes, I am wrestling with a profound sense of ambivalence toward my own leadership. But I simply do not understand how poor youth, queer youth, and/or youth of color are expected to live their best lives in Providence, let alone survive, without this space of sanctuary and study, this space of joy and delight, amid conditions in Providence that have only worsened in many ways for them since the 1990s. I cherish the fact that young people have seized the opportunity of New Urban Arts to trouble violent and shameful representations of them as members of the underclass, precisely because those representations have provided the ideological backbone for a full-scale attack on minoritized and marginalized people living in cities during the past two decades. One front in that attack has been reconfiguring cities through the image of white creativity. I believe that the symbolic cultural practices theorized and enacted by young people in the storefront studio—troublemaking, the hot mess, chillaxing— have been so important to sustaining their lives and their political imaginaries during these bleak and troubling times. These times are bleak and troubling not only because of the ongoing violence and oppression of racial injustice, but the surrealist absurdity that we are still here, that this pattern remains so entrenched.

But it is also true that my interpretive stance has changed significantly since I left New Urban Arts in 2007, and even since I started this project in

2012. I no longer possess a liberal commitment to creativity as a pathway for mobility. The reality is far more complex, and the solutions require more than a creative education, or market-based, race-inflected conceptions of creativity. The solution requires political action supported by the cultural innovations of young people. This new interpretive stance has been shaped by my late arrival to understanding the dynamics of state-orchestrated, racialized class warfare in the name of creativity. Moreover, this new interpretive stance has been shaped by the political terrain and events that have been consuming the nation since I started this project in 2012. A major event for me was the police shooting of Michael Brown, an African American teenager in Ferguson, a suburb of St. Louis, Missouri, in 2014, which was of one of too many extra-judicial killings of black people that gave rise to the Black Lives Matter movement and the renewed appreciation for the role of street protest in stopping it.[4] Moreover, austerity politics following the global recession has shown nothing but contempt for the poor, concluding that everyone but the wealthiest top tenth of 1 percent will have to do with less. I have not been exempted from those politics, as I have worked at public universities since I left Brown University as a postdoctoral fellow in 2013, one in the United States, and the other in the United Kingdom. As I neared completion of this book in 2018, I was an active participant in the largest industrial action in the UK higher education sector in its history.[5] The #MeToo movement has also put the spotlight on men in positions of power who have perpetrated physical and symbolic violence on women across various institutions, bringing about confessions and letters of apology that can easily be construed as self-serving. Urban gentrification has also become a hot-button issue, more loudly echoed by young people who participated in this research project as it unfolded. The data I collected pointed me to the ambivalence of some youth toward New Urban Arts in light of that gentrification. This maelstrom has challenged me to reconsider and to recalibrate my own political and pedagogic commitments based on these lived experiences, as well as the ethnographic and autoethnographic evidence.

This new interpretive stance has forced me to engage critically with the underbelly of the Creative Capital. That critical engagement included coming to terms with my own willful blindness toward the "incorporation," as Stuart Hall might put it,[6] of marginalized youth and their youth development programs into the logic of creative urban renewal. That is to say, their potential threat to power has been refracted into a system of relations shaped by creativity, designed to shore up the power and privilege of white people. I recognize the compromises I made through New Urban Arts, which produced contradictory effects for young people in the city while enhancing my own

profitability as a white creative. Of course, that story repeats a familiar pattern of white people trying to help marginalized groups only to reassert their position. I have only illuminated this pattern within the context of the creative city. Moreover, I am at risk of reproducing this same dynamic through writing this book. I am susceptible to the criticism that this book is an effort to make up for past mistakes, putting on display my new understanding of how my participation as a white creative in Providence was structured through racial dominance, thus "gaslighting" my way to academic promotion without ceding any power or resources.

However, I hope that I have put forward a resonant and critical analysis of youth politics in the creative city, one that demands a critique of my own subject position, which is useful to the struggle for justice. Understanding how to engage in that struggle requires honoring the ambivalence of some youth toward my leadership and toward New Urban Arts. Ambivalence, it seems to me, is the right response to this conjuncture of the Creative Capital. After all, young people who have participated in New Urban Arts have experienced the pleasure and possibility of the storefront studio and have participated in transforming the city's creative underground scene. At the same time, they have experienced deteriorating economic conditions and disappearing ways of life as white people have felt entitled to move into their neighborhoods and do cool things. The intellectual challenge of this book has been seeing these contradictory truths at the same time, recognizing that the irreconcilability of these outcomes can be explained through the very conditions of the Creative Capital itself. The vision for the city proclaimed its commitment to transforming "troubled youth" into "creative youth" while capitalizing on the cultural labor of privileged young people, often white people such as myself, who came to the city to attend elite higher education institutions. Those two demands cannot be reconciled. I did not anticipate this complexity and these contradictions when I started New Urban Arts in 1997 or this research project in 2012. With the benefit of hindsight, it is easy to see how I was a more than complacent in this pattern of urban renewal. I was invested in it.

So, the reality is that my social entrepreneurship through New Urban Arts was never designed to level the playing field for poor young people of color who wanted to develop their creative practices. After all, if I wanted to accomplish that outcome, I would have fought for expanding arts and humanities education in schools, where the struggle for education equity is most important and the cuts have been most severe, as much as I did for such education outside schools. Moreover, I would have fought for material conditions that allow their creative practices to thrive throughout their lifetimes. Upon

critical reflection of the evidence, it is easy to see how those conditions have worsened in many ways for young creatives in Providence since I started New Urban Arts in the late 1990s. The reality is that the turn to creative youth development, to the teaching of creative skills, has come at the precise moment when there are few jobs for those skills to be put to work.

POSTSECONDARY OPTIONS FOR THE CREATIVE UNDERCLASS

One option for young creatives from New Urban Arts is to go to college. Yet college-bound youth from low-income and working-class communities will be doing so at the precise moment that US society is heaping unprecedented costs on young people that will only delay the possibility of economic independence, if not erase its possibility through lifelong indebtedness. Moreover, they can work for and receive this college degree when the promise of higher education as a means of socioeconomic mobility is in tatters. To compete among the next generation of creative thinkers, young people from New Urban Arts will need to earn advanced, postgraduate degrees. Indeed, this new labor requirement has become the new means of social stratification because postgraduate credentials are far more likely to be awarded to students from more affluent backgrounds, and, as youth studies scholar James Côté has indicated, the more affluent acquire more career advantages and higher incomes from postgraduate degrees.[7] Worse still, some young people at New Urban Arts are being forced to navigate higher education without knowing their citizenship status because politicians have used undocumented youth as a political pawn, thus failing to act on offering protections and pathways for "Dreamers" as I complete this book in 2018. But higher education still remains the best option, even if that option is not what it once was.

A second option is for these young people to try to make it as creative entrepreneurs while they go to high school and/or college, or bypass one or both. Indeed, that is precisely what Monty Oum decided to do when he dropped out of high school and participated in New Urban Arts to refine his skills as a digital animator. Yet creative entrepreneurs such as Monty Oum will have to take this social and financial risk at a particular moment in Providence's history when the public safety net has been eviscerated and housing is among the most unaffordable in the nation. As I noted, the total expenditures for cash assistance to poor families from the state government of Rhode Island decreased from $51.5 million the year I founded New Urban Arts in 1997 to zero dollars in 2017.[8] The state government passed a minimum wage local preemption law in 2014 that blocked local municipalities from raising their minimum wages, which, for Providence stood at $9.60 as of 2016.[9] Providence now has the

fourth-worst housing affordability gap for Latinx communities in the country, behind San Jose, California; Boston, Massachusetts; and San Francisco, California.[10] This unaffordability, and this hollowing out of the welfare state, has only compounded the risks for young creative people who might try to launch their own enterprises. So the expectation that creative entrepreneurship is the pathway to economic independence for these young people ultimately reasserts the advantages of those who are poised to take advantage of their upbringings and social positions because they have inherited a private safety net.

A third option for these creative youth is to compete for low-wage service sector jobs in Providence while pursuing high school and/or college degrees, and perhaps launching a creative hustle on the side. After all, the conventional creative city script in Providence has been most successful at transforming the city into a youthful and creative symbolic economy, which, in turn, is correlated with an increase in low-wage jobs in the local retail, food, and hotel industries. Yet young people of color from working-class and low-income backgrounds now face fierce competition for these jobs. Historically, young people who have attended programs such as New Urban Arts have depended upon access to service sector jobs, such as working at McDonald's. But given the changing demographics in Providence, and its dysfunctional labor market, these young people are now more likely to find themselves competing for low-wage jobs in upmarket cafes and grocery stores with, for example, graduates from Brown or RISD who stay in town and have the privilege of being able to choose to not get a "real job" and "stick it to the man."

A fourth option for young creatives is to reassert their own sense of self-determination by rejecting the need to get a "real job" or go to college. These youth can find solace and self-respect, as well as recognition, in Providence's creative underground scene, which celebrates the identities and radical politics of poor and queer youth of color. But, as I have shown, this choice reproduces their subordinate class futures at the precise moment that Rhode Island has eviscerated welfare support and profited from their cultural labor.

A fifth option for these young creatives is to leave Providence for better opportunities elsewhere. That is what Monty Oum did when he went to Austin, Texas, to become one of the most celebrated digital storytellers in the history of the web. But this pathway, too, reasserts advantages to those who have inherited the resources to be mobile and withstand the risks of doing so. National labor and welfare policy have simply not adapted to the precarious conditions of the workplace and the new geography of jobs, which would require new commitments to policies such as universal basic income, single-payer health care, and mobility vouchers.

As I reflect on these bleak postsecondary options now, fifteen years after I gave that speech at the National Young Leaders Conference, I recognize that I did not level the playing field through my work at New Urban Arts even as New Urban Arts has played a vital role in young people's lives. This honest assessment does not necessitate a turn to despair. Instead, I have reflected more deeply on what it means for me to forge solidarities and commit to political action that dismantles the conditions of creativity that have been designed to reassert (my) white profitability. My hope is that my concept of the creative underclass can play a performative role in this particular struggle for creative youth justice.

THE POLITICAL POSSIBILITIES OF THE CREATIVE UNDERCLASS

Throughout this book, I have used the term "the creative underclass" to refer to the political subjectivity of "troubled youth" who are transformed into "creative youth." I have argued that this new kind of citizen-subject has been key to the argument that the Creative Capital is both inclusive and trendy. But none of the young people who participated in this study stated that they identified as members of a "creative underclass." It is my term. At the same time, I have shown how their identity work as youth in the Creative Capital has been attached, if only temporarily, to the "creative" and the "underclass" aspects of the creative city script.[11] As a result, I think the term is useful in representing the experiences and perspectives of these youth in the creative city, as much as it is also helpful in undermining the uncritical acceptance of creativity as a force for urban good.

There were several examples of how young people's symbolic cultural practices at New Urban Arts engaged with "creativity" and the "underclass" as discursive material. For example, Gabriela theorized how young people at New Urban Arts construct their identities and fashion their bodies in ways that trouble their position as "troubled youth," as members of an underclass. Lunisol explained why she thought embracing the lifestyle of a "creative" reproduced her socioeconomic position as an underemployed person who might die from frostbite because she chose to live in an abandoned factory without heat during the winter. Andre found pleasure and artistic possibility in conforming to and exceeding underclass representations of poor young people of color as culturally deprived individuals who lack self-restraint. Laura speculated on a conspiracy theory that the government wanted young people to become either broke and powerless artists, or famous and civically disengaged artists, in order to protect its political and economic interests. Luis told me that he did not think he was going to be "my guy" because he had not par-

162

ticipated in the city's underground scene as a punk rocker or photographer. Theo described how they had infiltrated the creative underground scene and helped to transform it to affirm the identities of queer and poor youth of color in ways that differed from the "white hipster" scene of Boston. Each of these observations by young people who participated in this research show how they are negotiating these identities of "creative" and "underclass" youth in the Creative Capital.

These examples show how this term, "the creative underclass," can also be useful politically. The "under" in "the creative underclass" calls into question the commonsense attitude toward urban youth and creativity—that becoming creative is key to their future mobility. Rhetorically, "the creative underclass" compels us to ask, "How can someone become a member of the underclass— or reproduce their position as a member of the underclass—if they become creative?" The term itself defies the logic that is so key to justifying creative city politics. It breaks positive emotional attachments to a term that is so useful in building antagonistic political coalitions in the interests of whiteness. The conventional creative city script depends upon the assumption that becoming creative is the key to prosperity for all youth in the creative city. Without it, this script is simply revealed as a state-sponsored strategy to gentrify the city, to double down on the already guaranteed futures of white people.

163

Attaching the "under" to Richard Florida's concept of the creative class is also meant as a playful semantic inversion. After all, my rhetorical use of "the underclass" could be read as derogatory because that term has been used to explain poverty through cultural deprivation. "The creative class" signifies superior white creatives and my use of "the creative underclass" could then signify inferior creatives of color. But I am inverting this pejorative usage to speculate on what political possibilities might be opened up if the creative underclass is positioned as a site of political strength and opportunity in undermining the white creativity norm, not reinscribing creative inferiority and cultural deprivation on young people of color from low-income and working-class backgrounds.

This rhetorical move came to me after witnessing the 2014 art exhibition *Ruffneck Constructivists* at the Institute of Contemporary Art in Philadelphia, Pennsylvania, while I was working on this book project. This art exhibition was curated by Kara Walker, who, incidentally, received her graduate degree in fine art from RISD in 1994. The show featured sculpture, paintings, installations, and videos that together interrogated the productive power of black masculinity in reshaping the symbolic potential of space.[12] In explaining her curatorial vision for the show, Walker included wall text that stated,

I was wondering what Black Architecture would look like if there were enough Black architects to bring forth a spatial movement that contained all the angst and braggadocio and ego and rage that Black creatives have brought forth in other fields, particularly music, but also underground entrepreneurship, dance, "thug life," and spiritualism. Given the negative forces (economic, segregationist) that have shaped space around Black Bodies, what questions, concerns, or psychoses might inform or limit the Black Architect; and also, in what ways do folks *become* architects by their refusal to accept the limits of social space—who undermine (or mine under) the norm? To that end, *Ruffneck Constructivists* was conceived, a nexus between bebop, hip hop, modern architecture, state control and violently passionate self-determination.[13]

After witnessing and reflecting upon this profound art exhibition in 2014, only two years after I completed my first round of fieldwork at New Urban Arts, I pondered the power of the "under" in "the creative underclass." Given the negative forces that have shaped space around poor young people of color in Providence through the discourse of white creativity, how might a creative underclass "undermine (or mine under)" the white creativity norm?

In this book, I have provided several examples of how young people at New Urban Arts have done just that. I turned to Gabriela, whose theory and practice of troublemaking shows how youth at New Urban Arts are fucking up white notions of what it means to be black or brown children through, for example, the politics of style and self-fashioning. I turned to the hot mess at New Urban Arts, which provides young people momentary reprieve from toxic and traumatic racist encounters. In the hot mess, they produce a fun and pleasurable environment with a healthy degree of randomness and spontaneity that allow them to experiment with their creative practices and identities. I turned to Lewis and Lunisol, who theorized how chillaxing refuses the suggestion that young people of color from low-income backgrounds need to become more productive as creatives to get ahead at the precise moment that fewer opportunities and supports are available to them. I affirmed the rarely recognized intellectuality and emotional depth of young people in the studio as they sit and talk, as they share love and affection for one another during both exciting and difficult times. And I turned to Thomas, Laura, and Luis, who theorized how young people of color from New Urban Arts are "infiltrating" a creative underground scene so that it recognizes and affirms their nonnormative black/brown creative identities.

In this book, I have pointed out how each of these cultural practices

164

is contradictory and limited. But this ethnographic account has shown that young people are creating the pedagogic conditions that allow them to experiment with and transform their identities in ways that destabilize white creativity as supreme. As such, there is rich potential in working with these symbolic practices to complement political activism that resists gentrifying cities.

MAKING A HOT MESS OF GENTRIFYING CITIES

In 2011, Joey La Neve DeFrancesco, a disgruntled employee of the Renaissance Providence Hotel, handed his boss his resignation letter as his bandmates in the What Cheer? Brigade, a punk brass marching band, blared their horns and banged their drums. Together, they walked out of the bowels of the hotel, leaving DeFrancesco's boss dumbfounded and angry, as he held his arms in the air. This triumphant moment was captured on video and uploaded to YouTube; it has now been viewed over six million times.[14] This labor protest took place at a hotel that is another symbol of Providence's uneven renewal. It was opened in 2007 in a monumental Greek Revival building that was begun by the Freemasons before the Great Depression but was not completed as a result of that financial collapse. The building remained only a shell until it was completed and transformed into a hotel as Providence became the Creative Capital. DeFrancesco resigned after a long struggle with management of the hotel during a unionization campaign before becoming a member of the punk band Downtown Boys.

Staff members, artist-mentors, and former youth participants from New Urban Arts have all performed in the What Cheer? marching band over the years, and the band has shown strong solidarity with young people of New Urban Arts by performing during art openings in the studio and leading street parades for youth participants during the end-of-the-year Art Party. DeFrancesco's protest, and the band's strong support for New Urban Arts, challenged me to consider creative cultural strategies of resistance toward gentrification in Providence. In particular, I see parallels between DeFrancesco's protest and the hot mess of New Urban Arts. They are loud, fun, irreverent, pleasurable, and disrespectful. DeFrancesco's protest does not conform to respectable forms of labor protest in the same way that young people's participation in New Urban Arts does not conform to respectable forms of education. DeFrancesco disregards the notion that if he were to act more respectable as a worker then he could advance his career in the same way that young people from New Urban Arts are rejecting the notion that if they become more respectable as "troubled youth" they will experience mobility as creatives. Their tactics meet the absurd conditions that they have inherited with the same ab-

surdity. These tactics are so antagonistic because they are indifferent to power and they are invested in the pleasure and the possibilities of the protestors.

This analysis challenges typical views of what youth resistance is expected to look like. There is a tendency to appreciate youth resistance when young people are engaged in a rational and deliberate critique of their circumstances. There is a tendency to demand a clear demarcation between youth resistance and youth mischief. In other words, youth political resistance is often assumed to be right and proper when it is solemn and stoic, planned and purposeful, perhaps even respectful of power. But when Gabriela and DeFrancesco engage in their respective troublemaking, they are instead focused on the loudness of a "huge fucking Afro" and the big horns of blaring bandmates. The improvisational hot mess of New Urban Arts and DeFrancesco's protest are spontaneous and unexpected. Together, people smile and laugh, transforming the moment of protest, the moment of creative pedagogy, into collective aesthetic joy that gathers force by showing little concern for the ideas and feelings of those in positions of power. Given the bleak conditions that young people have inherited, it does not seem that power has warranted such respect. So, it seems to me that the creative underclass can draw upon this strategy of troublemaking to produce a hot mess in the Creative Capital, demonstrating their indifference to cultural sites and individuals in the city who signify white gentrification, while experiencing the excessiveness of being loud and being spontaneous. Along with their protest, they can put forward their demands for a city that honors the creativity of black and brown youth.

This proposal resonates with some of the most effective and recent youth activist strategies against white gentrification in American cities. Consider, for example, Defend Boyle Heights in Los Angeles, an activist group that has pioneered tactics over the past couple of years that have influenced other protest movements in other gentrifying cities, including Chicago and Austin. These young people of color have targeted public art events, art galleries, craft breweries, and single-origin coffee shops that have opened up in their neighborhoods, the kind of places that Luis singled out when he discussed gentrification in Providence.

In one example of Defend Boyle Heights' protests, high school students harassed the performance of a public art event by playing their trumpets and saxophones.[15] Youth activists have also showed up at gallery openings chanting, "Hey! Hey! Ho! Ho! These gentrifiers have got to go!" They have screen-printed and sold T-shirts that read "Fuck Hipsters."[16] And when a real estate developer rebranded a building "Mariachi Crossing," attempting to produce

yet another spectacle of ethnicity in their neighborhood for more affluent real estate buyers, they led a successful nine-month rent strike against the developer.[17]

Defend Boyle Heights also waged a protest against a coffee shop, Weird Wave Coffee.[18] More than a dozen protestors confronted customers entering and exiting the shop, demanding a boycott and shouting, "Fuck White Coffee!" and referring to the shop as "White Wave" coffee. The protestors handed out flyers that told customers that breaking the boycott was "an act of aggression and alignment with the racial destruction of Boyle Heights as a Latinx, working-class community."[19] One of the owners of the coffee shop, an entrepreneur who came to the United States as a political refugee from El Salvador, referred to the protests as "straight-up racism, reverse racism against me and my friends."[20]

This group has also resorted to more controversial and violent tactics, including smashing the storefront window of a craft brewery taproom. Their argument is that vandalizing property and making threats of violence are necessary because gentrification itself is a violent act of aggression, a not-so-subtle way of destructing shared ways of life. Of course, I would not advocate for making violent threats or destroying property. But I am calling attention to protest that can and should embrace tactics that produce ambivalence for some and anger for others, otherwise they would be neither disruptive nor effective. This mode of resistance must be loud and fun for the protestors and disruptive for consumers by making visible the "collateral" of gentrification. Of course, the mere presence of young people of color being creative with their bodies and their protests makes visible that collateral.

While youth participants at New Urban Arts might not have intended for their hot mess to be a crash course in how to protest, they can bring their hot mess into the streets of the Creative Capital in effective ways. They can try to have fun and be weird while they fuck up the notion that Providence is a cool place for white people, and upwardly mobile people, to do cool things. Gentrifiers need to be reminded of the costs of their symbolic actions. Young people can put on their T-shirts that say "Be the trouble you want to see in the world" or maybe even "Creative Underclass." They can grab their fifes and drums. They can embody Christopher Walken and craft hell-raiser hairstyles. They can put on their gangster bows and poop rainbows like unicorns. And they can get *turnt* as they drown out the enjoyment of gentrifiers who are hanging out in the city's new hip taprooms and galleries. Such protest—which is creative and pleasurable because it exceeds representations of them as members of an underclass who lack self-restraint—can reaffirm their identi-

167

ties and reassert the symbolic meaning of spaces for them. Policy changes in their favor will not come without this protest.

Antigentrification youth activists in the Creative Capital can also flip the conventional creative city script by running their own place-based marketing campaign. They can leverage new forms of media coverage to tap into the rising discontent over gentrification. In particular, they can run a media campaign that is oriented toward encouraging tourists to withhold their export income from cities until they alter local policy environment in support of communities that are being gentrified. For example, Fodor's, the world's largest publisher of English travel and tourist information, now creates a "No List" each year.[21] Fodor's recommends destinations that people should not visit in order to preserve the splendor and possibility of life there. In 2017, the state of Missouri made Fodor's "No List." Several reasons were cited, including a state law that made it more difficult to sue employers for sexual discrimination, hate crimes committed against Muslims, and the extrajudicial killing of black people by law enforcement.[22] This struggle to re-represent tourist destinations as troubled destinations is useful in the context of Providence because, more often than not, tourists and visitors to the city want to see themselves as modern and politically progressive. So advocates for youth in the city can pool together their resources and hire their own place-based marketing agencies that draw attention to the grim realities for communities of color that are being displaced. Perhaps North Star Destination Strategies, which drafted Providence's rebranding strategy and claims to save "the world one community reputation at a time," can be pressured to help frame this campaign and provide these services pro bono.[23]

Through calling attention to the ways in which the creative city has only made life more unequal for poor youth of color in Providence, this threat to property owners and businesses will provide leverage in altering local policy that serves young people's interests—a living wage, affordable housing, rent control, public transportation, greater public support for youth arts and humanities programs, creative learning in schools, and so forth. Of course, the city and the state will claim that they have no money for this agenda and that it will deter capital investment. So this place-based counternarrative campaign will have to highlight the ways in which the city has provided welfare for affluent white people during the past two decades through the conventional creative city script in ways that simply have not trickled down to low-income communities of color. This pattern has repeated itself for centuries in Providence. Enough is enough.

Another possible cultural protest strategy against the Creative Capital

could build upon the theory and practice of chillaxing at New Urban Arts. Chillaxing can be interpreted as a form of resistance because young people are, in effect, refusing the demand to be productive, to get ahead, to become more creative based on the false promise that creativity is key to their futures. Young people in Providence who participate in the city's numerous nationally recognized youth programs could go on a collective youth development strike through chillaxing in their respective programs. In other words, they could attend these programs but collectively refuse to participate in them until the city adopts certain policies and practices that make it worth it for them to "be developed."

This mode of resistance is an important consideration because I have come to the conclusion that youth arts and humanities programs have paradoxically provided political cover for worsening conditions for youth in Providence. Those who aspire to power can point to these programs as evidence that youth are being well served in Providence, even as the state takes steps to eviscerate support for those same youth. Moreover, these programs contribute to the narrative that if young people want to transition from the dependence of childhood to the independence of adulthood, then they need to invest in their own futures by participating in these programs, and in turn, become more creative. When this promised pathway does not pan out, then the very presence of these programs can be used to support the claim that the city provided youth with equal opportunity. So, if and when shit gets hard or they happen to fuck up, they are the ones to be blamed for being left behind as members of an underclass.

But youth development is not going to solve the problem of a suppressed minimum wage that affects people of color and women most in Providence. Youth development is not going to solve the redistribution of wealth through tax subsidies for property development. Youth development is not going to solve the problem of newspaper outlets choosing another ethnic enclave as the latest trendy neighborhood to gentrify. Youth development is not going to solve the problem of property developers rebranding buildings in their ethnic and/or creative image and then raising their rents until youth can no longer live there. So youth and their allies are going to have to make public their refusal to be developed, to call attention to the fact that youth development simply has not leveled the playing field. Through chillaxing, they can engage in the incessant and irreversible intellectuality of hanging out in the Zen Zone, doing nothing but talking and loving until particular policies in the city and the state are changed for their benefit. In the meantime, they can keep on surviving through chillaxing, because, as Lunisol put it, that is at least enough for

169

now. The counterreaction against a youth development strike will be fierce, using racist and classist representations of youth as lazy and shiftless, uppity and overly entitled. Allies will need to be poised and ready to provide solidarity to these young people as they engage in such acts of resistance. If it is useful, Rhode Island's "Best Role Model" from 2003 will be ready to lend support! And the national field of youth development will watch, wondering how a city with such a stellar reputation for youth development has gotten to this point, which will only provide young people with leverage for their own cause.

White people, particularly those young people graduating from Brown and RISD who decide to remain in the city, will also have to continue to engage in the difficult task of forging solidarity with the creative underclass as they engage in their struggle for creative youth justice. To do so, these white creatives need to engage in their own troublemaking to fuck up what it means to be a white creative or social entrepreneur, undermining the ways in which whiteness invests in its own superiority and profitability through reshaping the symbolic meaning of urban space. Key to that strategy requires thinking through what it means to be an effective white artist-mentor to youth in the Creative Capital. White artists who want to do good in the creative city can ask how the subject position of the "artist-mentor" has been produced discursively through the logic of creative-led urban renewal. This orientation asks how and why white people from elite institutions are in demand to transform "troubled youth," and who profits from that demand. That is precisely the kind of critical investigation that Lunisol suggested when she asked me why people adored me in the studio and why the privilege of artist-mentors was invisible to her as she formed meaningful relationships with these "real gems." She wanted to know why I possessed special status as a white creative and why the conditions of white creativity were made invisible to her through arts mentoring. Deconstructing that status and those conditions with the creative underclass can be key to forging solidarity and to thinking through new political possibilities for racially and class privileged creatives.

The script for urban renewal through creativity is not final, and the fates of youth are not determined. But creative youth justice requires new forms of cultural and political resistance after more than two decades of piloting creative youth development strategies. Through drawing on the perspectives and experiences of young people at New Urban Arts, I have presented some strategies for the creative underclass to undermine the power and privilege of white creativity in their fight for justice:

- creative troublemaking as a means for young people of color to fuck up degrading and dehumanizing representations of youth that serve the possessive interests of whiteness,
- participating in an unpredictable and spontaneous hot mess that brings pleasure and possibility through conforming to and exceeding representations of them as members of the underclass,
- taking that hot mess into the streets at key sites throughout the city that signify gentrification,
- chillaxing to recuperate from the institutional toxicity that threatens the well-being of marginalized youth,
- transforming the creative underground to affirm their identities,
- place-based counternarratives that re-represent the creative city of Providence as a no-go destination until policies are put into place which serve the interests of local youth,
- a youth development general strike, and
- new solidarities between the creative underclass and the creative class.

Surely, this list is only a start. Critical forms of research have an ongoing role to play in identifying and supporting the development of new political strategies in Providence and beyond. Clearly, Providence is not alone in refashioning itself from a disinvested and deindustrialized landscape into a youthful and creative symbolic economy. Further research can examine how youth programs, as well as other arts and humanities programs in other cities, have responded critically and creatively to various scripts for urban renewal that come at the expense of creative youth who lived in cities before they became creative.

With these added perspectives, youth arts and humanities programs will be better poised to support youth as members of the creative underclass, refusing to do the work of being trained and developed, fixed and corrected into normative conceptions of adulthood and white creativity. Youth can be supported by organizations such as New Urban Arts as they oppose regimes of supremacy and the reassertion of whiteness that are invested in transfiguring the bodies and lifestyles of young people of color who choose creativity into sources of profit and spectacles of ethnicity for their land grabs. These regimes, playing out under the rubric of urban renewal, are always looking to sink their hooks into the new, the young, the trendy, the ethnic, the quirky, and the queer.

So now, more than ever, youth arts and humanities programs need to

171

do what youth at New Urban Arts are asking them to do: Let them go underground and do the work of surviving and pleasure seeking. Refuse these above-the-ground demands, which tax their lives and render their bodies expendable. Here, in the underground for the creative underclass, these programs can support youth as they seek refuge during these troubled times, knowing that young people and their allies can reemerge on their own terms, living their best lives, being their best selves. And when they do, they will be justified in making a hot mess of the Creative Capital, fucking up white notions of what it means to be black or brown, denying from whiteness the ownership of what was, is, and will be rightfully theirs—their homes, their bodies, their histories, their lands, their loves, their laughs, and their creative futures of perpetual flight.

172

Notes

INTRODUCTION

1 Dreeszen and Associates, New Commons, and City of Providence Department of Art, Culture and Tourism, *Creative Providence*, 4.

2 I am thankful in particular for the work of Julie Bettie, who has helped me see more clearly how an ethnographic book on the cultural practices of youth might inform their activism. See Bettie, *Women without Class*.

3 By "entanglement," I am seeking to avoid the reductionist argument that the economic conditions of Providence determined this reconfiguration of the city for the benefit of upwardly mobile and white people. Moreover, I am seeking to avoid the foundationalist presumption that I am now standing outside that logic as a spectator subject, able to critique those conditions based on a correct representation of reality. "Entanglement" is a concept developed by feminist new materialist scholars such as Karen Barad who argue that the material worlds we represent are dynamic, producing us as much as we produce them. See Barad, *Meeting the Universe Halfway*. At the same time, this new materialist orientation seeks to avoid a relativist and nominalist viewpoint that presumes all knowledge claims are language games. In other words, I was, and I continue to be, imbricated in the material and discursive realities of Providence that I am seeking to represent. I am grateful for a paper by Jerry Rosiek on this epistemological and ontological perspective that has helped me understand the implications of this theoretical orientation more clearly. See Rosiek, "Art, Agency, and Inquiry."

4 Denzin, "Performing [Auto] Ethnography Politically."

5 Lipsitz, *Possessive Investment in Whiteness*.

6 All names have been changed.

7 hooks, *Where We Stand*, 137.

8 In a television interview by Kenneth Clarke, Baldwin describes urban renewal in San Francisco and other American cities as "negro removal." You can watch the relevant clip of the interview in Vince Graham, *Urban Renewal. Means Negro Removal. ~ James Baldwin (1963)*.

9 The term "performative wokeness" suggests that symbolic gestures of solidarity by people in positions of power have become performative. That is to say, the subject position of a "woke" individual, or one who is conscious of injustice, is now playing a productive role in shaping how people in positions of power act. They perform symbolic gestures, such as putting rainbows on their Facebook avatar or wearing safety pins, that comfort themselves and enhance their status by signaling their virtue, while perhaps doing little to change conditions that produce injustice.

10 See Runciman, "Too Few to Mention."

11 In her book *Women without Class*, Julie Bettie describes how her book is "not meant to be critical of individual people, but of the social systems, processes, and ideologies present in our culture that recruit individual actors and inform their actions." This way of describing poststructurally informed ethnographic analysis was highly influential in shaping my understanding of how I have been "recruited" by various discourses as well as entangled in the "recruitment" of youth as members of a creative underclass. See Bettie, *Women without Class*, x.

12 I am drawing on Bryant Alexander's interpretation of Victor Turner's concept of "performance reflexivity." See Alexander, "Critically Analyzing," 43.

13 See Montgomery, "Rise of Creative Youth Development."

14 There are a variety of youth scholars who have informed my poststructural orientation to creativity. Two influential texts for me include Bettie, *Women without Class*; and Kwon, *Uncivil Youth*.

15 Dávila, *Culture Works*, 73.

16 These white property rights include the right to disposition, the right to use and enjoyment, the right to reputation and status, and the right to exclude. See Harris, "Whiteness as Property."

17 It is important to note that I have omitted the perspectives, experiences, and cultural practices of one important group of youth in this research. I did not meet people who self-identified as indigenous youth in the studio at New Urban Arts. Their omission from this book is noteworthy because Providence is an ongoing settler colonial occupation, and creative city politics involves struggles over rights to land. More than 2 percent of the population of Providence are members of the Narragansett tribe. Educationalists such as Eve Tuck and K. Wayne Yang might quite rightly point out that the youth identities and creative cultural strategies presented here do not account for indigenous politics, educational concerns, or epistemologies. This omission points to an area of further research concerning indigenous youth, creativity, and urban life. See Tuck and Yang, "Decolonization Is Not a Metaphor."

18 Murphy, "No Beggars amongst Them."

19 Harper, "Slavery in Rhode Island."

20 Harper, "Slavery in Rhode Island."

21 Brown University Steering Committee on Slavery and Justice, "Slavery and Justice."

22 McLoughlin, *Rhode Island*, 110.

23 McLoughlin, *Rhode Island*, 115–16.
24 McLoughlin, *Rhode Island*, 109–47.
25 McLoughlin, *Rhode Island*, 109–47.
26 McLoughlin, *Rhode Island*, 156–57.
27 McLoughlin, *Rhode Island*, 118, 121.
28 McLoughlin, *Rhode Island*, 136.
29 Stanton, *Prince of Providence*, 125.
30 Rhode Island Kids Count, "Child Poverty in Rhode Island."
31 Leazes and Motte, *Providence, The Renaissance City.*
32 Americans for the Arts, "Mayor Vincent A. Cianci, Jr. (D-Providence, RI)." Retrieved January 30, 2017, from http://www.americansforthearts.org/by-program/promotion-and-recognition/awards-for-arts-achievement/annual-awards/public-leadership-in-the-arts/mayor-vincent-a-cianci-jr-d-providence-ri.
33 Leazes and Motte, *Providence, the Renaissance City.*
34 See Stanton, *Prince of Providence.*
35 Catalytix and Richard Florida Creativity Group, "Providence."
36 Dreeszen and Associates, New Commons, and City of Providence Department of Art, Culture and Tourism, *Creative Providence.*
37 Peck, "Struggling with the Creative Class."
38 Waitt and Gibson, "Creative Small Cities," 1230.
39 Waitt and Gibson, "Creative Small Cities," 1230.
40 Florida, *New Urban Crisis.*
41 Peck, "Struggling with the Creative Class."
42 Florida, "Cities and the Creative Class."
43 Dreeszen and Associates, New Commons, and City of Providence Department of Art, Culture and Tourism, *Creative Providence*, 4.
44 Dreeszen and Associates, New Commons, and City of Providence Department of Art, Culture and Tourism, *Creative Providence*, 2.
45 Dreeszen and Associates, New Commons, and City of Providence Department of Art, Culture and Tourism, *Creative Providence*, 11.
46 "Community MusicWorks."
47 "National Arts and Humanities Youth Program Awards."
48 Nicodemus, "Cultural Plan."
49 Rhode Island State Council on the Arts, "Program Guidelines."
50 Trinity Repertory Company, "Lie of the Mind."
51 Dávila, *Culture Works*, 82–92.
52 Dávila, *Culture Works*, 87.
53 Providence Downtown Improvement District, "2013 Annual Report," 10.
54 Dávila, *Culture Works*, 87.
55 "Now's the Time."
56 Berliner, "Rational Responses."
57 Berliner, "Rational Responses."
58 Rhode Island Department of Education, "Race to the Top."
59 Au, "Teaching under the New Taylorism."

60 For a discussion of this paradox in other educational contexts and countries, see Burnard and White, "Creativity and Performativity."

61 Dreeszen and Associates, New Commons, and City of Providence Department of Art, Culture and Tourism, *Creative Providence*, 37–41.

62 Krätke, *Creative Capital of Cities*, 91.

63 Robinson, *Black Marxism*.

64 Mills, "White Ignorance."

65 On "performativity," see Butler, *Gender Trouble*.

66 Moan et al., "Role Model," 122.

67 Moan et al., "Role Model," 122.

68 Conti, "Tyler Denmeade>>Arts," 19.

69 Editorial Board, "Denmead's Urban Uplift."

70 Dreeszen and Associates, New Commons, and City of Providence Department of Art, Culture and Tourism, *Creative Providence*, 4; italics mine.

71 See Vygotsky, *Mind in Society*.

72 Kwon, *Uncivil Youth*.

73 Kwon, *Uncivil Youth*.

74 Kwon, *Uncivil Youth*, 10–11.

75. Sukarieh and Tannock, *Youth Rising?*, 17–24.

76 Sukarieh and Tannock, *Youth Rising?*, 23.

77 See YouthPower, "Positive Youth Development."

CHAPTER 1. TROUBLEMAKING

1 Names have been changed.

2 Americans for the Arts, "Brief Conversation."

3 Anyon, "Social Class and the Hidden Curriculum of Work."

4 Kelley, *Yo' Mama's Disfunktional!*, 18.

5 See Lipsitz, *Possessive Investment in Whiteness*.

6 See Weissmann, "Newt Gingrich."

7 Szasz, "Sane Slave."

8 Quoted from Fallace, "Savage Origins," 95.

9 Quoted from Fallace, "Savage Origins," 95.

10 Fallace, "Savage Origins," 95.

11 Fallace, "Savage Origins," 95.

12 Quoted from Fallace, "Savage Origins," 95.

13 Fallace, "Savage Origins," 95.

14 Quoted from Fallace, "Savage Origins," 95.

15 Weissmann, "Newt Gingrich."

16 Ayers, Ayers, and Dohrn, *Zero Tolerance*.

17 Neuman, "Violence in Schools."

18 Petteruti, "Education Under Arrest."

19 Heitzeg, "Education or Incarceration."

20 Goodman, "Charter Management Organizations," 89.

21 Goodman, "Charter Management Organizations."

22 Mason, "Dennis the Menace."

23 Marcyliena Morgan has called this kind of discursive strategy "semantic inversion." See Morgan, *Language, Discourse, and Power.*

24 For a discussion of the distinction between affirmation and transformation, see Fraser, "From Redistribution to Recognition?"

25 For a public discussion of respectability, see Dyson, "Where Do We Go?"

26 Kelley, "Nap Time."

27 Davis, "Afro Images."

28 For a public discussion of respectability, see Dyson, "Where Do We Go?"

29 Noguera and Cannella, "Youth Agency," 335.

30 Quoted from Noguera and Cannella, "Youth Agency," 335.

31 Freire, *Pedagogy of the Oppressed.*

32 Freire, *Pedagogy of the Oppressed.*

33 Freire, *Pedagogy of the Oppressed.*

34 Noguera and Cannella, "Youth Agency," 335.

35 See Gaztambide-Fernandez, "Why the Arts Don't Do Anything."

36 Fine et al., "Educating beyond the Borders."

37 Fine et al., "Educating beyond the Borders," 132.

38 Cited in Grossberg, "Identity and Cultural Studies," 87–88.

39 Bowen, "New Black Hotties."

40 My discussion of this contradiction was influenced by analysis of this article on social media, in particular, by Ashon Crawley, assistant professor of religious studies and African American and African studies at the University of Virginia and the author of *Blackpentecostal Breath* (2017). See https://twitter.com /ashoncrawley/status/993226921461854209.

41 For a discussion of the property rights of whiteness, including the right to disposition, see Harris, "Whiteness as Property," 1731–34.

CHAPTER 2. THE HOT MESS

1 Bright, Oesch, and Puello, *We Make a Lot.*

2 Names have been changed.

3 See Hernandez, "Carnal Teachings"; Hernandez, "Miss, You Look Like a Bratz Doll"; Hernandez, "Ambivalent Grotesque."

4 Scholars such as Samuel Bowles, Herbert Gintis, and Jean Anyon made this same observation in the late 1970s and early 1980s. They argued that different modes of instruction are geared toward the children and adolescents of different social classes, and this differentiation plays a role in reproducing social stratification. In an industrial-based economy, the cultivation of sheepish rule followers, of plebeians, was designed to produce compliant low-wage workers for the factory floor, thus reproducing the social position of the working classes. See Anyon, "Social Class"; Bowles and Gintis, *Schooling in Capitalist America.*

5 Pinar, "Notes."

6 Fine, *Framing Dropouts.*

7 Fine, *Framing Dropouts,* 61.

8 Fine et al., "Educating beyond the Borders," 132.

9 Bettie, *Women without Class*, 144.

10 Demain, "Andy Kaufman."

11 I am relying on Julie Bettie's distinction between "performativity (structure) as unconscious iteration and performance (agency) as conscious, knowing display." See Bettie, *Women without Class*, xxix.

12 Bettie, *Women without Class*, xxix.

13 Fine et al., "Educating beyond the Borders."

14 Broke Boyz EBT Swipe (2014). "Don't Stop Walken." Providence, RI: New Urban Arts. Retrieved July 2016 at https://soundcloud.com/new-urban-arts/dont-stop-walken.

15 Broke Boyz EBT Swipe (2014). "Twerk for Jesus." Providence, RI: New Urban Arts. Retrieved July 2016 at fhttps://soundcloud.com/new-urban-arts/twerk-for-jesus-broke-boyz-ebt.

16 In a post to his Twitter feed on June 15, 2013, Monty described himself as "Cambodian, Vietnamese, Chinese, and Japanese." It is likely that Monty's family came to Providence in the early 1980s when over 100,000 Cambodians applied for and received refuge in the United States. A large settlement of refugees moved to Providence. For an account of Cambodian youth experiences in Providence, see Lay, "Lost in the Fray."

17 For more information on the now defunct Learn and Serve program, see Corporation for National and Community Service, "Learn and Serve America Fact Sheet."

18 Ryzik, "Monty Oum Dies at 33."

19 See a version of *Haloid* posted on YouTube by "AcefromRussia" that has received over five million views as of September 1, 2016, at https://www.youtube.com/watch?v=cL-mR79GErU.

20 Ryzik, "Monty Oum Dies at 33."

21 Chow, "'Model Minority' Myths."

22 Hernandez, "Carnal Teachings," 95. See also Hernandez, "Miss, You Look Like a Bratz Doll."

CHAPTER 3. CHILLAXING

1 K. West, *808s and Heartbreak*.

2 Simon and Pomrenze, "Black Men Arrested."

3 Kohl, *Open Classroom*.

4 Goodyear, "D.I.Y. School."

5 See Oakes, *Keeping Track*.

6 Pate, "Radical Politics."

7 Pate, "Radical Politics."

8 musicmandana, "On Twerking."

9 Du Bois, *Souls of Black Folk*.

10 Task Force on Youth Development and Community Programs, "Matter of Time."

11 Task Force on Youth Development and Community Programs, "Matter of Time," 9–10.

12 Providence After School Alliance, Rhode Island After School Plus Alliance, and Highscope Educational Foundation, "Quality Assessment Tool."

13 Providence After School Alliance, Rhode Island After School Plus Alliance, and Highscope Educational Foundation, "Quality Assessment Tool."

14 Providence After School Alliance, Rhode Island After School Plus Alliance, and Highscope Educational Foundation, "Quality Assessment Tool," 13.

15 Providence After School Alliance, Rhode Island After School Plus Alliance, and Highscope Educational Foundation, "Quality Assessment Tool," 13.

16 Providence After School Alliance, Rhode Island After School Plus Alliance, and Highscope Educational Foundation, "Quality Assessment Tool," 13.

17 Providence After School Alliance, Rhode Island After School Plus Alliance, and Highscope Educational Foundation, "Quality Assessment Tool," 13.

18 Providence After School Alliance, Rhode Island After School Plus Alliance, and Highscope Educational Foundation, "Quality Assessment Tool," 14.

19 Teitle, "Theorizing Hang Out."

20 Teitle, "Theorizing Hang Out," 185.

21 See Foucault, *Discipline and Punish*.

22 Kwon, *Uncivil Youth*.

23 Teitle, "Theorizing Hang Out," 151.

24 A common argument in the field of youth development is that it refutes the racist and classist representations of youth by using "positive" representations of poor youth of color, not deficit-based ones. They are represented as resilient youth, for example, and such resilience needs to be cultivated in order for them to be developed. But constructing "positive" and "negative" representations of youth simply uses two sides of the same coin. For example, a negative representation would posit that a young person of color from a low-income background lacks self-restraint, whereas the positive representation would suggest that a young person possesses self-restraint. The question, however, is how and why self-restraint, for example, is being used to judge youth and construct a normative trajectory for youth development, and what social and psychological positions are privileged through that construction.

25 Brown, "Evolution of DJ Sarah Grace."

26 Brown, *Hear Our Truths*.

27 Harney and Moten, *The Undercommons*.

28 Harney and Moten, *The Undercommons*, 110.

CHAPTER 4. THE CREATIVE UNDERCLASS

1 Dreeszen and Associates, New Commons, and City of Providence Department of Art, Culture and Tourism, *Creative Providence*, 4.

2 Grossman, "Downtown Boys."

3 Sherman, "Downtown Boys' Victoria Ruiz."

4 Bourdieu, *Outline of a Theory of Practice.*

5 Khan, *Privilege*, 86.

6 See Turner, "Church's Fried Chicken" for a discussion of how conspiracy theories and rumor indicate racial anxiety in black communities. I am drawing on this literature in my own interpretation of Laura's conspiracy theory.

7 This analysis is informed by David Gillborn's theorization of whiteness as a conspiracy in the persistence of the black-white achievement gap. See Gillborn, "Coincidence or Conspiracy?"

8 Brown and Thakur, "Workforce Development."

9 Dreeszen and Associates, New Commons, and City of Providence Department of Art, Culture and Tourism, *Creative Providence*, 3.

10 Dreeszen and Associates, New Commons, and City of Providence Department of Art, Culture and Tourism, *Creative Providence*, 4.

11 Dreeszen and Associates, New Commons, and City of Providence Department of Art, Culture and Tourism, *Creative Providence*, 9.

12 Americans for the Arts, "Creative Industries."

13 Americans for the Arts, "Creative Industries Jobs in Providence."

14 Americans for the Arts, "Creative Industries Jobs in Providence."

15 Zip Atlas, "Providence, Rhode Island Employment."

16 Americans for the Arts, "Creative Industries Jobs in Providence."

17 Wile, "What's the Matter?"

18 Taraborelli, "Hidden in Plain Sight."

19 Catalytix and Richard Florida Creativity Group, "Providence," 2.

20 Taveras, "Putting Providence Back to Work," 8.

21. Nesi, "Providence Phoenix."

22 Christopherson and Rightor, "Creative Economy."

23 Christopherson and Rightor, "Creative Economy," 341.

24 Christopherson and Rightor, "Creative Economy," 343.

25 Bai, "Curt Schilling."

26 Rhode Island Department of Labor and Training, "Providence/Cranston Workforce Investment Area."

27 Rhode Island Department of Labor and Training, "2012–2022 50 Fastest Growing Occupations."

28 Rhode Island Department of Labor and Training, "Providence/Cranston Workforce Investment Area."

29 Ahlquist, "Income Inequality."

30 Ahlquist, "Income Inequality."

31 Taveras, "Putting Providence Back to Work," 5.

32 Tung, Sonn, and Lathrop, "Growing Movement."

33 Tung, Sonn, and Lathrop, "Growing Movement."

34 Tung, Sonn, and Lathrop, "Growing Movement."

35 Woodman, "Congrats."

36 Pina, "R.I. House Holds Off."

37 Hall, *Fateful Triangle*, 93.

38 Marx, *Economic and Philosophic Manuscripts of 1844.*

39 Florida, "Cities and the Creative Class."

40 Deuze, "Convergence Culture," 249.

41 Hartley and Cunningham, "Creative Industries."

42 Bortolot, "Designing a Better Office Space."

43 Florida, "Cities and the Creative Class."

44 Ruth Eikhof and Warhurst, "Promised Land?," 499.

45 Dreeszen and Associates, New Commons, and City of Providence Department of Art, Culture and Tourism, *Creative Providence*, 21; italics mine.

46 Dreeszen and Associates, New Commons, and City of Providence Department of Art, Culture and Tourism, *Creative Providence*, 4.

47 Dreeszen and Associates, New Commons, and City of Providence Department of Art, Culture and Tourism, *Creative Providence*, 4.

48 Clarke, "New Labour's Citizens."

49 Clarke, "New Labour's Citizens."

50 Coates, "Capitalist Models."

51 Pratt, "Creative Cities."

52 See Frank, *Conquest of Cool.*

53 Haiven, "Privatization of Creativity."

54 Bramson, "Pockets of Hope"; Pina, "Young Providence Fashion Designer."

55 See Lipsitz, *Possessive Investment in Whiteness.*

56 Hall, *Cultural Studies 1983*, 143.

CHAPTER 5. AUTOETHNOGRAPHY

1 Kolko, "Urban Revival?"

2 Kolko, "Urban Revival?"

3 Kolko, "Urban Revival?"

4 Glass, *London.*

5 See chapter 12 in hooks, *Where We Stand.* hooks argues that "in the United States racial apartheid is maintained and institutionalised by a white dominated real estate market" (132). Her focus is on how racial apartheid has affected black communities in particular. She provides a variety of housing practices as evidence, including white real estate agents sharing information about select properties with white people, the choice by white people to prefer segregated neighborhoods, and the choice by white people to leave neighborhoods if black presence exceeds 8 percent. Of course, other racist real estate practices include the practice of lending discrimination, which has been one significant way in which black wealth accumulation and the intergenerational transfer of black wealth has been denied.

6 Strongin, "You Don't Have a Problem," 59–60.

7 Strongin, "You Don't Have a Problem," 59–61.

8 Strongin, "You Don't Have a Problem," 59.

9 Strongin, "You Don't Have a Problem," 59.

10 Strongin, "You Don't Have a Problem," 60.

11 See Haymes, *Race, Culture, and the City*.

12 Malinowski, "In the Renaissance City."

13 Gramsci, *Selections*.

14 Hall, *Cultural Studies 1983*, 143.

15 Wootton, "Downtown Providence."

16 Catalytix and Richard Florida Creativity Group, "Providence."

17 Althusser, "Lenin and Philosophy."

18 Tsui, "In Providence."

19 Tsui, "In Providence."

20 Tsui, "In Providence."

21 Hall, *Fateful Triangle*, 93.

22 Dunn, "Loft-Style Apartment Building."

23 Graham, *Urban Renewal*.

24 hooks, *Where We Stand*, 137.

25 When Audre Lorde, the black poet, feminist, and civil rights activist, wrote about dealing with white people's hurt feelings, she said that she could not hide her anger toward racism to spare white people from being hurt, from making them feel guilty. At the same time, she wrote, "Guilt is not a response to anger; it is a response to one's own actions or lack of action. If it leads to change, then it can be useful, since it is then no longer guilt but the beginning of knowledge" ("Uses of Anger," 130).

26 I am indebted to the scholarship of Eve Tuck and K. Wayne Yang, who discuss the variety of "moves to innocence" within the logic of settler colonialism. See Tuck and Yang, "Decolonization Is Not a Metaphor."

27 DiAngelo, "White Fragility."

28 Rhode Island General Laws §§ 44–33.2–1 to 44–33.2–6.

29 Providence Preservation Society, "Industrial and Commercial Buildings Survey."

30 The Industrial and Commercial Buildings Survey was a joint project between the Providence Preservation Society and the city of Providence. In 2014, the Industrial and Commercial Building District was combined with a list of residential properties to create the Providence Landmarks District, a scattered-site district overseen by the Providence Historic Districts Commission.

31 Gregg, "R.I. Treasurer."

32 Schwartz, "State Tax Credits."

33 Sgouros, "Outrageous Trading."

34 Clarkin, Jr., "Analysis of Tax Stabilization Agreements."

35 City of Providence, "Ordinance."

36 Corkery, "Buff Chace."

37 Corkery, "Buff Chace."

38 Lipman, Frizzell, and Mitchell, LLC, "Economic and Fiscal Impact Analysis."

39 Rhode Island Kids Count, "Rhode Island Kids Count Factbook," 41.

40 Rhode Island Kids Count, "Rhode Island Kids Count Factbook," 41.

41 Markusen and Gadwa, "Creative Placemaking."

42 Markusen and Gadwa, "Creative Placemaking," 5.

43 Markusen and Gadwa, "Creative Placemaking," 47.

CHAPTER 6. "IS THIS REALLY WHAT WHITE PEOPLE DO?"

1 hooks, "Eating the Other."

2 hooks, "Eating the Other," 367.

3 See Robinson, *Black Marxism*.

4 L. West, "Complete Guide."

5 Modrak, "Bougie Crap."

6 Modrak, "Bougie Crap."

7 Modrak, "Bougie Crap."

8 North Star Destination Strategies, "About Us."

9 North Star Destination Strategies, "Case Studies."

10 North Star Destination Strategies, "Providence, Rhode Island."

11 Peck, "Struggling with the Creative Class."

12 Nesi, "Providence Phoenix."

13 City of Providence, "FY2015 Approved Budget."

14 Donnis, "Providence's Development Boom."

15 See Lipsitz, *Possessive Investment in Whiteness*.

16 Abbott, "In Providence."

17 Abbott, "In Providence."

18 Hunt, "America's Best Cities for Hipsters."

19 Ekstein, "5 Reasons to Visit."

20 "The Avery."

21 See Smith, *New Urban Frontier*.

22 Hall observed this spectacle in the context of working-class black migrants being invited to "well-meaning and enlightened White church or community groups to prepare our 'ethnic food,' wear our 'ethnic dress,' and perform songs in our 'ethnic languages.'" See Hall, *Fateful Triangle*, 92–93.

23 Hall, *Fateful Triangle*, 93.

24 See Harris, "Whiteness as Property," for discussion of enjoyment as a property right of whiteness.

25 Armory Revival Company, "Live, Work and Play."

26 Donnis, "Class Warfare in Olneyville."

27 Donnis, "Class Warfare in Olneyville."

28 Donnis, "Class Warfare in Olneyville."

29 Dreeszen and Associates, New Commons, and City of Providence Department of Art, Culture and Tourism, *Creative Providence*, 1.

30 National Endowment for the Arts, "Art Works Guidelines."

31 Taveras, "Putting Providence Back to Work," 10.

32 Taveras, "Putting Providence Back to Work," 10–11.

33 Taveras, "Putting Providence Back to Work," 10.

34 Taveras, "Putting Providence Back to Work," 10.

35 Americans for the Arts, "Arts and Economic Prosperity III," 20.

36 Atkinson et al., "Worse than the Great Depression," 18.

37 Atkinson et al., "Worse than the Great Depression," 18.

38 Americans for the Arts, "Arts and Economic Prosperity IV."

39 Americans for the Arts, "Arts and Economic Prosperity IV," 3.

40 Americans for the Arts, "Arts and Economic Prosperity IV," 3.

41 Americans for the Arts, "Arts and Economic Prosperity IV," 3.

CONCLUSION

1 Swearer Center for Public Service at Brown University, "History."

2 Sizer, *Horace's Compromise.*

3 See "Coalition of Essential Schools."

4 Lowery, "Black Lives Matter."

5 Burns, "Universities"; Cumbo, "UK University Staff."

6 See Hall, "What Is This 'Black'?"

7 Côté, "New Political Economy of Youth," 533.

8 Rhode Island Kids Count, "Rhode Island Kids Count Factbook," 41.

9 Woodman, "Congrats."

10 Cox, "Progressive Cities."

11 See Hall, "Who Needs Identity?"

12 For a paper that I coauthored in response to that exhibition, see Denmead and Brown, "Ride or Die."

13 Walker, "Ruffneck Constructivists."

14 Amieson "Hotel Worker."

15 Franke-Ruta and Romano, "New Generation."

16 Franke-Ruta and Romano, "New Generation."

17 Franke-Ruta and Romano, "New Generation."

18 McGahan, "Gentrification."

19 Morse, "sjws."

20 Morse, "sjws."

21 Editors, "Fodor's No List 2018."

22 Editors, "Fodor's No List 2018."

23 See North Star Destination Strategies, "About Us."

Bibliography

Abbott, Elizabeth. "In Providence, Progress in Reviving an Urban Desert." *New York Times*, July 30, 2008. http://www.nytimes.com/2008/07/30/realestate/commercial /30prov.html.

Ahlquist, Steve. "Income Inequality in Rhode Island." *RI Future.Org* (blog). June 16, 2016. http://www.rifuture.org/income-inequality-ri/.

Alexander, Bryant K. Critically Analyzing Pedagogical Interactions as Performance. In *Performance Theories in Education: Power, Pedagogy, and the Politics of Identity*, edited by Gary L. Anderson and Bernardo P. Gallegos, 41–62. Mahwah, N.J: L. Erlbaum Associates, 2004.

Althusser, Louis. "Lenin and Philosophy and Other Essays." In *Ideology and Ideological State Apparatuses (Notes towards an Investigation)*, 127–86. Translated by Ben Brewster. New York: Monthly Review Press, 1971.

Americans for the Arts. "A Brief Conversation on Evaluation, Privilege, and Making Trouble." *ARTSBLOG* (blog). May 2, 2012. https://blog.americansforthearts.org /2012/05/02/a-brief-conversation-on-evaluation-privilege-making-trouble.

Americans for the Arts. "Arts and Economic Prosperity III: The Economic Impact of Nonprofit Arts and Culture Organizations and Their Audiences." Washington, DC: Americans for the Arts, 2007. http://www.metroatlantaartsfund.org/downloads /research/AtlantaGA_FinalReport_2007.doc.

Americans for the Arts. "Arts and Economic Prosperity IV: The Economic Impact of Nonprofit Arts and Cultural Organizations and Their Audiences National Statistical Report." Washington, DC: Americans for the Arts, 2012. http://www .americansforthearts.org/sites/default/files/pdf/information_services/research /services/economic_impact/aepiv/NationalStatisticalReport.pdf.

Americans for the Arts. "Creative Industries: Business and Employment in the Arts." Washington, DC: Americans for the Arts, 2008.

Americans for the Arts. "Creative Industries Jobs in Providence." Washington, DC: Americans for the Arts, 2012.

Amieson, Dave. Hotel Worker Tells Story Behind Viral Resignation Video. *Huffington Post*, October 19, 2011. Retrieved from http://www.huffingtonpost.com/2011/10/19/joey-quits-hotel-worker-video_n_1019579.html.

Anyon, Jean. "Social Class and the Hidden Curriculum of Work." *Journal of Education* 162, no. 1 (1980): 67–92.

Armory Revival Company. "Live, Work and Play in Beautiful Industrial Mill Space, Providence RI." Rising Sun Mills (website). Accessed September 8, 2016. http://www.risingsunmill.com/.

Atkinson, Robert, Luke Stewart, Scott Andres, and Stephen Ezell. "Worse than the Great Depression: What Experts Are Missing about American Manufacturing Decline." Washington, DC: Information Technology and Innovation Foundation, 2012. http://www2.itif.org/2012-american-manufacturing-decline.pdf.

Au, Wayne. "Teaching under the New Taylorism: High-Stakes Testing and the Standardization of the 21st-Century Curriculum." *Journal of Curriculum Studies* 43, no. 1 (2011): 25–45.

"The Avery." Zagat. Accessed September 9, 2016. https://www.zagat.com/n/the-avery-providence.

Ayers, William, Rick Ayers, and Bernardine Dohrn, eds. *Zero Tolerance: Resisting the Drive for Punishment in Our Schools: A Handbook for Parents, Students, Educators, and Citizens.* New York City: The New Press, 2001.

Bai, Matt. "Curt Schilling, Rhode Island and the Fall of 38 Studios." *New York Times*, April 20, 2013, sec. Business Day. https://www.nytimes.com/2013/04/21/business/curt-schilling-rhode-island-and-the-fall-of-38-studios.html.

Barad, Karen Michelle. *Meeting the Universe Halfway: Quantum Physics and the Entanglement of Matter and Meaning.* Durham, NC: Duke University Press, 2007.

Berliner, David. "Rational Responses to High Stakes Testing: The Case of Curriculum Narrowing and the Harm That Follows." *Cambridge Journal of Education* 41, no. 3 (2011): 287–302.

Bettie, Julie. *Women without Class: Girls, Race, and Identity.* 2nd ed. Berkeley: University of California Press, 2014.

Bortolot, Lana. "Designing a Better Office Space." *Entrepreneur* (blog). July 26, 2014.

Bourdieu, Pierre. *Outline of a Theory of Practice.* Cambridge: Cambridge University Press, 1977.

Bowen, Sesali. "The New Black Hotties." *New York Times*, May 7, 2018, sec. Opinion. https://www.nytimes.com/2018/05/05/opinion/sunday/the-new-black-hotties.html.

Bowles, Samuel, and Herbert Gintis. *Schooling in Capitalist America: Educational Reform and the Contradictions of Economic Life.* New York: Basic Books, 1976.

Bramson, Kate. "Pockets of Hope." *Providence Journal-Bulletin*, November 18, 2012.

Bright, Emmy, Andrew Oesch, and Noel Puello. *We Make a Lot. We Make Together. We Celebrate What We Make.* Providence, RI: New Urban Arts, 2011.

Brown, David E., and Mala B. Thakur. "Workforce Development for Older Youth." *New Directions for Youth Development* 2006, no. 111 (2006): 91–104. https://doi.org/10.1002/yd.185.

Brown, Ruth Nicole. "The Evolution of DJ Sarah Grace a.k.a. DJ Humble." Presented at the Humility in the Age of Self-Promotion Colloquium, Ann Arbor, Michigan, October 20, 2017.

Brown, Ruth Nicole. *Hear Our Truths: The Creative Potential of Black Girlhood.* Champaign-Urbana: University of Illinois Press, 2013.

Brown University Steering Committee on Slavery and Justice. "Slavery and Justice." Providence, RI: Brown University, 2003.

Burnard, Pamela, and Julie White. "Creativity and Performativity: Counterpoints in British and Australian Education." *British Educational Research Journal* 34, no. 5 (2008): 667–82.

Burns, Judith. "Universities Face 14 Days of Strikes." *BBC News*, January 22, 2018, sec. Family and Education. http://www.bbc.co.uk/news/education-42776449.

Butler, Judith. *Gender Trouble: Feminism and the Subversion of Identity.* Routledge Classics. New York: Routledge, 2006.

Catalytix and Richard Florida Creativity Group. "Providence: An Emerging Creativity Hub." *Creative Intelligence* 1, no. 5 (2003): 1–3.

Chow, Kate. "'Model Minority' Myth Again Used as a Racial Wedge between Asians and Blacks." *NPR.Org* (blog). April 19, 2017. https://www.npr.org/sections /codeswitch/2017/04/19/524571669/model-minority-myth-again-used-as-a-racial -wedge-between-asians-and-blacks.

Christopherson, Susan, and Ned Rightor. "The Creative Economy as 'Big Business': Evaluating State Strategies to Lure Filmmakers." *Journal of Planning Education and Research* 29, no. 3 (March 1, 2010): 336–52. https://doi.org/10.1177 /0739456X09354381.

City of Providence. "An Ordinance Extending Existing Tax Stabilization Plans for Harrisburg Associates, LLC, Lerner Associates, LLC, The Alice Building, LLC and Peerless Lofts, LLC (2013)." http://council.providenceri.com/efile/191.

City of Providence. "FY2015 Approved Budget (2015)." http://openbudget.providenceri .gov/#!/year/2015/operating/0/service?vis=barChart.

Clarke, John. "New Labour's Citizens: Activated, Empowered, Responsibilized, Abandoned?" *Critical Social Policy* 25, no. 4 (2005): 447–63.

Clarkin, Jr., Matthew. "Analysis of Tax Stabilization Agreements in Providence. Presented to Special Committee on Ways and Means." Providence, Rhode Island, January 30, 2014. https://www.providenceri.com/efile/5310.

"Coalition of Essential Schools." Accessed October 28, 2018. http://essentialschools .org/.

Coates, David. "Capitalist Models and Social Democracy: The Case of New Labour." *British Journal of Politics and International Relations* 3, no. 3 (2001): 284–307.

"Community MusicWorks." Community MusicWorks, June 30, 2014. http:// communitymusicworks.org.

Conti, Alli-Michelle. "Tyler Denmead>>Arts." *Providence Monthly*, November 2004.

Corkery, Michael. "Buff Chace Has Downcity Jumping." *Providence Journal-Bulletin*, February 27, 2005.

Corporation for National and Community Service. "Learn and Serve America Fact

Sheet." Washington, DC: Corporation for National and Community Service, March 2011. Retrieved from https://www.nationalservice.gov/sites/default/files /documents/factsheet_lsa.pdf.

Côté, James E. "Towards a New Political Economy of Youth." *Journal of Youth Studies* 17, no. 4 (2014): 527–43. https://doi.org/10.1080/13676261.2013.836592.

Cox, Wendell. "Progressive Cities: Home of the Worst Housing Inequality." *New Geography* (blog). October 14, 2017. http://www.newgeography.com/content/005767 -progressive-cities-home-worst-housing-inequality.

Crawley, Ashon T. *Blackpentecostal Breath: The Aesthetics of Possibility*. New York: Fordham University Press, 2017.

Cumbo, Josephine. "UK University Staff Consider Strike Action over Pensions." *Financial Times*, November 17, 2017. https://www.ft.com/content/07214e48-cb9b -11e7-aa33-c63fdc9b8c6c.

Dávila, Arlene. *Culture Works: Space, Value, and Mobility across the Neoliberal Americas*. New York: New York University Press, 2012.

Davis, Angela Y. "Afro Images: Politics, Fashion, and Nostalgia." *Critical Inquiry* 21, no. 1 (1994): 37–45.

Demain, Bill. "The Time Andy Kaufman Wrestled a Bunch of Women." Mental Floss, July 2, 2012. Retrieved January 26, 2017, from http://mentalfloss.com/article/31079 /time-andy-kaufman-wrestled-bunch-women.

Denmead, Tyler, and Ruth Nicole Brown. "Ride or Die." *Art Education* 67, no. 6 (2014): 47–53.

Denzin, Norman K. "Performing [Auto] Ethnography Politically." *Review of Education, Pedagogy, and Cultural Studies* 25, no. 3 (January 2003): 257–78. https://doi .org/10.1080/10714410390225894.

Deuze, Mark. "Convergence Culture in the Creative Industries." *International Journal of Cultural Studies* 10, no. 2 (2007): 243–63.

DiAngelo, Robin. "White Fragility." *International Journal of Critical Pedagogy* 3, no. 3 (2011). http://libjournal.uncg.edu/index.php/ijcp/article/view/249%3E.

Donnis, Ian. "Class Warfare in Olneyville." *Boston Phoenix*, May 24, 2006. http:// thephoenix.com/boston/news/13331-class-warfare-in-olneyville/.

Donnis, Ian. "Providence's Development Boom: Marvel or Menace?" *Providence Phoenix*, August 5, 2005. http://www.providencephoenix.com/features/top/multi /documents/04880698.asp.

Dreeszen and Associates, New Commons, and City of Providence Department of Art, Culture and Tourism. *Creative Providence: A Cultural Plan for the Creative Sector*. Providence, RI: Department of Art, Culture, and Tourism, 2009. https://www .providenceri.gov/wp-content/uploads/2017/05/City_of_Providence_Cultural _Plan.pdf

Du Bois, W. E. B. *The Souls of Black Folk*. New York: Dover, 1994.

Dunn, Christine. "Loft-Style Apartment Building in Providence Is Sold for $13.4M." *Providence Journal-Bulletin*, February 8, 2017. http://www.providencejournal.com /news/20170208/loft-style-apartment-building-in-providence-is-sold-for-134m.

Dyson, Michael Eric. "Where Do We Go after Ferguson?" *New York Times*, November 29, 2014. https://www.nytimes.com/2014/11/30/opinion/sunday/where-do-we-go -after-ferguson.html.

Editorial Board. "Denmead's Urban Uplift." *Providence Journal-Bulletin*, March 10, 2007.

Editors. "Fodor's No List 2018." *Fodors Travel Guide* (blog). November 15, 2017. https:// www.fodors.com/news/photos/fodors-no-list-2018.

Ekstein, Nikki. "5 Reasons to Visit Providence Now." *Travel + Leisure* (blog). 2014. http://www.travelandleisure.com/blogs/5-reasons-to-visit-providence-now.

Fallace, Thomas. "The Savage Origins of Child-Centered Pedagogy, 1871–1913." *American Educational Research Journal* 52, no. 1 (2015): 73–103.

Fine, Michelle. *Framing Dropouts: Notes on the Politics of an Urban Public High School.* Albany: Statue University of New York Press, 1991.

Fine, Michelle, Lois Weis, Craig Centrie, and Rosemarie Roberts. "Educating beyond the Borders of Schooling." *Anthropology & Education Quarterly* 31, no. 2 (2000): 131–51.

Florida, Richard. "Cities and the Creative Class." *City and Community* 2, no. 1 (2003): 3–19.

Florida, Richard. *The New Urban Crisis: How Our Cities Are Increasing Inequality, Deepening Segregation, and Failing the Middle Class and What We Can Do about It.* New York: Basic Books, 2017.

Foucault, Michel. *Discipline and Punish: The Birth of the Prison.* New York: Random House, 1976.

Frank, Thomas. *The Conquest of Cool: Business Culture, Counterculture, and the Rise of Hip Consumerism.* Chicago, IL: University of Chicago Press, 1998.

Franke-Ruta, Garance, and Andrew Romano. "A New Generation of Anti-Gentrification Radicals Are on the March in Los Angeles—and around the Country." *Huffington Post*, March 5, 2018, sec. US News. https://www.huffingtonpost.com/entry/a-new -generation-of-anti-gentrification-radicals-are-on-the-march-in-los-angeles-and -around-the-country_us_5a9d6c45e4b0479c0255adec.

Fraser, Nancy. "From Redistribution to Recognition? Dilemmas of Justice in a 'Post-Socialist' Age." *New Left Review* no. I/212 (August 1995): 68–93.

Freire, Paulo. *Pedagogy of the Oppressed.* 30th anniversary ed. New York: Continuum, 2000.

Gaztambide-Fernández, Rubén. "Why the Arts Don't Do Anything: Toward a New Vision for Cultural Production in Education." *Harvard Educational Review* 83, no. 1 (2013): 211–37.

Gillborn, David. "Coincidence or Conspiracy? Whiteness, Policy and the Persistence of the Black/White Achievement Gap." *Educational Review* 60, no. 3 (August 2008): 229–48. https://doi.org/10.1080/00131910802195745.

Glass, Ruth. *London: Aspects of Change.* London: MacGibbon & Kee, 1964.

Goodman, Joan F. "Charter Management Organizations and the Regulated Environment: Is It Worth the Price?" *Educational Researcher* 42, no. 2 (2013): 89–96.

Goodyear, Dana. "D.I.Y. School." *New Yorker*, June 1, 2015. http://www.newyorker.com /magazine/2015/06/01/d-i-y-school.

Graham, Vince. *Urban Renewal . . . Means Negro Removal. ~ James Baldwin (1963)*. Accessed September 12, 2018. https://www.youtube.com/watch?v=T8Abhj17kYU.

Gramsci, Antonio. *Selections from the Prison Notebooks of Antonio Gramsci*. Edited by Quentin Hoare and Geoffrey Nowell Smith. London: Lawrence & Wishart, 2005.

Gregg, Katherine. "R.I. Treasurer Suggests Ways to Cut Brokers Out of Tax-Credit Deals." *Providence Journal-Bulletin*, January 7, 2016. http://www.providencejournal.com/article/20160107/news/160109499.

Grossberg, Lawrence. "Identity and Cultural Studies: Is That All There Is?" In *Questions of Cultural Identity*, edited by Stuart Hall and Paul du Gay, 87–107. Thousand Oaks, CA: SAGE Publications, 1996.

Grossman, David. "Downtown Boys: Meet America's Most Exciting Punk Band." *Rolling Stone*, December 11, 2015. http://www.rollingstone.com/music/news/downtown-boys-meet-americas-most-exciting-punk-band-20151211#ixzz46yjef6gs.

Haiven, Max. "The Privatization of Creativity." *Dissident Voice*, May 9, 2012. http://dissidentvoice.org/2012/05/the-privatization-of-creativity/.

Hall, Stuart. *Cultural Studies 1983: A Theoretical History*. Edited by Jennifer Daryl Slack and Lawrence Grossberg. Durham, NC: Duke University Press, 2016.

Hall, Stuart. *The Fateful Triangle: Race, Ethnicity, Nation*. Cambridge, MA: Harvard University Press, 2017.

Hall, Stuart. "What Is This 'Black' in Black Popular Culture?" *Social Justice* 20 (April 1993): 104–14.

Hall, Stuart. "Who Needs Identity?" In *Identity: A Reader*, edited by Paul du Gay, 15–31. Thousand Oaks, CA: SAGE, 2000.

Harney, Stefano, and Fred Moten. *The Undercommons: Fugitive Planning and Black Study*. Wivenhoe, UK: Minor Compositions, 2013.

Harper, Douglas. "Slavery in Rhode Island." *Slavery in the North* (blog). 2003. http://slavenorth.com/rhodeisland.htm.

Harris, Cheryl I. "Whiteness as Property." *Harvard Law Review* 106, no. 8 (June 1993): 1707–91. https://doi.org/10.2307/1341787.

Hartley, John, and Stuart Cunningham. "Creative Industries: From Blue Poles to Fat Pipes." In *The National Humanities and Social Sciences Summit: Position Papers*, edited by M. Gillies. Canberra, Australia: Department of Education, Science, and Training, 2001.

Haymes, Stephen Nathan. *Race, Culture, and the City: A Pedagogy for Black Urban Struggle*. Albany: State University of New York Press, 1995.

Heitzeg, Nancy A. "Education or Incarceration: Zero Tolerance Policies and the School to Prison Pipeline." *Forum on Public Policy Online* 2009, no. 2 (2009).

Hernandez, Jillian. "The Ambivalent Grotesque: Reading Black Women's Erotic Corporeality in Wangechi Mutu's Work." *Signs: Journal of Women in Culture and Society* 42, no. 2 (2017): 427–57.

Hernandez, Jillian. "Carnal Teachings: Raunch Aesthetics as Queer Feminist Pedagogies in Yo! Majesty's Hip Hop Practice." *Women & Performance: A Journal of Feminist Theory* 24, no. 1 (January 2, 2014): 88–106.

Hernandez, Jillian. "'Miss, You Look Like a Bratz Doll': On Chonga Girls and Sexual-Aesthetic Excess." *NWSA Journal* 21, no. 3 (January 15, 2010): 63–90.

hooks, bell. "Eating the Other: Desire and Resistance." In *Black Looks: Race and Representation*, 21–39. Boston: South End Press, 1992.

hooks, bell. *Where We Stand: Class Matters*. New York: Routledge, 2000.

Hunt, Katrina Brown. "America's Best Cities for Hipsters." *T+L Culture and Design* (blog). November 18, 2013. http://www.travelandleisure.com/slideshows/americas-best-cities-for-hipsters-2013/5.

Kelley, Robin D. G. "Nap Time: Historicizing the Afro." *Fashion Theory* 1, no. 4 (November 1997): 339–51. https://doi.org/10.2752/136270497779613666.

Kelley, Robin D. G. *Yo' Mama's Disfunktional!: Fighting the Culture Wars in Urban America*. Boston: Beacon Press, 1998.

Khan, Shamus Rahman. *Privilege: The Making of an Adolescent Elite at St. Paul's School*. Princeton, NJ: Princeton University Press, 2011.

Kohl, Herbert R. *The Open Classroom: A Practical Guide to a New Way of Teaching*. 13th ed. New York: New York Review Books, 1975.

Kolko, Jed. "Urban Revival? Not for Most Americans." *Blog* (blog). March 30, 2016. http://jedkolko.com/2016/03/30/urban-revival-not-for-most-americans/.

Krätke, Stefan. *The Creative Capital of Cities: Interactive Knowledge Creation and the Urbanization Economies of Innovation*. West Sussex, UK: John Wiley & Sons, 2012.

Kwon, Soo Ah. *Uncivil Youth: Race, Activism, and Affirmative Governmentality*. Durham, NC: Duke University Press, 2013.

Lay, Sody. "Lost in the Fray: Cambodian American Youth in Providence, Rhode Island." In *Asian American Youth: Culture, Identity, and Ethnicity*, edited by Jennifer Lee and Min Zhou, 221–31. New York: Routledge, 2004.

Leazes, Francis J., and Mark T. Motte. *Providence, The Renaissance City*. Boston: Northeastern University, 2004.

Lipman, Frizzell, and Mitchell, LLC. "Rhode Island Historic Preservation Investment Tax Credit Economic and Fiscal Impact Analysis." Columbia, MD: Lipman, Frizzell, and Mitchell, LLC, September 7, 2007. http://www.preservation.ri.gov/pdfs_zips_downloads/credits_pdfs/hpitc_pdfs/hpitc-study_pdfs/hpitc_analysis-2007.pdf.

Lipsitz, George. *The Possessive Investment in Whiteness: How White People Profit from Identity Politics*. Revised and expanded ed. Philadelphia: Temple University Press, 2006.

Lorde, Audre. "The Uses of Anger: Women Responding to Racism." In *Sister Outsider: Essays and Speeches*, 124–33. New York: Ten Speed Press, 2007.

Lowery, Wesley. "Black Lives Matter: Birth of a Movement." *Guardian*, January 17, 2017, sec. US news.

Malinowski, W. Zachary. "In the Renaissance City, the Mean Streets Are What Many Youths Call Home." *Providence Journal-Bulletin*, February 10, 2008. http://app.providencejournal.com/hercules/extra/2008/gangs/.

Markusen, Ann, and Anne Gadwa. "Creative Placemaking." Washington, DC: National Endowment for the Arts, 2010.

Marx, Karl. *Economic and Philosophic Manuscripts of 1844*. Blacksburg, VA: Wilder
 Publications, 2011.
Mason, Margie. "At 50, Dennis the Menace Is Forever Young." *Los Angeles Times*,
 March 11, 2001. http://articles.latimes.com/2001/mar/11/local/me-36206.
McGahan, Jason. "Gentrification Conflict Brews over New Boyle Heights Coffee Shop."
 L.A. Weekly, June 19, 2017. http://www.laweekly.com/news/boyle-heights-weird
 -wave-coffee-shop-has-become-a-target-of-gentrification-protesters-8345835.
McLoughlin, William Gerald. *Rhode Island: A Bicentennial History*. The States and the
 Nation Series. New York: W.W. Norton, 1978.
Mills, Charles. "White Ignorance." In *Race and Epistemologies of Ignorance*, edited by
 Shannon Sullivan and Nancy Tuana, 13–38. SUNY Series, Philosophy and Race.
 Albany: State University of New York Press, 2007.
Moan, Ann, Paula Bodah, Sarah Francis, Lisa Harrison, and Megan Fulweiler. "Role
 Model." *Rhode Island Monthly*, August 2003.
Modrak, Rebekah. "Bougie Crap: Art, Design, and Gentrification." *Infinite Mile*, no. 14
 (February 2015). http://infinitemiledetroit.com/Bougie_Crap_Art,_Design_and
 _Gentrification.html.
Montgomery, Denise. "The Rise of Creative Youth Development." *Arts Education
 Policy Review* 118, no. 1 (2017): 1–18.
Morgan, Marcyliena H. *Language, Discourse, and Power in African American Culture*.
 Cambridge: Cambridge University Press, 2002.
Morse, Brandon. "SJWs Intimidate Hispanic-Owned Coffee Shop to Stop White Gen-
 trification." *TheBlaze* (blog). July 3, 2017. http://www.theblaze.com/news
 /2017/07/03/sjws-intimidate-hispanic-owned-coffee-shop-to-stop-white
 -gentrification/.
Murphy, Michael Warren. "'No Beggars amongst Them': Primitive Accumulation,
 Settler Colonialism, and the Dispossession of Narragansett Indian Land." *Human-
 ity & Society* 42, no. 1 (2018): 45–67.
musicmandana. "On Twerking with Gravitas and Capriciousness." Tumblr, June 2,
 2015. http://musicamundana.tumblr.com/post/120564807567/luvyourself
 someesteem-ojhungry-golden-brooks.
"National Arts and Humanities Youth Program Awards." President's Committee on
 the Arts and the Humanities. Accessed October 13, 2016. http://www.pcah.gov
 /national-arts-humanities-youth-program-awards.
National Endowment for the Arts. "Art Works Guidelines: Grant Program Descrip-
 tion" (website). Accessed September 13, 2016. https://www.arts.gov/grants
 -organizations/art-works/grant-program-description.
Nesi, Ted. "*Providence Phoenix* to Publish Last Issue Next Week." *WPRI 12 Eyewitness
 News*, October 9, 2014. http://wpri.com/2014/10/09/providence-phoenix-to
 -publish-last-issue-next-week/.
Neuman, Scott. "Violence in Schools: How Big a Problem Is It?" *NPR.Org* (blog).
 March 16, 2012. https://www.npr.org/2012/03/16/148758783/violence-in-schools
 -how-big-a-problem-is-it.

Nicodemus, Anne Gadwa. "Cultural Plan Backs Up 'Creative Capital' Branding: A Creative City Initiative Case Study on Providence, Rhode Island." Easton, PA: Metris Arts Consulting, October 2012. http://metrisarts.com/wp-content /uploads/2013/01/ProvidenceFullCaseStudy.pdf.

Noguera, Pedro, and Chiara Cannella. "Youth Agency, Resistance, and Civic Activism." In *Beyond Resistance! Youth Activism and Community Change: New Democratic Possibilities for Practice and Policy for America's Youth*, edited by Pedro Noguera, Shawn A. Ginwright, and Julio Cammarota, 333–47. New York: Routledge, 2006.

North Star Destination Strategies. "About Us" (website). Accessed December 20, 2017. http://northstarideas.com/about-us.

North Star Destination Strategies. "Case Studies" (website). 2016. http://www .northstarideas.com/our-work.

North Star Destination Strategies. "Providence, Rhode Island" (website). 2016. http:// www.northstarideas.com/case-studies/providence-rhode-island.

"Now's the Time: Expanding Access to Arts Opportunities for Providence Children Symposium." Providence, RI, 2013.

Oakes, Jeannie. *Keeping Track: How Schools Structure Inequality*. 2nd ed. New Haven, CT: Yale University Press, 2005.

Pate, SooJin. "The Radical Politics of Self-Love and Self-Care." *Feminist Wire* (blog). April 30, 2014. http://www.thefeministwire.com/2014/04/self-love-and -self-care/.

Peck, Jamie. "Struggling with the Creative Class." *International Journal of Urban and Regional Research* 29, no. 4 (2005): 740–70.

Petteruti, Amanda. "Education under Arrest: The Case against Police in Schools." Washington, DC: Justice Policy Institute, November 2011. http://www.justicepolicy .org/uploads/justicepolicy/documents/educationunderarrest_fullreport.pdf.

Pina, Alisha. "R.I. House Holds off on Another Minimum Wage Hike." *Providence Journal-Bulletin*. June 8, 2016.

Pina, Alisha. "Young Providence Fashion Designer Learned a Lot from His Mother's Work." *Providence Journal-Bulletin*. March 25, 2015.

Pinar, William F. "Notes on Understanding Curriculum as a Racial Text." In *Race, Identity, and Representation in Education*, edited by Cameron McCarthy and Warren Crichlow, 60–70. New York: Routledge, 1993.

Pratt, Andy C. "Creative Cities: The Cultural Industries and the Creative Class." *Geografiska Annaler. Series B, Human Geography* 90, no. 2 (2008): 107–17.

Providence After School Alliance, Rhode Island After School Plus Alliance, and Highscope Educational Foundation. "The Rhode Island Program Quality Assessment Tool (RIPQA)." Providence, RI: Providence After School Alliance, 2012.

Providence Downtown Improvement District. "2013 Annual Report." Providence, RI: Providence Downtown Improvement District, 2013. http://downtownprovidence .com/wp-content/uploads/2014/02/Annual-Report-2013-PDF_web_revised.pdf.

Providence Preservation Society. "Industrial and Commercial Buildings Survey"

(website). Accessed September 30, 2016. http://www.ppsri.org/ppsresources
/industrial-and-commercial-buildings-icbd-survey.

Rhode Island Department of Education. "Race to the Top—Additional Information"
(website). Accessed September 16, 2016. http://www.ride.ri.gov/InsideRIDE
/AdditionalInformation/RacetotheTop.aspx.

Rhode Island Department of Labor and Training. "2012–2022 50 Fastest Growing Oc-
cupations." Cranston, RI: Rhode Island Department of Labor and Training.
Accessed January 14, 2018. http://www.dlt.ri.gov/lmi/proj/expdecind.htm.

Rhode Island Department of Labor and Training. "Providence/Cranston Workforce
Investment Area." Cranston, RI: Rhode Island Department of Labor and Training,
September 2016. http://www.dlt.ri.gov/lmi/pdf/pcwia.pdf.

Rhode Island General Laws §§ 44-33.2-1 to 44-33.2-6. 2014.

Rhode Island Kids Count. "Child Poverty in Rhode Island: A Statistical Profile."
Providence: Rhode Island Kids Count, January 2006. http://www.rikidscount.org
/Portals/0/Uploads/Documents/Child%20Poverty%20in%20Rhode%20Island
%20A%20Statistical%20Profile,%20January%202006.pdf.

Rhode Island Kids Count. "Rhode Island Kids Count Factbook." Providence: Rhode
Island Kids Count, 2016. http://www.rikidscount.org/Portals/0/Uploads
/Documents/Factbook%202016/Cash%20Assistance%202016.pdf.

Rhode Island State Council on the Arts. "State Cultural Facilities Grant Program
Guidelines" (website). Accessed January 10, 2017. http://www.arts.ri.gov/scfg/scfg
-guidelines.php.

Robinson, Cedric J. *Black Marxism: The Making of the Black Radical Tradition.* Chapel
Hill: University of North Carolina Press, 2000.

Rosiek, Jerry. "Art, Agency, and Inquiry: Making Connections between New Material-
ism and Contemporary Pragmatism in Arts-Based Research." In *Arts-Based Re-
search in Education: Foundations for Practice*, edited by Melisa Cahnmann-Taylor
and Richard Siegesmund, 32–47. 2nd ed. New York: Routledge, 2018.

Runciman, David. "Too Few to Mention." *London Review of Books*, May 10, 2018.

Ruth Eikhof, Doris, and Chris Warhurst. "The Promised Land? Why Social Inequali-
ties Are Systemic in the Creative Industries." *Employee Relations* 35, no. 5 (August
9, 2013): 495–508. https://doi.org/10.1108/er-08-2012-0061.

Ryzik, Melena. "Monty Oum Dies at 33, and His Fans Grieve." *The New York Times*,
February 4, 2015. Retrieved from http://www.nytimes.com/2015/02/05/arts/monty
-oum-dies-at-33-and-his-fans-grieve.html.

Schwartz, Harry. "State Tax Credits for Historic Preservation." Washington, DC:
National Trust for Historic Preservation, November 15, 2016. https://forum
.savingplaces.org/HigherLogic/System/DownloadDocumentFile.ashx
?DocumentFileKey=54e27df7-1135-ce87-4bc7-41ea6e55f70d.

Sgouros, Tom. "Outrageous Trading on R.I. Tax Credits." *Providence Journal-Bulletin*,
November 5, 2014. http://www.providencejournal.com/article/20141105/opinion
/311059892.

Sherman, Maria. "Downtown Boys' Victoria Ruiz on Writing Chicana Protest-Punk

Anthems." *Rolling Stone*, September 20, 2017. https://www.rollingstone.com/music
/features/downtown-boys-victoria-ruiz-on-sub-pop-lp-cost-of-living-w498777.

Simon, Darran, and Yon Pomrenze. "Black Men Arrested at Philadelphia Starbucks
Reach Agreements." *CNN*. Accessed June 7, 2018. https://www.cnn.com/2018/05/02
/us/starbucks-arrest-agreements/index.html.

Sizer, Theodore R. *Horace's Compromise: The Dilemma of the American High School.*
Boston: Houghton Mifflin, 1984.

Smith, Neil. *The New Urban Frontier: Gentrification and the Revanchist City.* London:
Routledge, 1996.

Stanton, Mike. *The Prince of Providence: The Rise and Fall of Buddy Cianci, America's
Most Notorious Mayor.* New York: Random House, 2004.

Strongin, Fay. "'You Don't Have a Problem, until You Do': Revitalization and Gentrifi-
cation in Providence, Rhode Island." Master's thesis, Massachusetts Institute
of Technology, 2017. https://dspace.mit.edu/bitstream/handle/1721.1/111259
/1003291357-mit.pdf?sequence=1.

Sukarieh, Mayssoun, and Stuart Tannock. *Youth Rising? The Politics of Youth in the
Global Economy.* New York: Routledge, 2014.

Swearer Center for Public Service at Brown University. "History." Accessed October 5,
2017. https://www.brown.edu/academics/college/swearer/history.

Szasz, Thomas S. "The Sane Slave: Social Control and Legal Psychiatry." *American
Criminal Law Review* 10, no. 3 (spring 1972): 337–56.

Taraborelli, John. "Hidden in Plain Sight." *Providence Monthly*, March 18, 2013.

Task Force on Youth Development and Community Programs. "A Matter of Time:
Risk and Opportunity in the Nonschool Hours." New York: Carnegie Corporation
of New York, December 1992. http://files.eric.ed.gov/fulltext/ED355007.pdf.

Taveras, Angel. "Putting Providence Back to Work: An Action Plan for Economic
Development in Rhode Island's Capital City." Providence, RI: City of Providence,
March 27, 2013. https://www.providenceri.com/efile/4353.

Teitle, Jennifer Rebecca. "Theorizing Hang Out: Unstructured Youth Programs and
the Politics of Representation." University of Iowa, 2012. http://ir.uiowa.edu/etd
/2998.

Trinity Repertory Company. "A Lie of the Mind." Providence, RI: Trinity Repertory
Company, 2014. https://issuu.com/trinityrep/docs/lie_of_the_mind_program.

Tsui, Bonnie. "In Providence, Faded Area Finds Fresh Appeal." *New York Times*, June
6, 2005, sec. Travel.

Tuck, Eve, and K. Wayne Yang. "Decolonization Is Not a Metaphor." *Decolonization:
Indigeneity, Education & Society* 1, no. 1 (2012): 1–40.

Tung, Irene, Paul Sonn, and Yannet Lathrop. "The Growing Movement for $15." New
York: National Employment Law Project, November 4, 2015. http://www.nelp.org
/publication/growing-movement-15/.

Turner, Patricia A. "Church's Fried Chicken and the Klan: A Rhetorical Analysis of
Rumor in the Black Community." *Western Folklore* 46, no. 4 (October 1987): 294.
https://doi.org/10.2307/1499891.

Vygotsky, Lev. *Mind in Society: The Development of Higher Psychological Processes.* Cambridge, MA: Harvard University Press, 1980.

Waitt, Gordon, and Chris Gibson. "Creative Small Cities: Rethinking the Creative Economy in Place." *Urban Studies* 46, no. 5–6 (May 1, 2009): 1223–46.

Walker, Kara. "Ruffneck Constructivists." Philadelphia: Institute for Contemporary Art at the University of Pennsylvania, August 2014.

Weissmann, Jordan. "Newt Gingrich Thinks School Children Should Work as Janitors." *Atlantic*, November 21, 2011. https://www.theatlantic.com/business/archive/2011/11/newt-gingrich-thinks-school-children-should-work-as-janitors/248837/.

West, Kanye. *808s and Heartbreak.* Glenwood Studios in Burbank and Avex Recording Studio in Honolulu: Roc-A-Fella and Def Jam, 2008.

West, Lindy. "A Complete Guide to 'Hipster Racism.'" *Jezebel* (blog). Accessed May 25, 2018. https://jezebel.com/5905291/a-complete-guide-to-hipster-racism.

Wile, Rob. "What's the Matter with Rhode Island?" *Business Insider*, August 8, 2014. http://www.businessinsider.com/the-fall-and-rise-of-rhode-island-2014-8.

Woodman, Spencer. "Congrats on That New Citywide Minimum Wage. Now Republicans Are Going to Try to Kill It." *Nation*, February 22, 2016. https://www.thenation.com/article/congrats-that-new-citywide-minimum-wage/.

Wootton, Anne. "Downtown Providence of Today Vastly Different from City of Early '90s." *Brown Daily Herald*, March 13, 2006. http://www.browndailyherald.com/2006/03/13/downtown-providence-of-today-vastly-different-from-city-of-early-90s/.

YouthPower. "Positive Youth Development (PYD) Framework" (website), January 9, 2017. http://www.youthpower.org/positive-youth-development-pyd-framework.

Zip Atlas. "Providence, Rhode Island Employment" (website). Accessed February 9, 2017. http://zipatlas.com/us/ri/providence.htm#employment.

Index

198

creative city discourse: antigentrification activism against, 165–72; community-led revitalization and, 124–27; creative underclass and, 163–64; economic security and, 11–14; labor policies and, 106–17; racist/classist representations of Providence and, 121–22; rebranding of urban areas and, 146–50; urban renewal and, 18–19

creative placemaking discourse, 131–32

Creative Providence plan, 18–29, 147; job creation and, 106–8; "troubled" youth discourse and, 32, 112–17, 125–27

creative underclass: Creative Capital and, 3–5, 81–82, 113–17; defined, 1–2; economic immobility of, 96–117; gentrification's impact on, 118–22; loudness associated with, 57–63; political possibilities of, 162–65; postsecondary options for, 160–62; troublemaking by, 32–44; troubling representations of, 103–5

creative youth development: creative practices and, 10–14; transformation from troubled youth through, 103–17

critical race theory: creativity and, 12–14; troublemaking and, 32

critical thinking, teaching of, at New Urban Arts, 51–57

cultural deprivation theory, 32–34; Wits' challenge to, 67–68

cultural politics: chillaxing and, 86–96; creative underclass and, 154; excessiveness and, 48; necessity for, 158–60; performances and, 73–75; racial hierarchies and, 34–35; strategies in, 29; troublemaking discourse and, 32, 37–44

dance ciphers, 46

Dávila, Arlene, 10

Davis, Angela, 39–40

Defend Boyle Heights group, 166–67

DeFrancesco, Joey La Neve, 165–72

Dennis the Menace, privilege of troublemaking and image of, 30–34, 37, 40

Department of Art, Culture and Tourism (Providence), 20, 147

development: collateral damage of, 148–50; economic incentives for historic restoration and, 128–32; economic redistribution and, 5; Grant Mill project and, 124–27; whiteness and, 148–50

Dewey, John, 156

dive bars (Providence), 142–43

"Dogicorn" (Brontë), 70–71

"Do I still have time to grow?" (painting by Alicia), 76–77

Donnis, Ian, 147

"Don't Stop Believin'" (song), 64

"Don't Stop Walken" (song), 64

double consciousness, internalized racism and, 86–87

Downcity Arts and Entertainment District (Providence), 135

Downtown Boys (band), 103, 165

Downtown Improvement District Commission (Providence), 21

drapetomania, 34–35

Du Bois, W. E. B., 86–87

"Eating the Other" (hooks), 141

Echoing Green Foundation, 17

economic-base theory, tourism and, 152

Economic Development Corporation, 108

economic growth: barriers for creative underclass to, 96–117; Creative Capital concept and, 103–17, 151–54; creative city discourse and, 10–14; race and ethnicity and, 13–15

education: racist discourse in, 35–36; student artists' portrayal of, 51–52; tracking processes in, 84–85; workforce development and, 111–12

Eikhof, Doris Ruth, 112

Eliot, Charles, 35–36

entanglement: creative underclass and, 19, 27; defined, 173n3; privileged creativity and, 4, 10; of state power and creativity, 24; of youth creativity and Creative Capital, 78–82

entrepreneurship, creative labor and, 113–17

199

ironic speech acts, class and race and, 142–43
"I Will Survive" (song), 71

job creation in Providence: arts and, 151–54; creative underclass and, 103–17; neoliberal concept of creativity and, 115–17
Journey (band), 64

Kelley, Robin D. G., 32, 39
Khan, Shamus, 103
Kid 'n Play, 46
kitsch, Creative Capital and, 142–43
Kohl, Herbert, 83–84
Krätke, Stefan, 22
Kwon, Soo-Ah, 27

labor market: Creative Capital and, 105–17; wage inequality and, 110
Landesman, Rocco, 151
Latinx communities in Providence, 16–18; gentrification and, 137–40; NUA mural project and, 122–27
Latinx community in Providence, unemployment among, 109–10
Lauper, Cyndi, 46
Lorde, Audre, 182n25
Loudest Human Beings to Ever Exist, New Urban Arts students as, 57–63
Lupo, Richard, 120–21

MacArthur Genius Award, 19
market-oriented framework: creative city discourse and, 27–29, 151–54; educational policy and, 177n4; funding for New Urban Arts and, 144–45; social entrepreneurship and, 157–60
Markie, Biz, 46
Markusen, Ann, 132
Marx, Karl, 40, 111
"matter of fact" ethnic restaurants, 140–45
"A Matter of Time" (Carnegie Council), 87
McCormack, Lynne, 20–21
media industry: coverage of Providence

by, 147–49; creative city discourse in, 148–50; job creation in, 107–8; racist/classist representations of Providence in, 120–22
#MeToo movement, 9, 158
Meyer, Sarah, 60
Mills, Charles, 24
minimum wage laws, 109–10, 131–32, 160–61
Modrak, Rebekah, 144–45
Monáe, Janelle, 43
"The Monster Mash" (song), 46
Moten, Fred, 95–96
"move to innocence," 127, 182n26
municipal arts projects, classism and racism and, 150–54
MUSE School (Malibu Canyon, CA), 83–84

Narragansett Indians, 14
National Endowment for the Arts, 151
National Young Leaders Conference, 155
"Native Tongue" (poem), 52–56, 103
neoliberal concept of creativity, 115–17
nerd identity, race and, 38–43
"Nerd Week," 46
"The New Black Hotties" (Bowen), 42–43
New Orleans bounce music, 64–65
New Urban Arts: artist-mentors at, 26–29; chillaxing at, 82–95; Craftland fundraiser for, 144; Creative Capital and, 96–117; creative city discourse and, 19–29; creative underclass and, 1–4; cultural politics and, 41–44; demographics of participants in, 12–14; founding of, 17–18; gentrification and, 119–22; legacy of, 157–60; loudest students at, 57–63; mural project at, 122–27; pedagogic model at, 96; Plebians at, 48–57; popular culture parodies at, 45–47; programs in competition with, 89–95; public support for, 165; Silents as students at, 68–73; staffing at, 50–57; state evaluation of, 91–95; structured environment of, 47–55; student types at, 48–73; temporal structure at, 83–85;

202

203